THE ULTIMATE

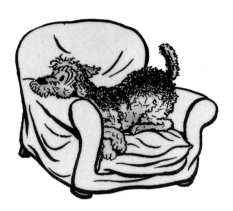

Also by Peter Tory

Giles: A Life in Cartoons
The Giles Family
Giles at War

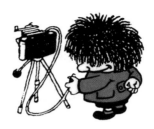

THE ULTIMATE

Peter Tory

HEADLINE

First published in 1995
by HEADLINE BOOK PUBLISHING

10 9 8 7 6 5 4 3 2 1

British Library Cataloguing in Publication Data

Tory, Peter
The Ultimate Giles
A British Library Cataloguing in Publication
Data block for this book may be obtained
from the British Library

ISBN 0 7472 1592 8

Designed by Penny Mills

Printed and bound in Italy by
Canale & C. s. p. A

HEADLINE BOOK PUBLISHING
A division of Hodder Headline PLC
338 Euston Road
London NW1 3BH

For David, Wendy, Michael and Anne

Acknowledgements

My thanks go to my publisher, Alan Brooke, for his help and
encouragement in the preparation of this book and to Mark Burgess,
yet again my invaluable researcher.

Contents

Giles: An Epitaph

1916–1995

Since I wrote this book, Carl Giles sadly died on 27 August 1995. He never really recovered from the death of his beloved wife Joan on Christmas Day 1994.

One of Giles's wartime cartoons, set against a background of blackened trees and shell-holes, shows a Tommy leaning over a crest and looking down at a disconsolate, tattered German soldier. The Tommy's helmet is pushed back on his head, his face is cracked in a mischievous smile and he is supporting his chin on his right hand.

The caption reads: "'Ow is Mr Invincible, this morning?"

The British public, with the war on the turn, adored it. Here, Giles had caught the mood of the nation precisely on its wartime funny-bone. Here we had the cheeky British private, cocky though not malicious, friendly, cheerful and gently ironic, reminding Jerry that he was about to lose the ruddy war. The cartoon showed the British as we like to see ourselves: decent, humane and good-natured.

All of Giles's Tommies, extraordinarily, had individual characters, as did the sergeant-majors and the officers. Even the generals. But while they were all drawn in gentle, detailed caricature – the Tommy an obvious skiver, the brigadier with an absurd moustache perched over rabbit teeth – they were created with great

affection and warmth. The British, in Gilesland, liked to recognise themselves. They were reassured and endlessly amused by what they saw.

After the war, during which Giles's morale-boosting cartoons had quickly elevated him to that splendid level of a national institution, the artist – briefly – was at a loss. After all, he could hardly continue to draw Tommies. So one weekend *Sunday Express* readers were introduced to a group of characters who, during the next half a century, were to pass into cartooning immortality. They were The Family.

Who were the Family? They were probably lower-middle-class and they lived in suburbia. They were led by a tyrannical matriarch in bombazine black known simply as Grandma. They included a long suffering mother and father, daughters in tight sweaters and a monstrous scattering of young, including baby twins. These offspring, some of unknown parentage, were malevolent creatures who attached live wires to Grandma's knitting needles, shot arrows at the neighbour's cat and stuffed holly into father's slippers. Yet for all that they were among the most loved youngsters in the land. As for the terrible Grandma, she became a sort of terrifying suburban empress.

So here was Giles's Middle England, where Christmases were always deeply and crisply white and where the rough kids threw snowballs at the scurrying parson and at the angelic carollers. This was the

England, far from the inner city, of caravans and allotments and the seaside. It was the England of the dog biting the postman, of the vicar's cricket team and of dad snoring in front of the telly.

The Family lived in what appeared to be a North London, Edgware, sort of a place. Giles had himself lived in Edgware. Their house, with its tool-shed, dog kennel and sometimes its half-painted dinghy, was occupied by impossibly many people. It also changed shape, curiously, from one cartoon to another. And its occupants never grew any older.

So why did we love them? Giles had the artistry of a great master and his draftsmanship won the admiration of such as Annigoni. What happened in his cartoons was funny in its particulars, though often the central joke was quite weak. He also had the ability, gained from his days as an animator with Sir Alexander Korda, to give the impression of movement.

Giles was loved for something more. His cartoons were reassuring. His Family fulfilled something of the role of royalty by representing continuity. In Giles's world, all was well, and there would always be a tomorrow.

There are those who say that Giles's England is a thing of the past, that at some stage he stopped the progress of his family and held them back, preserving them in another time. Giles would not have agreed. In Ipswich pubs he pointed out his characters to me. There they all were, even Grandma, bustling her daughter into a teashop.

There are still allotments. There are still caravans. Go to the seaside and you will see father with a handkerchief knotted on his head and the kids burying a sister. It is not Middle England that has gone, but Giles.

This volume is a tribute to an incomparable English genius; his cartoons enriched all our lives.

Peter Tory
Cleveley, Oxfordshire
August 1995

Giles combined a great talent for draughtsmanship with a highly developed sense of humour. Whatever the message he wished to convey, his cartoons were, above all, funny. He had a genius for pulling people's legs without being cruel or offensive. I say this as one who has been the subject of several of his efforts and I don't think I would have been unhappy to hang the original of any of his cartoons in my collection.

Of the several originals that I managed to winkle out of him, it was one of the first that made the deepest impression on me. I was young and unused to public attention, so I took it as quite a compliment to be noticed by the famous Giles. I had just become President of the National Playing Fields Association and I had started to play polo. The combination must have tickled his imagination for Giles produced a delightful cartoon of street urchins playing their version of polo on bicycles and scooters with saucepans on their heads as helmets. One of them had driven a ball into the back of the head of a rather serious passer-by. The caption read: "Whoever is popularising polo can't know what we already have to put up with from football and cricket."

Tributes

When the Prince of Wales was asked to contribute to this volume he responded immediately – as did Prince Philip. Both Prince Charles and his father receive hundreds of such requests, thousands maybe, so it is of considerable significance that they were so quick to make available their precious time in order to pay tribute to the subject of this book.

Prince Philip's appreciation is the foreword, which precedes this chapter. Prince Charles, through his private secretary, Commander Richard Aylard, sent the following letter:

The Prince of Wales was pleased to contribute, and has written as follows:

'I think I must be a part of the generation which has grown up under the cartoon "spell" of Giles, to the extent that his cartoons have become a national institution – and a much loved one at that. I am lucky enough to have one or two original Giles cartoons on my wall (my father has many more!) and my favourite one is based on a remark I made nineteen years ago when I was commanding HMS *Bronington,* to the effect that I felt I had aged at least ten years during my time in command! The resulting cartoon has always made me chuckle when I look at it!'

His Royal Highness hopes that you might have an opportunity to pass his best wishes to Giles, and to say how sorry he was to learn that he is now confined to a wheelchair. He will greatly look forward to seeing your book.

Prince Charles's message was, of course, passed on. Giles, who for many years was an almost self-appointed, unofficial cartooning jester to the royal family, was very touched.

At the time of writing he is well enough, everything considered. Giles, who is now seventy-nine, lives at his farmhouse home at Witnesham, just outside Ipswich. He has had both of his legs amputated in recent years due to circulation problems. His right hand is also affected and sadly he is unable to draw any more. His hearing is not good. Neither is his eyesight.

Most sadly of all, Giles's beloved wife Joan died on Christmas Day, 1994. Since then Giles has been cared for by a pretty housekeeper-nurse, much like many of those creatures who appear in his cartoons, and enjoys the companionship of his minder, driver and friend, known simply as Louis. Louis is a giant, bespectacled fellow with a huge heart and unshakable loyalty. In his eyes the world is seen, in all of its aspects, as 'bootiful'.

'Mornin', Carl,' he will say when he arrives for his daily business. 'Bootiful, bootiful.'

So Giles is well cared for. But the terrible vacuum left by the death of Joan can only be understood by those who knew her and, more importantly, who saw at close hand her relationship with Carl. For Joan, to use a much abused word with some consideration, was a

"Diana—where did you put William's old pram?"

Daily Express, Feb. 14th, 1984

It is announced that the Princess of Wales is pregnant with Harry.

saint. 'She is my elevator,' Giles would say, rather strangely. He would then explain: 'She uplifts me.'

There is much about Joan later in this volume, but it is fitting that we should pay tribute to this remarkable woman here since everything written about her in the later parts of the book was composed while she was alive; while she was, in constant and loving service to her seriously disabled husband, still fetching and carrying and cooking and bed-making and advising and

laughing and, I suspect, occasionally, and very privately, crying.

Joan was attractive, strong, practical, soft-voiced, clever, charming, loyal and enormously courageous. She cooked like an angel, as I can confirm, and laughed like one too. She was a very, very special kind of English lady, the sort we see in those black and white movies of the war standing amidst the rubble, grimy-faced, shocked but defiant. In fact, she was herself bombed

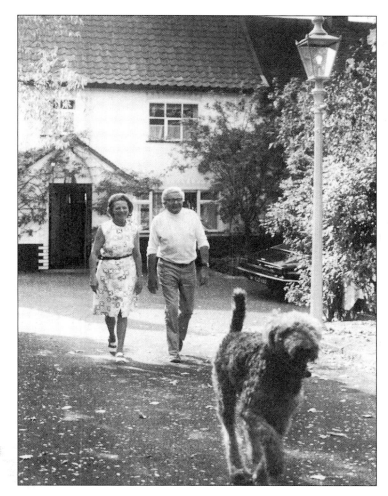

Giles, when still fit and mobile, walks up the drive of Hillbrow Farm with Joan. Butch leads.

counsellor and archivist. Of the many thousands of cartoons which Giles had drawn, Joan could not only remember every one, in detail, but could find it immediately in her files.

Let this book, as much as anything, be a tribute to Joan Giles. For had she not existed, it may be that this volume would never have come to be written. It may have been, indeed, that Giles would never have achieved his greatness, for seldom can it have been so true to say that behind a successful man was a woman, quiet and unassuming, who provided the stability and strength, and the neat and ordered, impregnably protective home, which allowed Giles at once his freedom and his security.

*

It is now over three years since I began researching the life of the amazing, engaging, funny, difficult and often infuriating Carl Giles. It has never been easy. Imagine it! Here was the subject of a biography who had never spoken publicly about himself during his considerable life and who hated the idea of intrusive reporters and 'note-taking'. When I first arrived at his airy, brightly painted Ipswich farmhouse he sat in his wheelchair by the open French windows and glowered at me. During the first day I hardly managed to fill even one sheet of notepaper. The task became easier, in time. But it was never plain sailing. As will be understood from subsequent chapters, Carl Giles can be a fairly difficult old curmudgeon when he wishes to be.

Still, here we are, nearly four years later, and proud and happy to be producing an ultimate tribute to the great man and to be able, indeed, to offer the words and thoughts of those, in many cases, better qualified than I am to speak of Carl Giles and his genius.

First, let Carl Giles tell you a bit about himself. Here is the brief account which he offered as the introduction to the fourth of the Giles annuals.

Son of a Newmarket racing family. Keeps horses himself. Breeds pigs. Born while parents were

and did indeed stand in the ruins of her London home, deeply shaken but proud.

How Giles must miss her. How we all do. It is difficult to imagine, on careful reflection, how the cartoonist would have coped with his life had not Joan been there to keep quiet control. She was not only his wife and lover but his secretary, personal assistant,

A profile of Giles taken from a Daily Express *calendar he contributed to in 1951.*

staying within one mile of Bow Bells, making him officially a Cockney. Schooled all over the place, but never at art school.

Graduated throughout the wilds of Wardour Street film studios, working on mighty epics which never saw daylight.

Reached dizzy heights of working for Alexander Korda and then decided he'd had enough of films. Migrated to work in riding schools and goodness knows what else.

LIKES: farming; riding; drinking; Benjamin Britten's music; cars; engineering; drawing; people who congratulate him on cartoons which he didn't do; drinking.

DISLIKES: cinema organists who are forever telling him they are going to play him an old favourite which never is an old favourite by any means; and ever so many other things.

HABITS: calls all policemen and editors 'Sir'.

Avoids all children under the age of thirty.

Somerset House knows the rest.

Giles adored comedians. They were, in a sense, verbal cartoonists and were, at any rate, able to see life as a merry and often preposterous parade. One such friend of Giles is Michael Bentine, ex-Goon, scholar and man of considerable kindness and compassion. He writes:

Her Majesty Queen Elizabeth II is the Royal custodian of a superb collection of Old Master drawings, including some of the famous 'Leonardo Da Vinci Cartoons'; so, when I see Carl Giles described as a great 'Cartoonist', I feel that his unique drawing talent is being correctly placed among the Masters.

As an enthusiastic, if inept draughtsman, I greatly admire the work of artists who draw that well, and in today's Gimmick-ridden Art World a real 'Master-draughtsman' like Carl Giles stands out as a giant.

Ronald Searle and Bill Tidy are two outstanding masters of the cartoon genre, and both of them have told me that they consider the incredibly prolific work of Giles to be in a Master class of its own.

But Carl is much more than a great artist, an architectural expert, and, above all, a shrewd observer of humanity with all its odd quirks and foibles.

Giles has many close imitators, but unlike them his own gentle sense of humour is never cruel, and he makes his hilarious points without malice.

When introducing one of his delightful annuals I wrote that I owed Carl Giles a great debt of Gratitude, because during the Second World War he had helped me to overcome my Fear of the monstrous Nazis, and their equally dreadful Axis partners. By the sheer magic of his pen and brush, Carl had completely defused their explosive images of terror, by transforming them into the ridiculous

"She let us give her a lift to her polling booth providing we dropped her off at her sister's on the way home."

Sunday Express, May 6th, 1984

and grotesque mountebanks that they really were.

To have known Carl as a friend and a fellow sailor is another added privilege, for which I am equally grateful.

The Royal Art Collection is one of Britain's greatest National Treasures. With respect, I believe that it will never be complete without examples of the work of my much admired friend, and undoubted National Treasure, Carl Giles, Master Draughtsman!

"What's cooking, Honey?"

Daily Express, Aug. 1st, 1944

Another funny man who is a close friend of Giles is Eric Sykes. The comedian used to attend the regular banquets provided by Joan at the farmhouse and recalls here the special nature of these occasions. I have attended a number of them and can confirm that they were so uproarious that they made the notion of more conventional conviviality sound like a bleak smile on a damp Monday morning.

Whenever I am invited to lunch in the West End I hum and hedge about going all that way just to have something to eat. Why should I? My office is

"Are you addressing ME?"

Sunday Express, Oct. 8th, 1944

in Bayswater and there are plenty of good restaurants thereabouts. However, to be invited to lunch with Carl Giles at his home near Ipswich is a horse of a very different colour.

Indeed, were there no trains to the East Coast I would happily make my way there by bullock cart.

Carl's lunches are always magnificent occasions.

To be met at Ipswich Station by his cherubic, smiling face is more beneficial than six months on the National Health. On one such journey my companions were Johnny Speight and Peter Tory and the atmosphere was jolly and excitable. We were

"I bet you think it funny that a bloke like me can choose wot Government I like."

Daily Express, May 23rd, 1945

like three kids going to the seaside for the first time.

During the five minutes' greeting on Ipswich Station even the porters were smiling over the reminiscences of the days when we used to thank the engine driver, then put a penny in the machine for a slab of Nestle's.

Then off to Carl's house which is not too far away – though it could take you three hours to reach it. This was due to the fact that everyone seemed to know Carl and all those who did appeared to own bars or, at the very least, to know someone who knew someone who did.

"Sh!—We're listening to Churchill."

Sunday Express, June 5th, 1945

When you eventually arrived at Carl's house there was so much good talk and fine drink that it was always touch and go whether or not you'd get back to Ipswich Station for the very last train home to London.

I think of Carl as a benign, gentle man. I have never seen him angry, but I hasten to add I'd hate to put him to the test; underneath that placid, amused façade there is some very heavy metal.

Most importantly, I marvel at the years of genuine pleasure he has brought to millions of aficionados of the Giles cartoons, the same

"Mrs Thatcher would certainly give Grandma's State Benefits a radical overhaul if she knew they all went on Lester Piggott yesterday."

Daily Express, June 6th, 1985

characters, Grandma, the vicar, Vera with a hanky to her ever-sniffling nose and, of course, the twins, always at the end of a leash and, curiously, always hovering just a few inches above the ground.

They haven't changed but have managed to adapt to the subtle developments in humour and background.

I feel proud and very privileged to have laughed and joshed and called Giles one of my friends. As

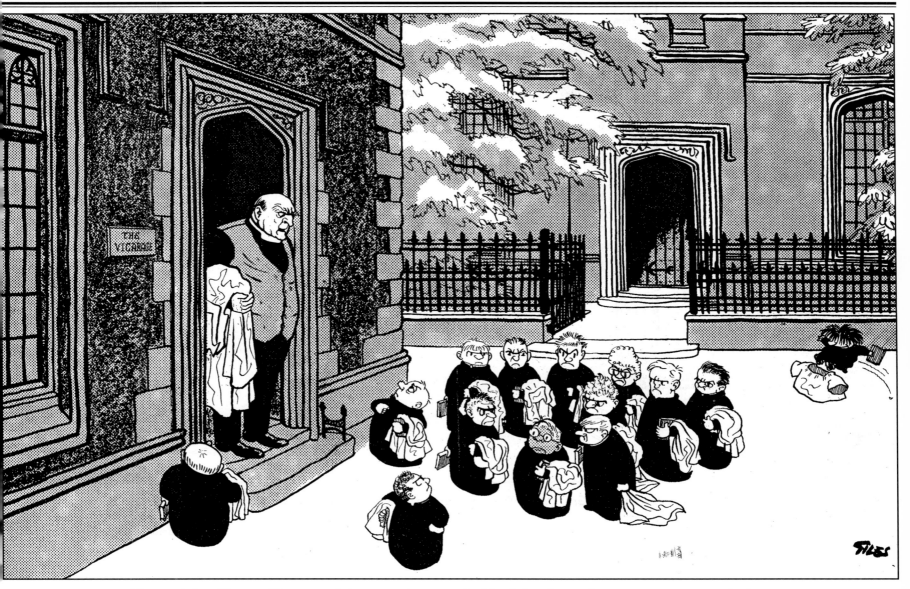

"I certainly will not offer a special prayer that your inside right plays a better game next week than he did yesterday."

Sunday Express, Aug. 19th, 1961

always, I look forward with pleasure to our next meeting.

Of those who have written contributions to this book, many found it curiously difficult to put into words exactly what it is, or was, that so attracted them to the world created by Giles. Some apologized and said little more than 'Please send Giles my very best wishes. I cannot think what to say except that he has always made me laugh – or just made me feel good.' Others have sent jaunty little messages. Princess Margaret, a long-time self-confessed fan, was not quite sure how to react. Her private secretary sent the following letter:

I am writing to thank you for your letter which I have of course laid before Princess Margaret.

Her Royal Highness was most interested to learn about the biographical account, which is to be published in the autumn, of the life of the cartoonist, Giles.

The princess asks me to say that sadly she has not got any specific cartoon that Giles drew, but there is one that she particularly loved, which was drawn after he had been to lunch at Buckingham Palace.

Princess Margaret has a rule, which she strictly adheres to, that she does not give interviews.

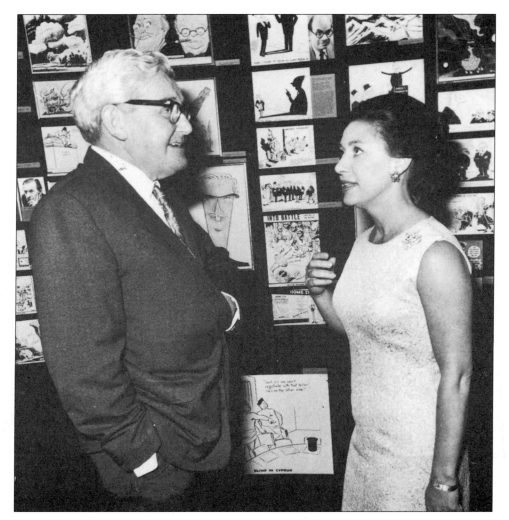

Here Giles, as President of the British Cartoonists' Association, is seen with Princess Margaret at an exhibition of newspaper cartoon art in 1970.

This last sentence has a certain charming regality about it; for we were not seeking an interview. But what is interesting is that she is referring to a cartoon, never published, which Giles sent to the Queen after he had enjoyed his first visit to Buckingham Palace and his first informal meeting

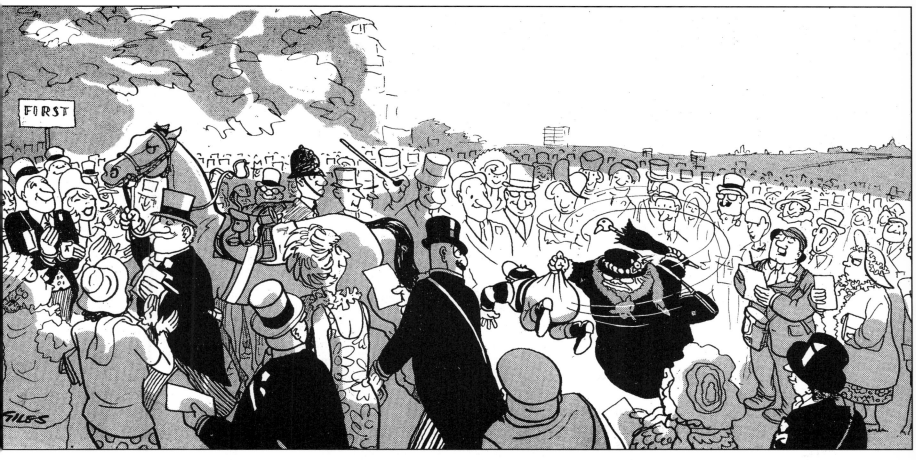

"She always was a poor loser."

Daily Express, June 3rd, 1965

with a gathering of the royal family. As is described in more detail in a later chapter, Giles had been amused by the presence of the corgis, and when he returned home to Ipswich he drew a private cartoon showing corgis and the tattered trouser-legs of guests. He sent it with a thank-you note. The Queen was delighted and wrote back to say so. It is rather reassuring that, after all these years, the royal family still giggle over the

moment when Giles, though they hardly saw it in these terms, rather cheekily appointed himself personal cartooning jester to the monarch.

Sir Robin Day sent in a charming postcard, done for him by Giles when he was in hospital in 1985 for a heart bypass operation. 'I had met Giles only once or twice,' he writes, 'so it was very considerate of him to do the cartoon, which cheered me up tremendously.'

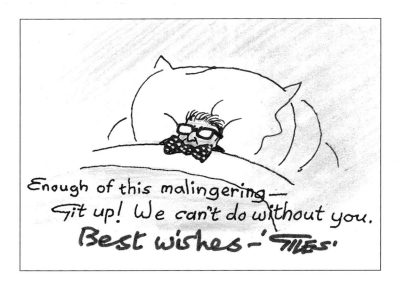

Enough of this malingering —
Git up! We can't do without you.
Best wishes - 'GILES'

An exception to the more tongue-tied among Giles's fans is Sir Alastair Burnet. The distinguished journalist and former newscaster was for a time editor of the *Daily Express* and thus, for a period, was Giles's boss.

If Dickens and Wodehouse had had editors, as Giles had innumerable editors, they might have called in their help to impose a little discipline. But Giles has never bothered about that. He has been part of the revolution himself, and if he ever had any doubts a look from Grandma soon quelled them.

As an editor myself, briefly, I was relieved not to be called in. Let Giles run his own show was my watchword. When lesser management wanted a modicum of order, I simply could not face the Gilesland lot decanting from the train or sailing up to Blackfriars Bridge with an angry demonstration up Fleet Street in mind. Funding a half-crown or even a ten-shilling note to the guard on the afternoon train to ensure that the Giles cartoon was on board was as close as I thought it politic to get.

As neighbours of Gilesland we enjoy his slant on the news. Uninterrupted supply of events and incidents has been our priority and whatever trouble poor old Giles got into with his creation was his affair. We enjoyed his reports from the front and we knew the Family as if we lived there ourselves.

This, I suppose, has been the Giles secret, as it was the secret of Dickens and Wodehouse. It's an understanding of the , of what they like and know, and of what they like to think of themselves. That means it takes place squarely in England, among undeniably English people; not necessarily England as it is now but England at its supposed best, as it recognisably was sometime in our memory over the past fifty years.

Giles was timely whenever he chose to be. As early as 1944 he had gum-chewing American aircrew calling a taxi in Nazi Germany after they'd been shot down. He has always been good on the Yanks. Unflaggingly, he took in teddy boys, spivs, mods and rockers, Foreign Office spies, Churchill's death and even the Berlin Wall whenever the occasion demanded.

But his calendar has a homely routine to it: the first snowballs of winter, the Boat Show, the old Budget box, cricketing teas, a day at the races, Lifeboat Day, speech day, the beach, leaves on the line, Smithfield, and then back to carols again.

This is as endearing as his own characters are. Of course, Grandma herself is a prodigious creation, a symbol of why the Battle of Britain, any battle of Britain, could not be lost, and the image of bedrock feminism before the professional agitators arrived.

The children of Gilesland are astute and alert. They have their own local wars with dogs and cats and Chalky and each other, but their eye is mainly on occupying parts of the cartoon for their own use. Seldom for Giles an obsession with a single theme.

His is a timeless commentary on our generation. It is not easy to say which is his foremost decade, for he spans so many, and deals faithfully with each current English absurdity.

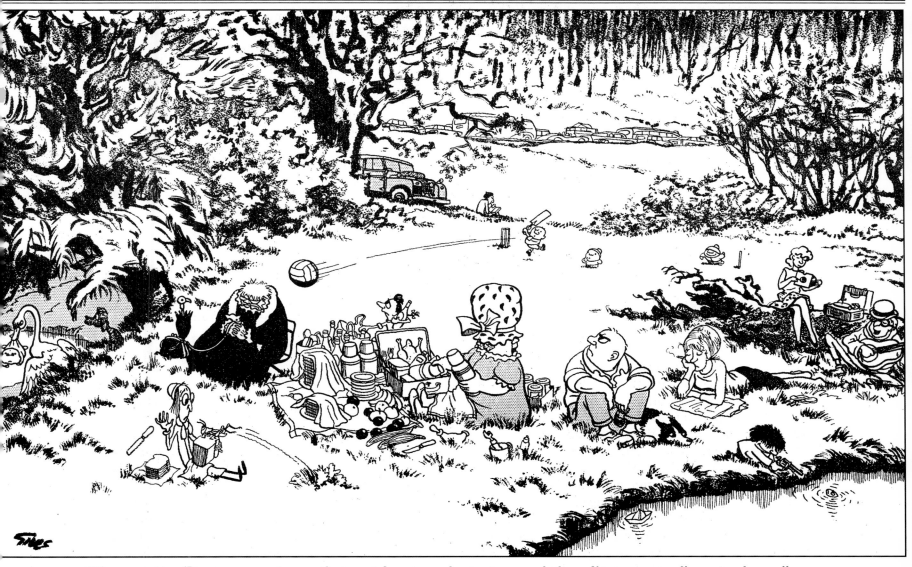

"If you mutter 'Do you mean to say that cost four pounds nineteen and eleven?' once more, I'm going home."

Sunday Express, April 2nd, 1961

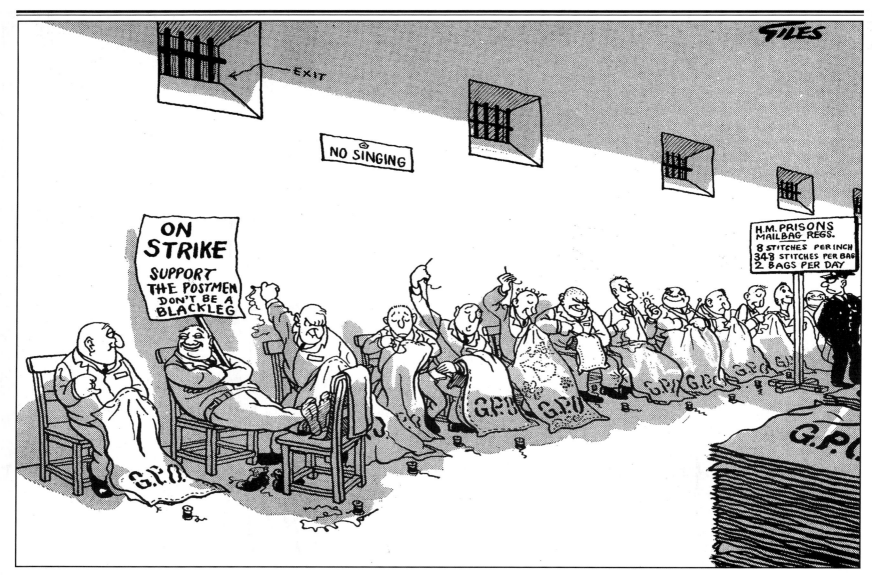

"It's worth a try."

Daily Express, July 23rd, 1964

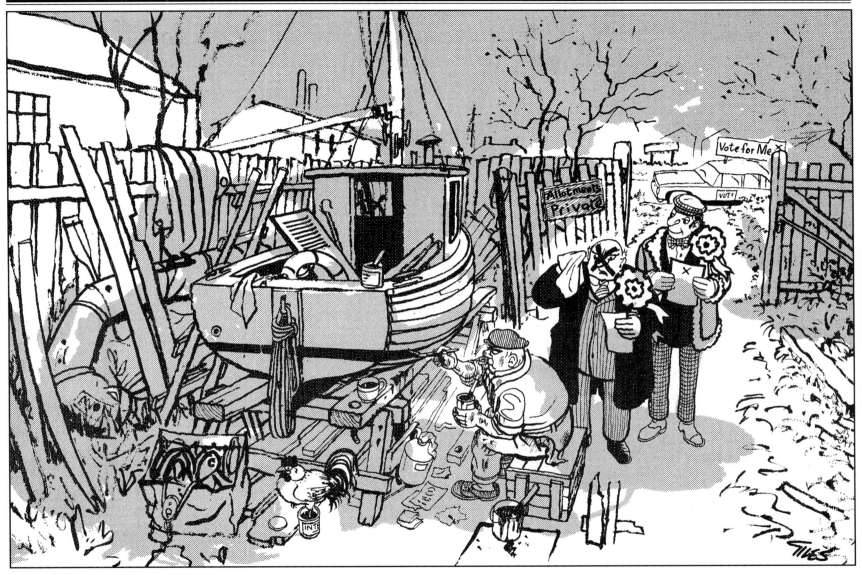

"When I asked you where you would be putting your cross I was asking a perfectly civil question."

Sunday Express, April 15th, 1979

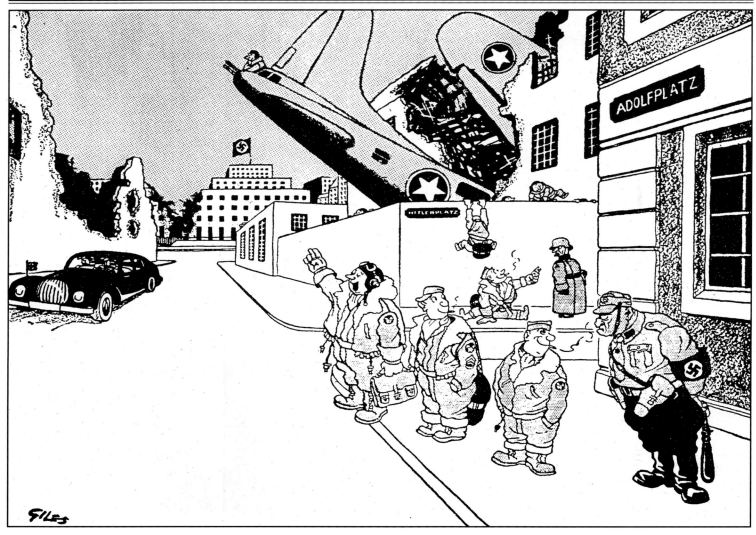

"Taxi!"

Daily Express, April 23rd, 1944

Giles's drawings of GIs became particularly famous during the war. They were loved by both the British and the Americans. The former thought they were rude, the latter regarded them as flattering.

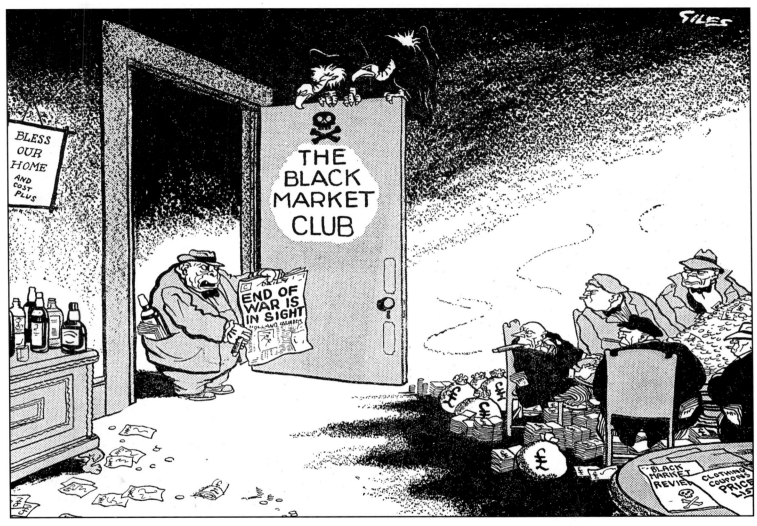

"Have you boys seen the bad news?"

Daily Express, Sept. 19th, 1944

But I think he has been happiest when watching an England which knew, understood and even enjoyed its visible role: an economy (and a country) plainly in relative decline but one aware of, and still in touch with, its more important past, and so able to laugh with him at itself and its follies, but not to be bitter or crude or too hurtful in its laughter.

His may have been an imaginary country all along. England has always been full of them.

Wodehouse in the 1920s averted his eyes from the world that lay beyond the scope of Bertie Wooster, Jeeves and Lord Emsworth. Dickens carefully delayed the Pickwickians in a warm-hearted, stagecoach England in which provincial society and its country sports controlled most chapters and hospitable inns properly faced ancient abbeys across the street.

The art has been in contriving reality. The representative Gilesland family is fixed in everyone's mind. It is patriotic, largely apolitical, careful but not penurious, visibly numerous (high fertility except among spinster aunts), sports-oriented, Church of England, literate but hardly book-loving, fashion-conscious if seldom approving, and always English-speaking and thinking. Very much his sort of place.

And because it is certainly our sort of place too, he is very much our man.

Max Hastings, editor of the *Daily Telegraph*, wrote warmly of Giles:

For anyone who, like me, grew up in the 1950s in the great days of the *Daily Express,* Giles was an institution. I loved his dreadful family from my first days as a newspaper reader, and his annuals made bearable a host of dentists' and doctors' waiting rooms, not to mention bathrooms. A hundred years hence, students of the English class system will understand the whole business at once, if they look up the *Daily Express* files from the postwar period, and look first at Osbert Lancaster's pocket cartoons of the ruling class on the front page, and then turn inside to Giles's matchless vision of 'them downstairs'. Giles's family were perpetual victims. In a material sense, whatever Harold Macmillan might have said, they never had it very good at all. They were the least upwardly mobile family in history. They never got much beyond owning a telly, some wheels and a very small boat. But they were also the inheritors of the spirit of the blitz – they never let the buggers get them down. Readers adored their relentless perkiness in the face of adversity, not to mention their ruthless willingness to circumvent officialdom and bureaucracy, to deflate pomposity. They mistrusted politicians of any party, their holidays were always disastrous, they regarded education with the deepest suspicion. We shall not see their like again, because it is so wildly unlikely that another generation will produce another genius to match their sole begetter, Carl Giles.

Another celebrated senior journalist who is a friend and ex-associate is Lord Cudlipp, former editor-in-chief and chairman of Mirror Group Newspapers. Hugh Cudlipp, before greater glory, served as managing editor of the *Sunday Express.* Hugh, indeed, was one of the privileged few who were asked out to the Giles farm in

"Balance of Nature—Vera feeds 'em, we thin 'em out."

Sunday Express, May 1st, 1966

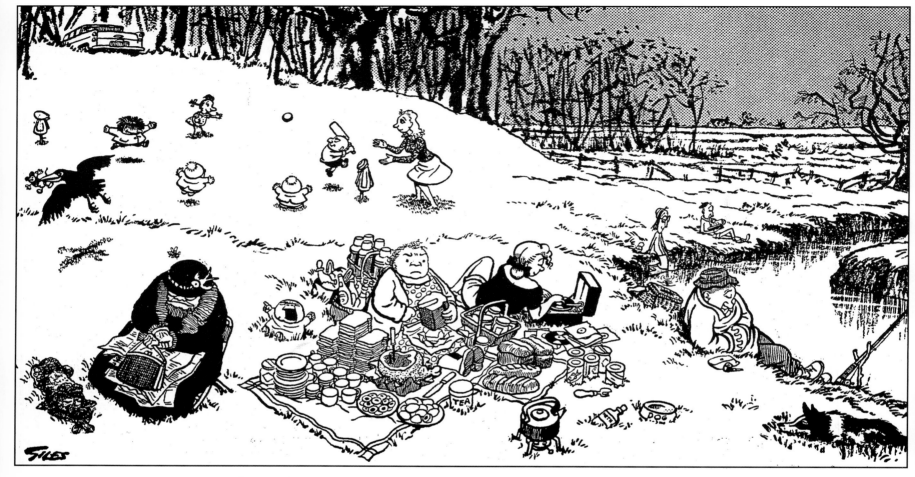

Mother's Day. Give her a rest from cooking—take her out for a picnic.

Sunday Express, March 27th, 1960

Suffolk. In those days, the early sixties, Giles was still very actively running his farm. His interests were wide: horse-riding, sailing, motoring, DIY to a professional standard – and, curiously, pig-farming.

Cudlipp tells the following story. It is, he says, his favourite Giles recollection.

I was staying with Giles at his farm. When I assured him hand-on-heart that I had never seen (or heard) pigs making love and he was strolling me to the piggery to expand my rural know-how, he told me of a surprise visit during the post-war rationing period from a Ministry of Agriculture Inspector, fortunately a Giles fan.

The Inspector inspected, made notes, then

"I'll tell you what I think about Bank Holidays by the sea."

Daily Express, May 27th, 1975

cheerfully accepted a drink in the cartoonist's studio, delighted to accept also Carl's shrewd offer of an original cartoon with an agricultural flavour.

As he departed at the gate with a warm handshake, the Giles fan said: 'Mr Giles, I noticed the two sides of bacon hanging in one of your outbuildings.'

'Of course,' said Giles. 'Dammit, that's the official Ministry allowance for a pig farmer's personal consumption. One pig, one farmer, fair enough.'

'I know,' said the Inspector, 'but may I suggest, Mr Giles, that you do not select your one pig with four left trotters?'

33

Hugh Cudlipp, when he moved to a position of power at the *Daily Mirror*, once made a serious attempt to lure the cartoonist away from the *Daily Express*. Remembers Hugh: 'I certainly did him a favour, in any case. For I knew darn well that he was shackled by a contract. As a result of my approach they gave Carl a handsome rise and a new contract which we celebrated over lunch at the Savoy.'

Another colleague of Giles's was the *Express*'s long-serving political cartoonist, Michael Cummings. He says:

The enduring charm of Giles's cartoons reposes in the fact that all of his characters are drawings and caricatures of real human beings. You feel you have met them before. Almost all cartoonists today, amusing though they may be, do not caricature flesh and blood humans – they produce symbols or shorthand notes of the human race. Giles observes and marks his fellow men. And he puts them in vast panoramic vistas where they are dominated by endless perspectives and great skies. He invented the panoramic style cartoon, teeming with incident and sub-plots.

He is a masterly depicter of animals. Whether it be a cat, fox, pheasant or insect, that animal has a personality and character that his humans are also endowed with. Even when he draws an object like a teapot or a bucket he gives it a vibrant personality.

My favourite cartoon is one he did many years ago in colour of a large family who are about to picnic in the country. All their sandwiches, cakes, biscuits, lemonade and tea have been lovingly laid out before them.

But in the bushes is a gleeful, ravening army of wasps, hornets, dragonflies, ants, flies and insects of every description. The leader urges: 'Now, boys, go and get them!' The Blitzkrieg on the picnic.

Giles's sense of landscape and colour is outstanding. He recently did a series of cartoons for the Royal National Lifeboat Institution in which the colour, waves and mood of the sea are in the tradition of the East Anglian landscape painters.

The comforting element in his cartoons is that they give the impression that nothing ever changes, that his eternal family will remain in its eternal sitting room for eternity, and that the waves of anarchy will never overwhelm them.

Another tribute which should be placed on record in this particular volume is that of the *Daily Express*'s current cartoonist, Brook. Rick Brook not only now occupies the old space of Giles in the newspaper but proudly declares that his style and approach owe much, if not most, to his profound childhood admiration for the great master.

Writes Rick:

My first recollection of a Giles cartoon was when my father brought home a Giles Annual. My parents were *Express* readers like most people in the country and my father must have been a particular fan. But I thought: 'What's a grown man doing reading comics?'

Now I'm the great fan – and have been for the past twenty-five years. It's the detail I admire, of course, as well as the humour. But it is not just detail for detail's sake. Anyone can do that. Giles captures the spirit of the place and the age. From the forties and fifties to his last drawings in the nineties, we've all been to that pub he's drawn, down that street, in that golf club . . .

When I was interviewed by the *Daily Express* editor, Sir Nicholas Lloyd, for the job as cartoonist on the paper I saw behind his chair a Giles cartoon of the Henley Regatta – a dozen boats or so in the foreground, lots of people in the water, hundreds on the bank and so on. A train is going past with more and more people waving out of the windows. Behind that a village, its streets milling with villagers.

As I was studying the cartoon Sir Nicholas was looking at an example of my work. My drawing

"Don't take it personal, Sir—he do that to anyone who pats his head wearing a rosette."

Sunday Express, April 29th, 1979

"I don't know why she's 'ollering. She's never sent a letter with a stamp on yet."

Sunday Express, Sept. 15th, 1968

had four figures in it and one of them was waving from behind a tree.

My hope has always been that Giles wasn't all that good when he started. I keep looking for early Giles cartoons where he hadn't quite got it right. I'm still looking.

"Off you go and rejoice—and steer clear of the Falklands 200 mile restricted zone."

Daily Express, May 2nd, 1982

The Falklands War was at its height.

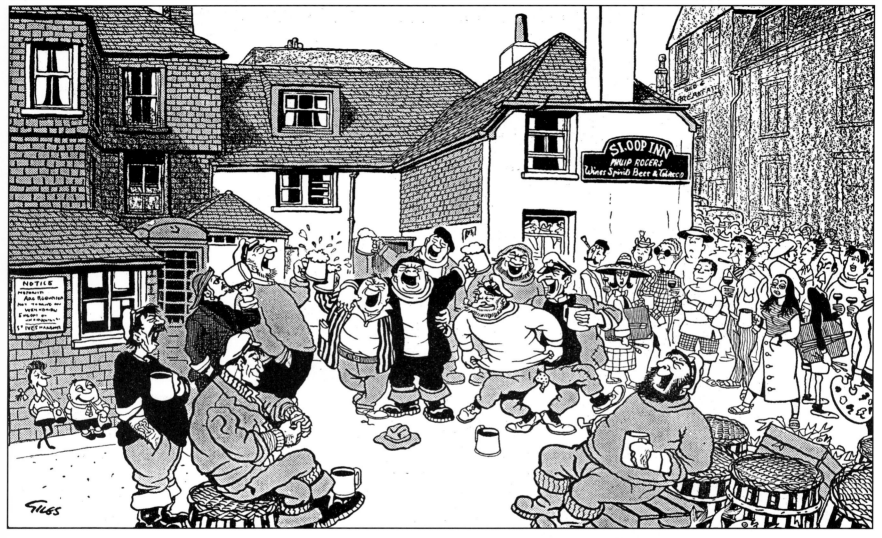

"Dad'll get 'Fishermen of England' when he arrives home two hours late."
(St Ives, Cornwall)

Daily Express, Aug. 24th, 1951

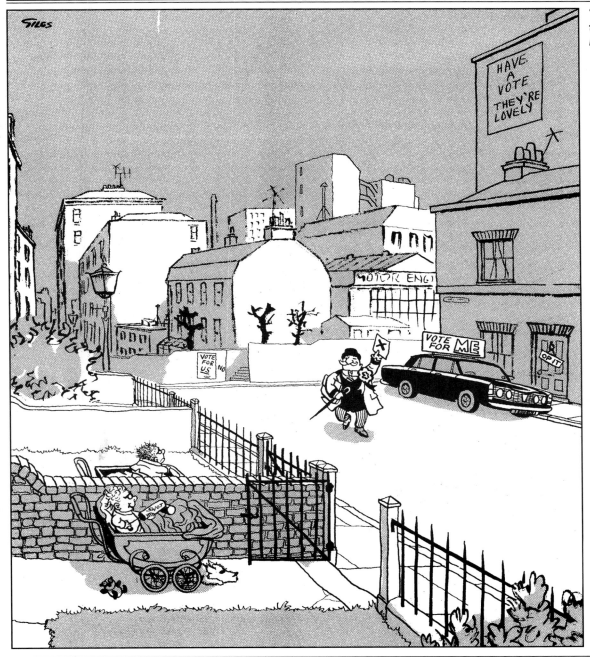

"He's not kissing me on top of me head this time, mate."

Daily Express, March 1st, 1966

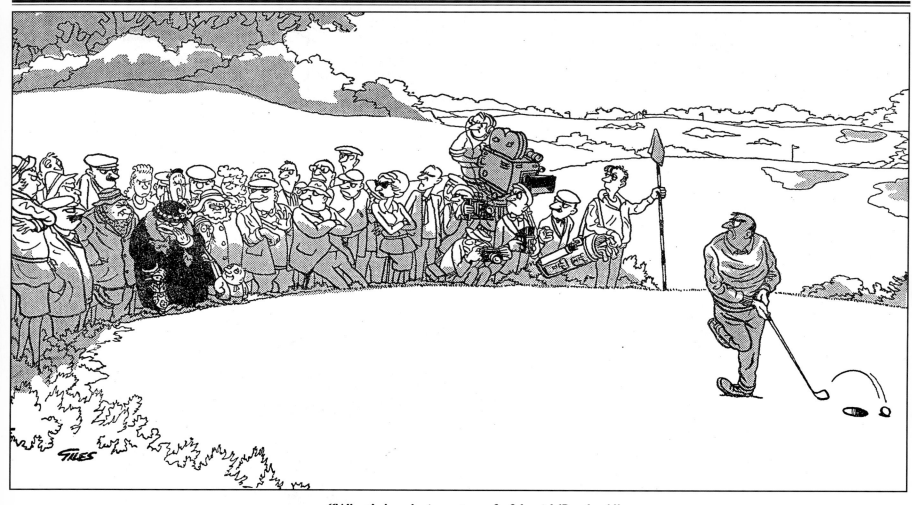

"What's he glaring at me for? I said 'Pardon'."

Daily Express, July 10th, 1962

(OPPOSITE) *The occasion was the General Election of 1970. The day after Grandma's polling activities, the Tories were voted back into power with Edward Heath as their leader. Grandma must have been Tory by nature, though she often seemed to express socialist views. Her politics were confusing, like those of her creator, Giles. He drove a Bentley, lived like a king, but was once a Communist.*

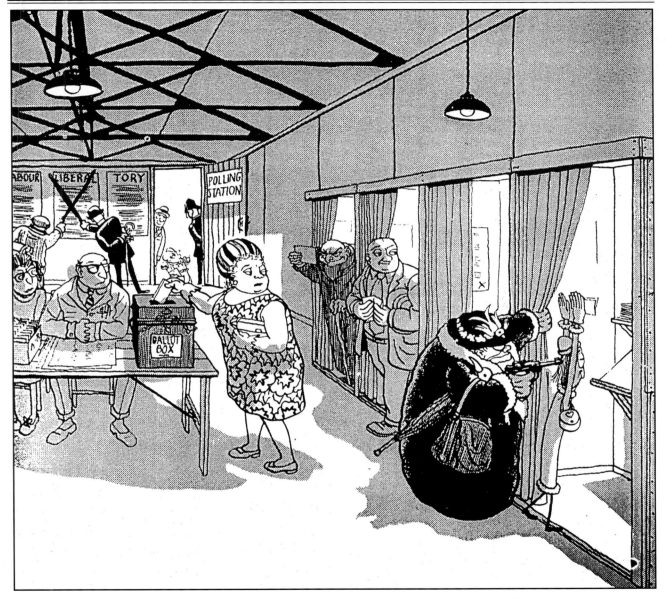

"Grandma, you must let Vera vote for whom she chooses."

Daily Express, June 18th, 1970

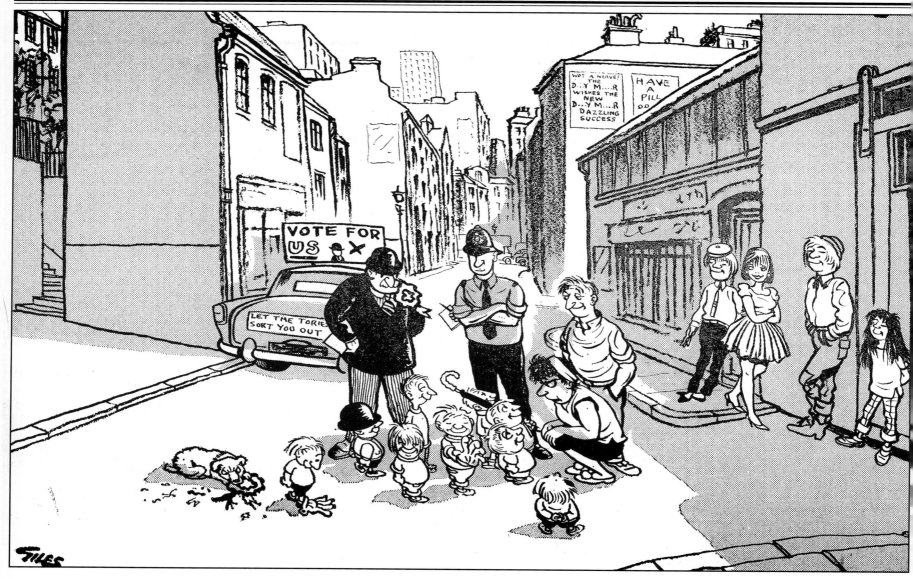

"I know you want to help daddy's party win the election but you must tell mummy where you've hidden the Conservative candidate."

Daily Express, Sept. 14th, 1964

"It is most certainly not time for Service yet madam—I suggest a junior member of your family has put your clock a few hours forward instead of one hour back."

Sunday Express, Oct. 31st, 1971

Many sportsmen have also sent their good wishes to Giles and we have selected here the thoughts of golf commentator Peter Alliss. Mr Alliss, also a man of gentle good humour who is not averse to the occasional waspish sally, is quintessentially middle England. In some ways it is difficult to think of a more typical lifetime fan – for that he is. He writes:

I've been a fan of Giles's cartoons for far longer than I can remember. Somehow or other he always manages to convey, with just a raised eyebrow or a few simplistic lines, the feeling of unjustness, gross stupidity and humour. In fact all human frailties are constructed quite brilliantly.

I've lost count of the number of my Giles annuals, collected from various Christmas stockings. They have often been picked up and thumbed through and I still marvel at his ability to create fresh situations that immediately convey to the reader the situation prevailing.

It's remarkable to still have that freshness of mind, and although not in good health in his later years, his love of life, with all its twists and turns, remains steadfast.

It must have given him a tremendous feeling of pride to know that he has given so much pleasure to many millions.

He has always enjoyed the reputation for being a modest man and somehow that modesty comes through even when producing his more 'serious' cartoons, but whatever he creates and wherever his thoughts wander, gentle humour is never far away.

We should, perhaps, allow that great humorist of our times, Willie Rushton, to conclude this chapter of tribute. Willie's thoughts were used some years ago as the introduction to a Giles Annual:

I cannot remember the moment precisely when I decided to be a cartoonist. I think I can recall Sir John Gielgud saying how he saw Dan Leno, or was it Danny La Rue, in *Puss in Boots* at the Old Alhambra, Oldham and from then on it was to the back legs of the Pantomime Cat for ever.

My own moment of truth was the cover of what must have been the first Giles annual. A simple Tommy with a mug of tea and a wad standing amidst the ruins of Berlin was on the front.

On the back, emerging from a cellar, with hands aloft and a white flag, a number of German generals stood in immaculate uniforms and monocles and Heidelberg scars. From then on all I wanted was to be a cartoonist.

To tell the truth, I wanted to be Giles, but he was doing that already.

Funnily enough, it is not the notorious Family that turns the eyeballs green with jealousy – it's the backgrounds. I wish I could draw trees as well, I wish I could use colour like he does. I wish . . .

The most important lesson I learned from a lifetime's study of Giles, is that the drawing should make the reader smile, even before he laughs at the caption.

That's proper cartooning in my book. And in his book, of course, which this is.

You are in the presence, gentle reader, of an Old Master.

Call to Arms

As the thirties slid towards European conflagration, with the Spanish Civil War at its height, Carl Giles was revelling in his first job as a full-time cartoonist – at *Reynolds News*, the left-wing Sunday paper owned by the Co-op, in its office at the top of Gray's Inn Road near King's Cross.

Gordon Schaffer, a crusading journalist of the time, now in his eighties, offers an appealing image of the young Giles at work: 'Giles had an easel in the library. And goodness, how he enjoyed working on his cartoons. He would do a bit – draw a character – then stand back and say, with a huge grin on his face: "Look at that silly bugger there." We didn't know how famous he was going to be.'

Another description of the cartoonist around this time, by a Fleet Street editor, could have been of any one of the young idealists of Europe and America flocking to join the struggle against Fascist Franco: 'Giles is slight, his fair hair is extremely untidy, he peers at you with a quizzical, puckered face, and he usually wears a pair of wide, uncreased, baggy trousers and often a leather golfing jacket.'

Giles didn't head for Spain, and was – is – no ideologue: but his left-wing sympathies, fostered by the leading Communist intellectuals and commentators of the day such as Alan Hutt and Monty Slater, who wrote for *Reynolds* and became heroes to the young cartoonist, stayed with him long after he left Gray's Inn Road for an establishment of a very different political flavour.

Just a mile to the south of the *Reynolds News* office, behind a monstrous black glass frontage, sat the *Daily Express*, a formidably successful right-wing paper masterminded – and ruled – by an equally formidable, and equally successful, right-wing owner. Lord Beaverbrook, born William Max Aitken in Canada in 1979, had come to England in 1910, bringing with him the huge fortune he had built up in his home country, and by 1923 was proprietor of the *Daily Express*, the *Sunday Express* and the London *Evening Standard*. This trio of newspapers he unashamedly used to trumpet loudly and eloquently his imperialist and isolationist political views to a massive and ever-growing readership.

It is unlikely that Beaverbrook and the denizens of *Reynolds News* would have had anything remotely appreciative to say about each other. Nonetheless, though Giles was serenely unaware of it at the time, appreciative eyes had been drawn to the page of the despised organ which carried his drawings. In vain did the *Express* editors come to tell their lord and master that the cartoonist was not interested in moving; Beaverbrook was not to be deflected. 'We must have Giles.'

So what were the cartoons that had aroused the press lord's acquisitive instincts? Beaverbrook had spotted what only those who read *Reynolds* or worked in the newspaper trade had hitherto had a chance to see for themselves – that Giles's talents projected that unique

"The correct term, Private Wilson, when referring to a Commanding Officer is 'C.O.' Not 'there goes the toffee-nosed old basket.'"

Daily Express, May 30th, 1943

British combination of humour and stoicism in a time of crisis with more comic effectiveness, and more artistic skill, than had yet been seen on newsprint.

The Fascist dictators Hitler and Mussolini had already begun to figure as prototypes of the major comic characters they were to become, but at this stage Giles was more interested in demonstrating the cheeky disregard for both danger and authority that character-ized the ordinary bloke in uniform. One typical such cartoon shows a couple of Tommies at the front, who, in the middle of a shell bombardment, with Nazi soldiers creeping towards them, are cheerfully engaged in showing each other family snaps. '… And here's a picture of my brother Fred when he was six!' says one, refusing to be distracted by a shell plunging into the ground ten feet away.

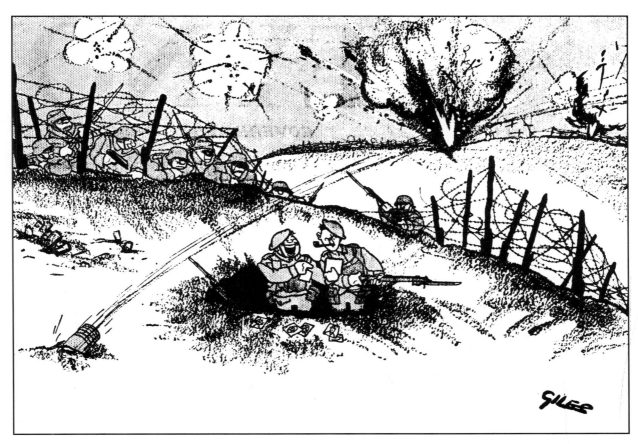

"... And here's a picture of my brother Fred when he was six!"

Giles's sense of mischief was also fuelled by the tension between the ranks. In another cartoon he depicts a pretty girl observing with devastating tactlessness to a group of privates in a bar: 'What! You take orders from that funny little man in the corner with the big black whiskers?' In the corner, of course, rigid with outrage, is an English major, his silly moustache waxed at the extremities to absurdly sharp points.

There were, too, occasional glimpses of ideas germi-

nating that were to come to full bloom after the war. You don't have to look long at a cartoon showing a funny little lady in a black coat with a flower on her hat giving a hard time to a couple of sentries to see the first stirrings of Grandma.

By this time Giles was also establishing a reputation for his drawings of American GIs. After his marriage to cousin Joan Clarke in 1942, Carl had moved with his bride from London to Badger's Cottage near Ipswich,

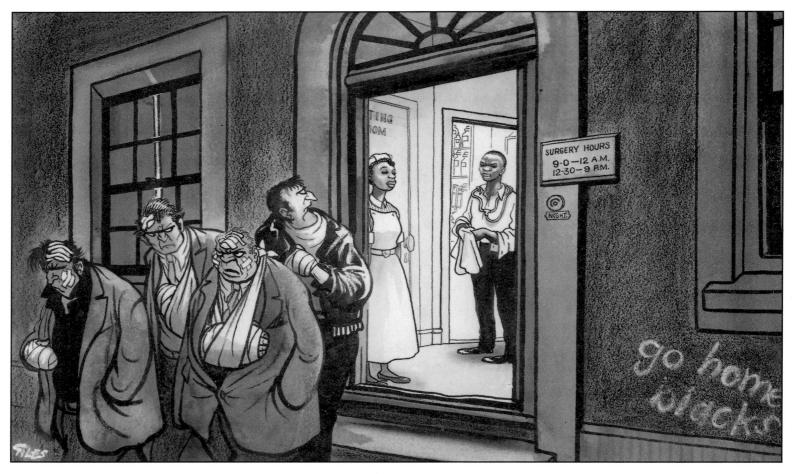

"Now there's an embarrassment for yer, Tosh."

x

Sunday Express, Sept. 7th, 1958

Giles drew this cartoon at the time of the Notting Hill race riots in which white racists attacked black immigrants. Giles has had a life-long hatred of racial prejudice.

an area which had more than its fair share of the visiting US servicemen. Giles loved them – indeed, he loved Americans generally, but had a special affection for the American military. Later on in the war, his cartoons of the grinning, swaggering Yankee soldiers, with their insatiable appetite for cigars and taxis, became one of his hallmarks – and, he insists, while some of his British readers thought that he was being unkind, 'the Americans loved my cartoons. They are cartoon people – they understood and appreciated them.'

y

z

"All right, all right. You carry on. You'll soon find out WHY it's silly to sit there."

Jan. 26th, 1941

Drawn for Reynolds News *in 1941.*

No one who had known Giles in his local village of Tuddenham could have suspected him for an instant of being 'unkind' to Americans. Many of the GIs based in the area drank in The Fountain, Giles's local, and here he particularly befriended a group of black Americans who were building runways at the nearby USAF base. Soon these new friends were eating and sleeping in Badger's Cottage, Joan gamely serving up endless meals to the houseful of laughing, joking men her husband brought home from the pub.

"Hey, you—how do you spell mirage?"

March-April 1943

Giles, a newspaperman, of course, drew a number of cartoons during the war – between the summer of 1942 and the autumn of 1944 – for The Journalist, *the magazine of* the National Union of Journalists. The Cheshire Cheese is one of the most celebrated of olde English eating houses in Fleet Street.

(OPPOSITE) *In the photograph we reproduce here, the characters in* The Fountain *include two of Carl's GI friends, Butch playing the drums and Joe Louis facing the camera. Standing to the right of Carl in naval uniform is* local lad Eric Ossard, known always as 'Dotsie'. Dotsie at the time was serving in the Navy and is seen here at home on leave. Dotsie has for many years now been Carl's chum about the farm and tireless odd-job man.

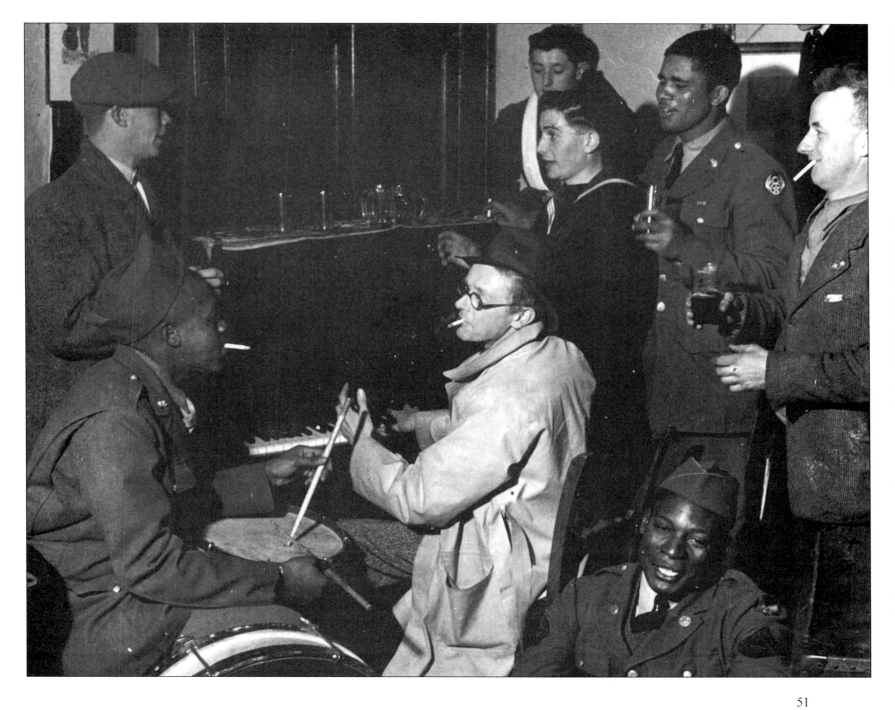

"I assure you, Herr Major, with these Americans all over the place our chance of getting a taxi is out of the question."

Daily Express, Aug. 22nd, 1944

"You know—there's something definitely un-American about you two guys at the end."

Sunday Express, Dec. 31st, 1944

Older inhabitants of Tuddenham and its environs still recall with pleasure the impromptu jazz band which Giles and his American friends put together in the public bar of The Fountain. An American correspondent of the time wrote of how

on Saturday evenings, the negro engineers would cycle to the local pub, The Fountain, balancing bass fiddles, drums, trumpets, trombones and saxophones and other instruments on their handlebars ... The Suffolk farmers would then crowd into the back room with their pints of mild and bitter as Giles struck up the opening bars on his piano and the six-piece hot band went into: 'Fat Mama With The Meat Shakin' On Her Bones'.

Giles recalls: 'Yes, the villagers were astonished to see these black American servicemen. They'd not seen their like before. But they took to them too. Some of the local girls even found themselves in the family way.' And he remarks: 'They especially got on with me; they knew, you see, that their colour didn't matter a damn. They could have been black, green or blue as far as I was concerned.'

Not everyone in the area was as liberal-minded as Giles and his friends at The Fountain. Johnny Speight, creator of ranting working-class bigot Alf Garnett and later a close friend of Giles, was based in Suffolk during the war, and saw a rather different side of the locals' attitude towards their visitors:

I was in a Suffolk pub one evening – I forget which it was – and there were all these Americans in there creating a bloody riot. They were objecting to the fact that one of their black soldiers had taken up with a local girl. A white girl, of course. They had 'im up at one end of the bar and they were going to lynch 'im. It was bloody terrifying.

Then this village copper comes in – a real country bobby – and elbows his way through. It

Ike, the black GI stationed in Suffolk whom Giles befriended during the war, and for whom he searched in vain in America after the war.

"Rare boys for souvenirs, these Americans."

Sunday Express, July 15th, 1945

"I don't care if the war is nearly over—I'm not selling my cab for a fiver for a souvenir."

Daily Express, Mar. 25th, 1945

This cartoon combines the two principal American 'sins' of taxi-hogging and memento-grabbing. London cabbies, it suggests, are not to be bought. Not for a wretched fiver, anyway.

"I'd like to see them ven they 'af been out here a veek or two."

Daily Express, Jan. 23rd, 1944

was almost as if he had said: 'Ello, ello, ello.' He hadn't even got a truncheon with him. They all fell back and it went quiet. They had been confronted by the full majesty of the law. It was amazing. He just led the bloke out. And that was before the American military police could get there with all their riot sticks and heavy gear.

But even at The Fountain things were to change. No visiting contingent of soldiers was around for very long in those days, and, perhaps with the imminent departure of his jazz-playing friends in mind, Giles had done paintings of them, which were hung up in the bar. The next batch of visiting Americans were white, and it became clear that they were offended by the portraits of black service-men in the pub: so the lady who ran the establishment took them down. 'It was a bloody disgrace,' says Giles.

Would this man have willingly gone to work for the *Express*? Surely not . . .

At first, certainly, it seemed that Beaverbrook would

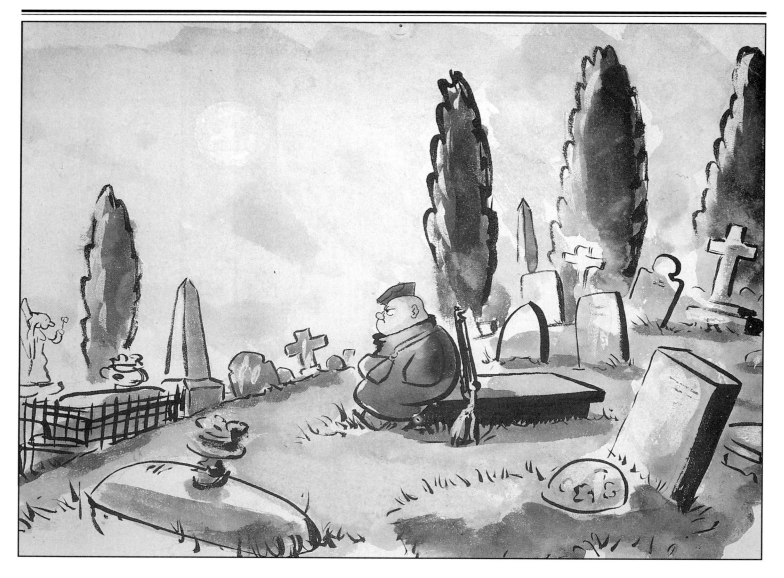

Giles drew this gloomy study of Arnold Russell, his news editor at Reynolds News, *doing sentry duty for the Home Guard in a Richmond graveyard. Giles didn't like the fellow much.*

"Beef-eaters? We ain't beef-eaters. We live on Spam like everybody else."

Reynolds News, Jan. 10th, 1943

Spam was the tinned meat which almost everyone lived on during the war.

sing in vain for his cartoonist. The first letter from the *Express* offering Giles a job sat unopened on the mantelpiece for days; when he finally remembered to look inside the envelope, he needed only as long as it took to read the proposal to reject it. He told his friends at *Reynolds News* of the approach that had been made,

and joined in their vociferous expressions of incredulity and derision. Beaverbrook, of all people . . .

But Beaverbrook was not to be put off by a little resistance, and the rather one-sided courtship continued, with Giles, happier where he was than he had ever been, stubbornly rejecting each approach.

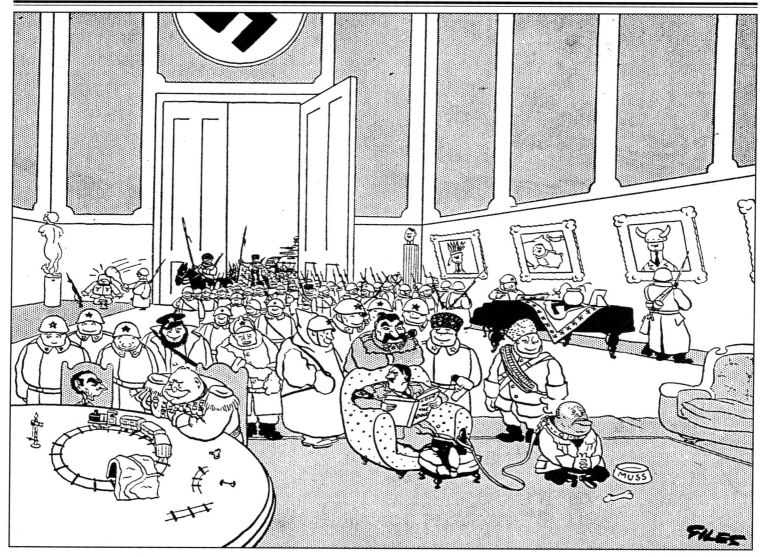

"Hermann—you've left that verdammt door open again."

Sunday Express, Oct. 3rd, 1943

Here, in the first Giles cartoon which was to appear in the Sunday Express *or* Daily Express, *Hitler is blaming Hermann Goering, his Luftwaffe chief, for letting the Russians in through the back door, the Eastern Front. Note Mussolini at the end of a dog leash; also Goering playing with his train set.*

Giles says that he cannot now remember precisely why or exactly when he decided to take the Express up on its offer. One answer to the puzzle is offered by an anecdote related by his *Reynolds News* colleague Gordon Schaffer.

'I think what happened is that the news editor, Arnold Russell, whom Giles didn't get on with anyway, wanted to squeeze some more news into the page. As a result he demanded that Giles's cartoon be cut down.'

'Cutting down', apparently, did not mean reducing the cartoon in size, but actually slicing off an inch or so of the illustration. It may have been an inch of sky, of pavement, of wall – whatever it was, to the artist it constituted an act of wanton vandalism.

'He was furious,' recalls Schaffer. 'I think, though I cannot be certain, that this is what triggered him off.'

From the other side of the barricade, John Gordon, at that time editor of the *Sunday Express*, remembers the struggle to lure Giles over, his sudden and mysterious change of heart, and the anguish – albeit temporary – it caused:

I will tell you frankly that the transfer was not an easy matter. Geniuses, as everyone like myself who has driven a team of them knows, are 'Kittle Cattle' as they say in Scotland. Sometimes you coax them, sometimes you drive them, sometimes they cry on your knee, sometimes they drive you almost to crying on theirs.

But by and large they have one attitude in common. At the start, at least, whatever change may come over them later, they are not susceptible to money persuasion. You can't bribe them.

Giles was like that. He was making very little money indeed. I took the lid off Aladdin's cave and let him peep in. All he kept saying was: 'I am very happy where I am. I would be very unhappy if I changed.' . . .

It would probably be true to say, and I think Giles would agree with it, that having made the change he became for a time a very unhappy man. He missed the old familiar faces and the old comfortable setting. He was uncertain, diffident and thoroughly miserable.

Then all of a sudden he changed. The old certainty of touch returned. The sad grey eyes began to twinkle again behind the heavy spectacles. One day I heard him laugh uproariously at one of his own jokes.

What had caused the change? The usual thing. Readers had begun to write to him in masses telling him how much they liked him.

From October 1943 on through the remaining years of the war, once each Sunday and twice a week in the *Daily Express*, Giles lifted and sustained the spirits of wartime Britain with a continuous stream of superb cartoons, brilliantly drawn vehicles for his inimitable blend of acute observation, sometimes waspish humour, compassion and celebration of the ordinary man.

The very first offering for his new employer, published in the *Sunday Express* of 3 October, contained motifs that he was to develop and refine in the following months. It showed Hitler disposed at his ease in an armchair in a huge hall, berating Goering (shown playing with a toy train set) for having let the Russians in through the back door – and, of course, into the back of the hall are swarming the hordes then in reality spreading in from the Eastern Front. A good, sound, patriotic subject for the paper, it also shows the characteristic and hilarious incidental elements for which Giles became so renowned. Mussolini, the Italian Fascist leader, whom Giles loved to portray as a bumbling bucolic poor relation of Hitler, reduced to semi-slave status, is here pictured squatting at Hitler's feet on the end of a dog leash, disconsolately gazing at the bone and empty dish in front of him. Portraits on the wall show Hitler as a baby, as a boy in Red Indian headdress and as a youth in outsize two-horned helmet – each picture bearing the characteristic moustache.

"Watch this, Bert—this is going to be funny."

Sunday Express, June 4th, 1944

Less than a year later, Giles was jerked abruptly out of his settled new routine. By then he was working much of the time at home in Suffolk, sending his cartoons up by train; but in early September 1944 he was summoned to London in person at the behest of his editor on the *Daily Express*, Arthur Christiansen – 'Chris'.

He had often been to Chris's office before, usually to receive plaudits and praises, but on this occasion was aware of a different atmosphere, an unusual tone.

'Sit down,' said Chris.

Giles sat. Surely this wasn't the sack?

Chris leant forward. 'How would you like to be a war correspondent?'

"I am afraid I must insist on da absolute quiet, please."

Sunday Express, Oct. 17th, 1943

Drawing for Victory

Within a fortnight of that meeting in Arthur Christiansen's office Captain Carl Giles, resplendent in battledress and carrying a heavy khaki kitbag, took his place on the canvas seating of a DC3 Dakota transport bound for Belgium. He had never been in a plane before; he had never been out of the country before; he had certainly never been to war before. Glancing around at his fellow passengers, he caught sight of a familiar face – more than familiar, indeed: it belonged to one of the most celebrated comedians and music-hall performers of the age, Bud Flanagan of Flanagan and Allen. He must be off to entertain the troops.

Giles was commissioned to provide entertainment, too – for *Express* readers back home and at the Front. 'Your cartoons have done so much for morale both here and amongst the troops,' Chris had said. 'Just think what effect they'd have if you were actually out there.'

Now he was actually out there – and wondering how he was to draw any cartoons at all. 'The noise was unbelievable,' he recalls. 'Shattering. At first all you wanted to do was dodge in and out of doorways like in the Blitz but a bloody sight worse – and make your way to where you knew there was an HQ. Bullets seemed to be coming from every direction, which I suppose they were. The last thing that came naturally to mind was to set up an easel, get out the pencils and start drawing amusin' cartoons.'

But he did, of course – and the *Express* regularly carried on its leader page cartoons which epitomized Giles's immeasurable contribution to the war effort, and in particular his championing of the ever-stoical, down-to-earth Tommy. This was the time of Arnhem, the 'bridge too far' campaign that ended in disaster for the Allies with only 2,400 of the 10,000 men who took part getting away; 1,200 were killed and over 6,500 were taken prisoner. Giles, following the advance with his travelling companion and fellow *Express* correspondent Alan Moorehead, was already feeling that the artist's pencil, however sharp and however well applied, was not of much account as a weapon – and that the soldiers at the sharp end of the fighting would not have much time for it.

He was wrong. The cartoons he sent back to London, printed in the *Daily Express* and *Sunday Express*, appeared back in Europe only days later, ripped from the papers and stuffed into letters from home, or just in the papers themselves. And they did wonders for morale. Some of them today hardly raise a smile; but they caught the mood of the time, epitomized the spirit of the hour, expressed in picture and caption exactly what Britain's fighters wanted to hear. His ridicule of the enemy – whether the brutish, loutish, stupid Nazis with their square jaws and square helmets, or the obsessive, identikit Japanese with their motor-grille teeth – helped to make the dangers to be faced both less threatening and extremely comical.

But there were people behind the caricatures on all

"Wot, you a journalist? You must 'ave an interesting life."

June-July 1943

Another Giles cartoon from The Journalist.

sides, as Giles knew only too well. Setting out in a borrowed jeep for a day trip towards the Front along with Moorehead and a couple of other correspondents, he was enjoying the fine autumn morning and the experience of being in the kind of vehicle which, at the time, he loved best of all, when, a few miles east of Brussels, Moorehead stood on the brakes. No more than fifty yards ahead of them stood another jeep, parked by a tree

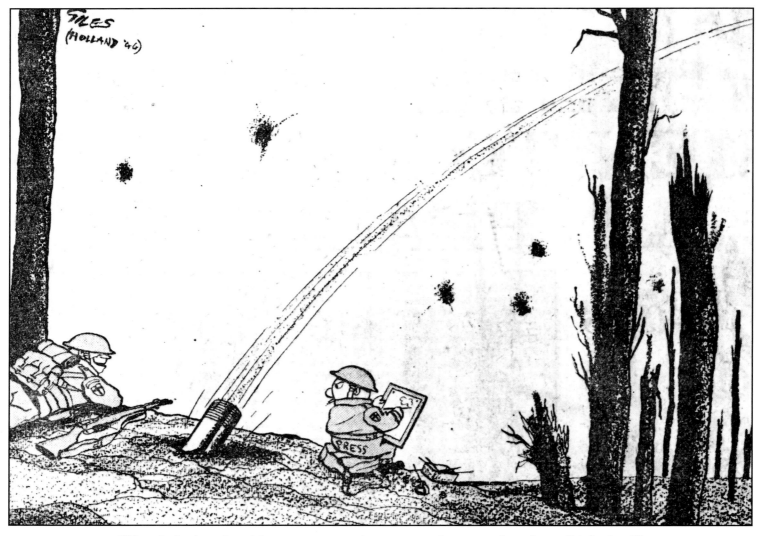

"Nearly had to do without a cartoon in tomorrow's paper that time, didn't they?"

Daily Express, Oct. 10th, 1944

– a German jeep, containing four German soldiers, all uniformed and helmeted, all smoking – and all armed.

One of the Germans picked up his rifle and carefully took aim. Moorehead and the others froze, waiting for the seemingly inevitable bullets. For a whole minute no one moved. Then, evidently noting that the interlopers were unarmed and bore the 'C' for Correspondent on their helmets, the German lowered his rifle. Giles

"Well—what are YOU waiting for?"

Daily Express, April 19th, 1944

D-Day approaches over the Channel. Happy Dutchmen look out to sea. The invasion was seven weeks away.

watched, mesmerized, as Moorehead, keeping his arms well away from his sides, slowly clambered down from the jeep and advanced at a cautious, dignified but unthreatening pace towards the other vehicle. A few moments later, it became clear that the conversation had taken a friendly, even relaxed turn. Heads were thrown back and the sound of laughter reached the British jeep. Cigarettes were passed round. Moorehead turned and waved Giles and the others over.

The Germans, too, were newspaper correspondents.

Unlike their British counterparts, they were armed to the teeth with sidearms and grenades as well as their rifles; but, won over by the eloquence of Moorehead's German, and by the open and good-natured manner of his approach, they had decided on friendship rather than slaughter. Soon Giles, despite not speaking a word of German, was joining in the exchange of cigarettes, putting out his own in order to accept one offered by the German group's driver. Moorehead introduced him, in German, as 'the famous English cartoonist'.

"I wish my mum could see me and you now."

Daily Express, Oct. 3rd, 1944

"Roll up your map, Herr General—I don't think your counter-attack's going to come off."

Sunday Express, July 16th, 1944

Field Marshal Montgomery is in the foreground.

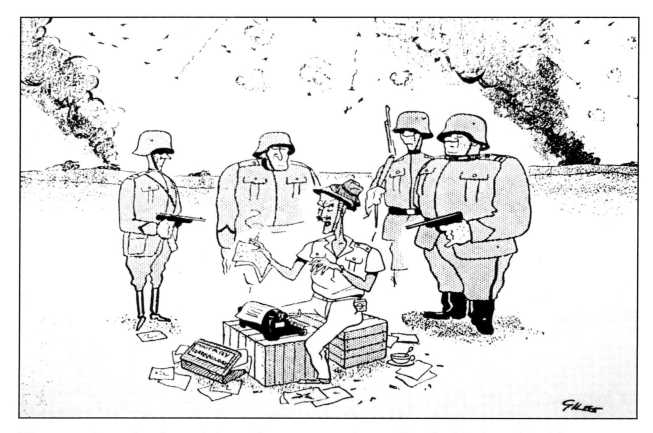

"Now run along, there's good chaps. I've got to get this stuff finished by four o'clock."

Aug. 1942

From The Journalist.

'Ah, so – ja, so,' chorused the Germans, laughing with a mixture of good humour and relief, as if to say that if the world were left to men of humour, there need be no wars.

For Giles there was something deeply touching about the encounter.

'We really thought they were going to shoot us,' he recalls. 'It was undoubtedly the cool behaviour of Alan which saved the situation. He was marvellous.

'But in a way it reminded me of that story of the First World War when, on Christmas Day, the two sides – only a hundred yards apart – slowly climbed out of their trenches and moved across no man's land to shake hands, then to embrace. They eventually sang "Oh Come All Ye Faithful".

'Our meeting wasn't quite like that, but there was something of the same feeling. We were enemies who discovered in an instant that we were actually capable of being friends. It was a brief friendship of great intensity. It was strange.

"There 'e goes—says he's going to get this ruddy invasion over, then get some leave."

Sunday Express, May 14th, 1944

D-Day is now three weeks away.

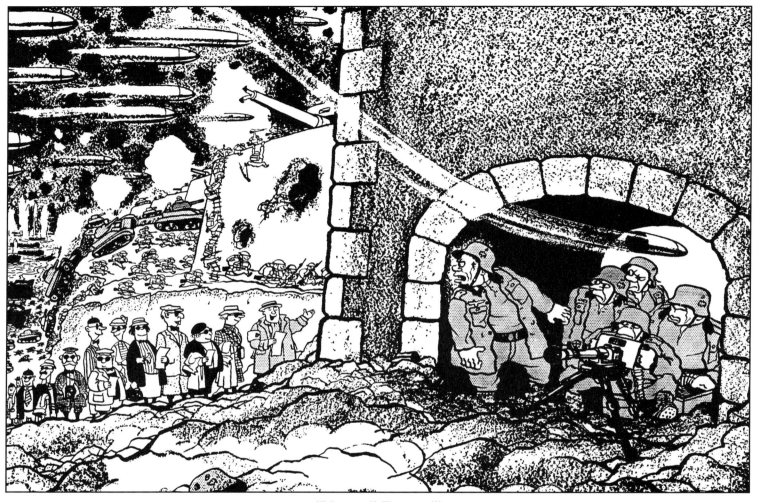

"Himmel! Tourists!"

Sunday Express, June 11th, 1944

D-Day plus five.

'Eventually the two jeeps went their separate ways – we were at war, after all – and we waved, I remember, until we were out of sight.'

A little after this event, while in Holland before accompanying the advancing troops into Germany itself, Giles was invited by his Dutch hosts to visit one of their own camps. He was escorted round by a young man in a suit and rimless glasses who, at each cell, would invite the visitor to stop and look at the wretched inmate. 'In the morning,' said the Dutchman,

pointing through the bars, 'he will be taken out and shot.' All the prisoners, Giles remembers, had the hollow-eyed, despairing look of the condemned. He met the eyes of one or two and felt compassion for them; and he also felt revulsion at the pleasure with which the young Dutchman displayed the doomed men.

'Whenever I met people in the war I learned how all are really the same,' he said. 'They all seemed equally capable of terrible acts of cruelty, and also of being wonderfully human. It depended on which role they were playing and in what circumstances.

'Whenever I met the so-called enemy, I found it difficult, after I had spoken for only a few minutes, not to see them as I would anyone else – on Ipswich High Street, in Islington or anywhere. Equally, I was aware that those who were supposed to be on our own side could behave barbarically.'

As the Allied advance continued through the winter of 1944 and into 1945, Giles was to find more opportunities for meeting 'the so-called enemy'. He acquired a jeep of his own, along with a driver, Private Bishop – Reg Bishop, a fellow Londoner. He had also worked out a routine to enable him to draw in safety, and could judge where he would be able to set up his easel to work without having suddenly to dive for cover. Giles enjoyed his new mobility to the full, snapping at the heels of battle ever more boldly – sometimes more boldly than Private Bishop would have liked.

'C'mon, mate,' Giles would say with a characteristic disregard for the proper mode of address between Captain and Private, 'let's go down there. It looks quiet enough.' This in some area of Germany only just conquered, where half the buildings were reduced to rubble and where dark smoke curled around the new ruins. Sometimes Bishop would demur; then, with a 'Don't say I didn't warn you, sir,' he would engage first gear and down they would go – flying like the devil: if their jeep was going to be a target, it was going to be a moving one, and a fast-moving one at that.

They sometimes came across dispirited Germans,

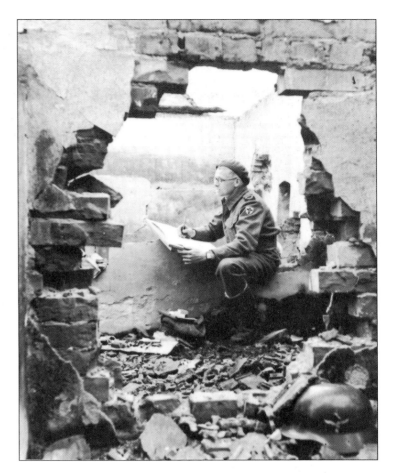

Giles sketches in a wrecked house in Belgium.

walking through the tumbledown streets or just sitting in doorways: 'Actually, they usually saluted,' remembers Giles. He was keen to speak to anyone for whom the war had so recently stopped, and in one small town told Bishop to pull up at a fairly decent-looking house on the main street where a middle-aged woman stood in the doorway. She spoke English, and invited Giles and Bishop inside. There they found a large family of women assembled in the main room.

Laval was the French politician who was given dictatorial power by the Germans in 1942. After the fall of his country Laval was vice premier in the Vichy government. In 1945 he surrendered to the Allies and was executed for treason.

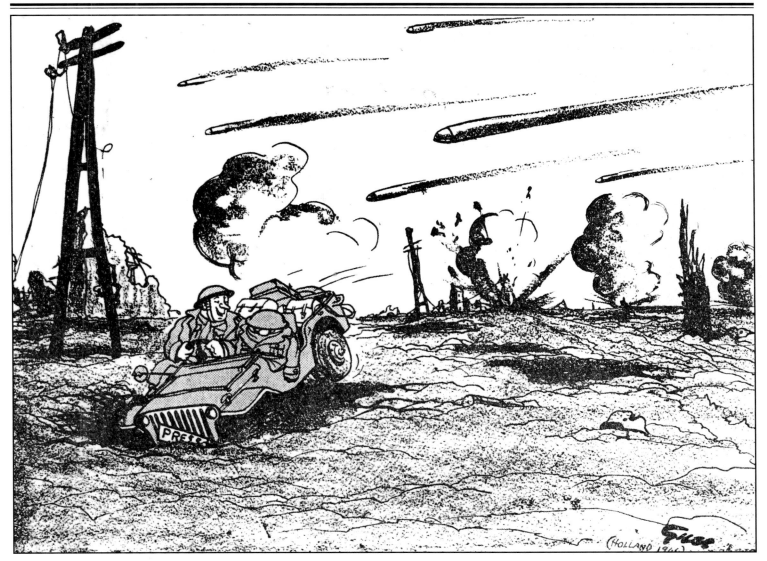

"Unsociable lot, these Germans, sir."

Oct. 5th, 1944

This is Giles in his jeep with his cheery driver.

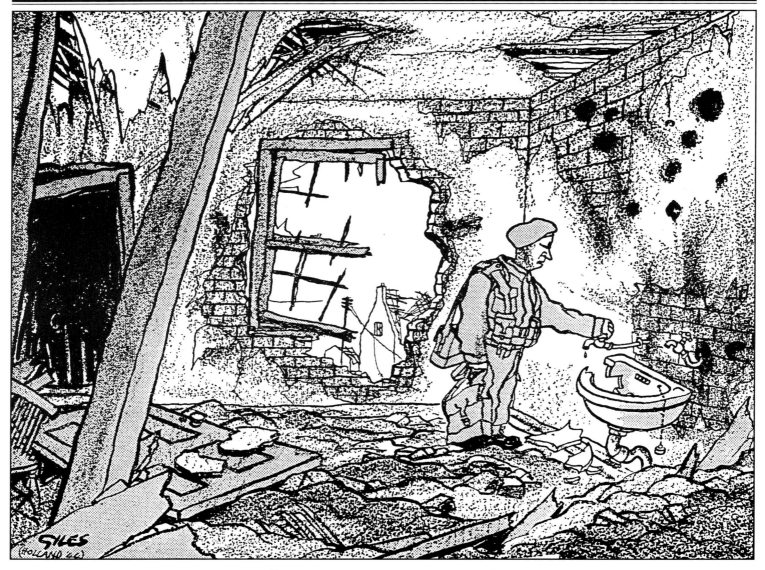

"Just as I expected—no hot water."

Daily Express, Oct. 17th, 1944

"Well—how's Mr Invincible this morning?"

Sunday Express, Sept. 10th, 1944

The Allies prevail, after the battle for Normandy.

'Please,' said the older woman, indicating that the two men should sit down.

There followed for Giles another experience of war that was both confusing and encouraging. The family was educated and cultured and the women spoke reasonable English; they readily embarked on discussion with Giles of the war, the British, Hitler and Churchill, death, defeat and victory. There was no bitterness in them; just sorrow, and a great weariness, and perhaps too relief that it was over.

The father of the house was away fighting with the navy; the women had little money and few provisions, but nevertheless indicated that Giles and his driver were most welcome to stay for dinner and spend the night there: there were spare rooms and clean linen. The talk became less general, more personal; the women talked of their relatives who had died and of those who might come back; Giles talked of Ipswich and of the estuary pubs and of going home – and reached into his bag and showed them his drawings, of the cheeky, indomitable Tommies, of the square-faced Germans in their square-headed helmets, and of his preposterous Hitler, scrambling for shelter with bullets whistling round his ears. And they smiled; for now they dared.

'It was very strange,' remembers Giles. 'We were a conquering army racin' through their country. There was destruction everywhere. Yet they made us as welcome as if we had been long-lost relatives. These people weren't the enemy, they were just people.'

But it was not long before Giles was to come up against the people who represented the enemy at its worst: the custodians of Belsen, a death factory still in full production, still sucking wagonloads of Jews, gypsies, the insane and other 'undesirables' into its insatiable maw as the Allied advance reached its gates.

At this stage Giles was often in the company of his *Daily Express* colleague Paul Holt, no more a professional war journalist than himself: Holt, the paper's film critic, had been sent out to the Front in accordance with the celebrated Beaverbrook policy of giving what

appeared to be the most inappropriate jobs to the most unlikely of reporters. At its best, as with Holt, this produced original and inspired journalism.

Thus it was that this improbable pair of war correspondents, film critic and cartoonist, both still faintly awkward and uncomfortable in their military uniforms, found themselves on an eerily hot and still day in mid-

As a war cartoonist Giles drew a number of pictures of the German concentration camp at Belsen and of Breendonk outside Brussels (seen here). They are dark and chilling and show an aspect of Giles's observation which is dramatically unfamiliar. Giles prevailed upon his editor not to publish them, and they remained unpublished for fifty years.

April 1945 staring through the perimeter fence of Belsen extermination camp.

'I'm not goin' in there,' said Giles quietly.

Holt looked at him and then back through the fence, to the endless lines of huts, some with figures shuffling and jerking at the doors, probably incapable of believing that their rescuers had come.

'You have to go in, Carl,' he said. 'We both have to. It is important that we see it so that we can pass it on. Tell the world. We have a duty. We have to go in. We really do.'

There was practically nothing that Giles had seen in the whole of his life which could not be cheered up with a stroke of the pen. Until now. Holt went on:

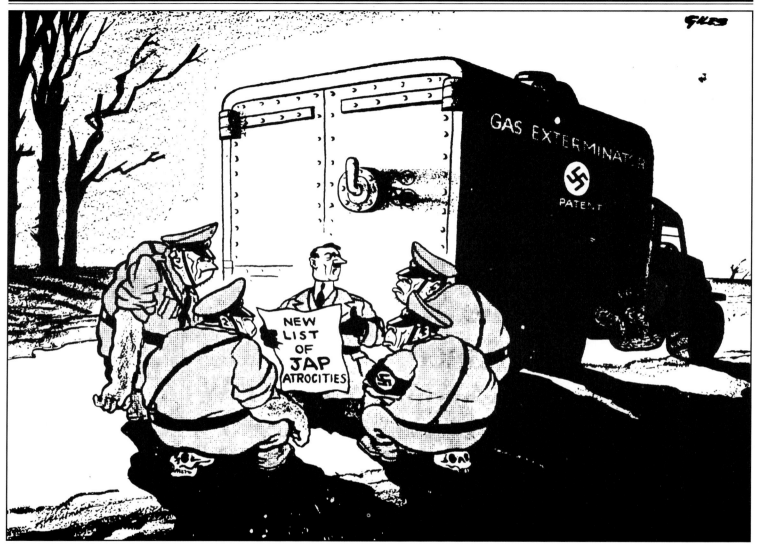

"These damn Japs are showing us up—we shall have to think up a few new ones."

Daily Express, Feb. 3rd, 1944

Giles would occasionally abandon his comical representation of the war's protagonists, with devastating effect.

"We'll sell the picture to the Express and Grandma's comments on sailing to the BBC."

Daily Express, June 6th, 1960

Giles Annual *cover 1967.*

Giles Annual *cover 1966.*

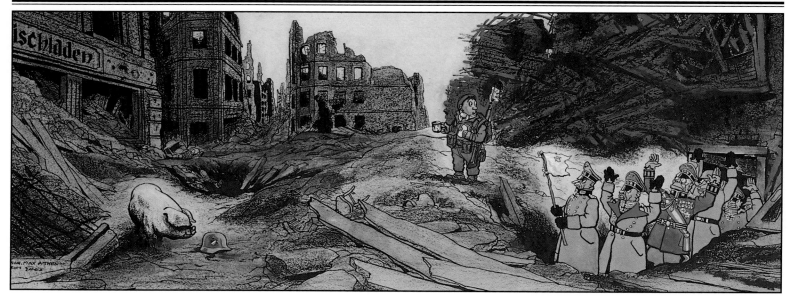

Original artwork for Giles Annual *cover 1946.*

Original artwork for Giles Annual *cover 1957.*

Giles Annual *cover 1981*.

Original artwork for Giles Annual *cover 1974*.

Original artwork for Giles Annual *cover 1975.*

'When you see this in the papers back home you won't want to believe it, any more than will the readers. We have to confirm to them that this place existed. We must go in.'

The horrors Giles witnessed there were beyond both his own words and the skill of his pen. 'What could I have drawn that would have told anything more vivid than the dreadful photographs which continue to haunt us? If you want to know, look at those. Read the newspaper reports of the time.'

Giles met Kramer, the camp commandant, in the room where he had been told to stay put by the Coldstream Guards who were taking over control of the camp.

'My name is Carl Giles,' he said. 'I am a cartoonist for the London *Daily Express*.'

Kramer replied in fluent English that he knew of Giles and his work and admired his cartoons greatly; indeed, he went on to say how honoured he would be if Giles could send him an original. Before Giles could respond to this startling request, the door crashed open; two Guardsmen, livid with anger, faced Kramer. 'Bastard!' exploded one of them. 'We'll be seein' you later.' Then they left. Perhaps the rank of the prisoner had deterred them from attacking him; many of the camp guards had been beaten beyond recognition, some to death. Most such incidents were not even reported.

Giles, aware of the absurdity of their conversation, agreed to send Kramer an original cartoon. In return, Kramer offered the artist his ceremonial dagger and pistol. Giles still has these; taking them out of the cardboard box in which he has kept them on a shelf over the sink in his farmhouse, he says:

'They are not mementoes, as such, but they are certainly reminders of the only thing in my life which could not be expressed in a cartoon. Not a day goes by when I do not think of Belsen. I am as haunted and horrified as the day I entered those gates. These objects represent the purest evil you can imagine.'

He didn't sent the cartoon. 'What was the point? He had been hanged.'

Giles sketches a cartoon, using a tank as his easel, somewhere in Germany.

Giles and Holt remained near Belsen for about a fortnight. At the camp the British troops, aided by medical staff, were attempting to sort out the desperately sick from the merely skeletal: though there were about 30,000 prisoners, mainly Jews, still alive when they arrived, epidemics of typhus and dysentery were threatening to deprive even these of their chances of survival. Those who were not actually ill, it was decided, should be given a party: on the orders of a senior officer, a dance was arranged for them in the local town hall. Giles recalls:

'Soldiers were told to go to all the homes around and about and get hold of smart evening suits and ballgowns. Huge hampers of garments were collected, and

81

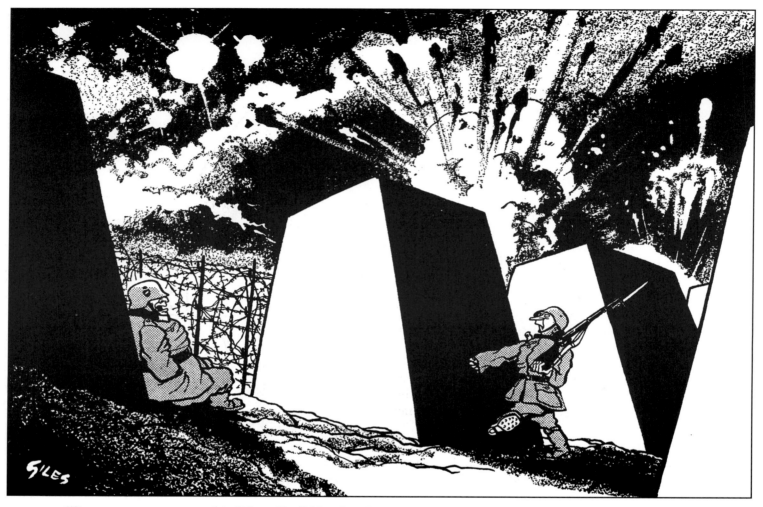

"Suppose you cut out this 'They Shall Not Pass' stuff. Their advance patrols went past hours ago."

Daily Express, Sept. 12th, 1944

the former prisoners tried them all on until they found clothes which would roughly fit. Of course, everything was much too big.

'We were all asked to the dance.

'The regiment provided a small band, and we all did our best to join in. I remember dancing with one or two

of the women and all I could feel were the bones in their skinny little hands and their almost bare ribs and sharp shoulder blades.

'It was, truly, a *danse macabre*. It was a terrible idea.

'But they were free. And alive.'

Glad beyond measure eventually to get away from

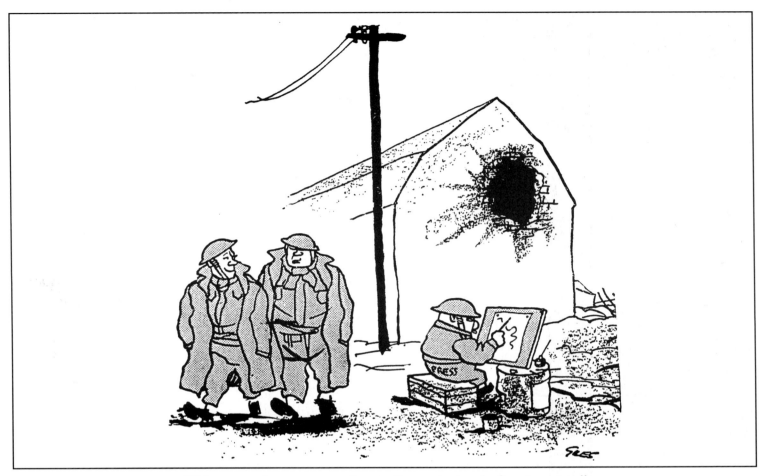

"I'd sooner they sent us a few pullovers instead of cartoonists."

Sunday Express, Nov. 22nd, 1944

the horrors of Belsen, Giles followed happily in the wake of the Allied advance through Germany. By now the cartoons he was sending back to London were almost all celebrations of the Tommy's victory over the Kraut. Picture after picture of unkempt and miserable-looking German foot-soldiers flowed from his pen, their bony faces and shovel-like chins protruding gloomily from under their coal-bucket helmets as they straggled through forest and wilderness or skulked in the doorways of ruined buildings. They were often shown scuttling out of the way of cheery Cockneys and robust Northerners, and were generally given a very hard time by the enthusiastic tip of Giles's pencil.

Fifty years on, many of these cartoons don't seem all that funny; to appreciate them it is necessary to try to see them from the perspective of people of that time,

"What a beautiful morning! It wouldn't surprise me if you get your invasion today."

Daily Express, May 4th, 1944

Giles loved depicting Mussolini.

through the eyes of the British servicemen and civilians who had struggled, suffered and fought through to their eventual triumph. Brilliantly drawn, they show the British and their allies sweeping to victory, and doing so in good cheer and with honour; and they show the routed Nazis, ugly and evil, cowering and in disarray.

That was what the *Express* readers wanted; and that was what they received. The newspaper headlines still spoke of deaths and of continuing battle, and logic said that there was a hard time ahead; but Giles's cartoons reflected exactly the emotions of the time: we had won, and the Hun was in flight.

84

Giles had great fun creating caricatures of the principal protagonists of the war, especially on the enemy side: while Churchill, Montgomery and Eisenhower do appear, it is his portrayals of Hitler and his henchmen that express his mischievous impulse most effectively – Goering, Goebbels and, perhaps above all, Mussolini.

'I called him Musso, and really got to like him. If you draw funny versions of bad people – if you remove the evil – then you can develop a great affection for them. I even liked Hitler, in a way, because I drew him as a funny little man who was always in disastrous circumstances, being let down by fools.

'Musso I sometimes saw as Hitler's pet dog, always on the end of a leash. I think Musso was my favourite, really.'

Now, one by one, Giles was to lose the originals of the characters who had bustled in his own imagination, who had peopled his own war. Hitler shot himself in his Berlin bunker; a week later, the Italian dictator and his mistress were shot and strung up by Italian partisans. Giles's reaction to the latter news, in a letter to Joan, was: 'I've lost my Musso.'

There was one, however, among the grim gallery of Nazi notables whom Giles was in no sense sorry to see go: Heinrich Himmler, chief architect of the Holocaust.

'He wore half-moon glasses and never removed his peaked hat. He was very self-conscious about his baldness. I hated him. He was the most chilling of the leading Nazis, and there was no way I could find a way to be funny about him. So I just drew him as he was.'

Perhaps ironically, Himmler was the only one of his war characters whom Giles actually saw in the flesh. Captured on the run, he was too quick for the examining doctor and bit on his cyanide phial before it could be removed. Despite stomach pumps and emetics, he died, thus evading trial for his war crimes.

'I was told he was dead that same evening, and went along to the HQ,' recalls Giles. 'There were people around and much excitement. Everyone was havin' a look.

'I pushed past a group of British officers and stood in the door. It was difficult not to be fascinated. I had drawn this man and there he was – dead, but looking exactly as I had always imagined him. He still had his hat on, I remember, even in death.'

Earlier that month of May 1945 Viscount Montgomery had taken the surrender of the German high command in a tent on the desolate Luneburg heath north-east of Hamburg. Giles and his pens and pad were there.

'It was a very English occasion,' he remembers. 'The Germans were suddenly face-to-face with what had defeated them: the British. But there was something entirely English about it. Many of the witnesses, with their grave officers' faces and moustaches and funny thin noses, were like characters out of a film made at Ealing studios. I drew several pictures of Monty. He was very easy. He was just a long knobbly nose, a black beret and heavy sort of duffle coat. The Germans wore greatcoats, some those shiny leather ones.

'It was all very sombre. And you didn't really think of what a moment of history you had been some small part of until later.

'When Monty read the surrender terms to the Germans it was almost as if he were declaring a list of new school rules.'

Giles dallied in Hamburg for a while, enjoying the conviviality of the British forces, who were only too happy to entertain him. 'Giles?' they'd say, 'Is it really? Well, let's have him over to the mess this evening. Give 'im a party.'

Then, finally, it was time to be going home.

The question was, how?

'There was an army dispatch rider called Bill Hollingsworth,' says Giles, 'a Londoner. He was a decent bloke, not loud, but he laughed a lot – laughed that is, when he was meant to laugh, when things were genuinely funny.'

Giles has always judged men by the manner of their laughter.

"Ain't there enough trouble in the world without you coming in here saying you've got measles?"

(It was alleged that Mussolini is probably ill)

Sunday Express, Feb. 13th, 1944

"Musso gorn, Goering gorn—you'll be in the cart when they've all gorn—won't 'ave nuffin to draw, will you?"

From an unpublished 1945 cartoon in the artist's collection.

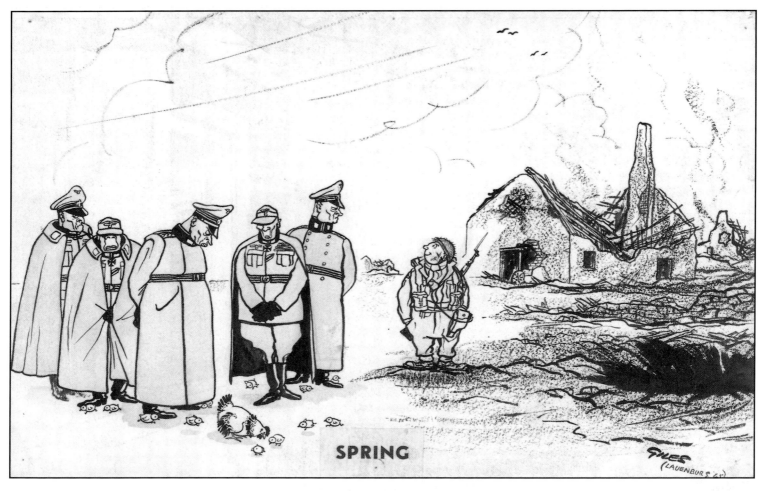

SPRING

May 5th, 1945

The end of the war.

'Bill rode a Harley Davidson like the devil himself,' says Giles. 'Still, I was happy with motor bikes, even though I nearly bloody well killed myself on one, and I asked Bill – who was going from Hamburg back to Holland – if he would give me a lift. I had kitbags full of stuff which could be strapped into those back satchels on the side. It was amazin' what you could carry on a bike if you were determined enough.

'We set off and just clung on.

'Bill was the kind of rider who would hurtle down the street straight at a war memorial and just bank round it at the last moment. You were sure you were

"Good-bye, sergeant, I must leave you, though it breaks my heart to go."

Sunday Express, June 24th, 1945

"Come on, Florrie, we can't wait until you see your first Red Army man—the Russians may be another week before they get to this side of Germany."

Daily Express, Jan. 25th, 1945

"The sun never sets on the British Empire, do it."

Daily Express, April 29th, 1947

going to be jam all over the granite, but we always seemed to survive.

'Bill took us through this forest where there were long wide breaks – like avenues – where the trees had been cut down. The trunks had been taken off just six inches from the earth. Bill went straight across the lot of them. Every time we hit a stump I got thrown into the air by about a foot and would then come crashing down on my balls. You could not imagine a less enjoyable manner of leaving behind a world war.'

Enter the Family

Peacetime. Who was to people Gilesland now that Hitler and Musso and their cohorts had gone? Who was to epitomize British stoicism, waywardness, eccentricity and mischief now that the Tommies were being demobbed?

A clue appears in a Giles cartoon of 5 August 1945. The war was not over – not quite: the atom bombs were about to devastate Hiroshima and Nagasaki. In England, however, the return to normality has begun its long haul, and a family is setting out for a day at the seaside in indomitable English fashion – walking along a railway line, not to be deterred from their excursion by the fact that trains were still very few and erratically scheduled.

Not all the members of the Giles Family, as they came to be known and loved over the next half-century, were present on this first appearance. Mother is there, pushing the twins (her grandchildren, as will later become apparent), on this occasion little more than two cavernous shrieking mouths; and so is Father, laden on one side with a bag containing thermos and sandwiches, on the other with a scowling baby, prevented from joining in the twins' chorus by a dummy stuffed into his mouth. Trudging grimly alongside is young Ernie, spotty and determined and already betraying the Family likeness in his features. Another, unidentifiable kid tumbles down the bank as a pigtailed girl – Bridget? – looks on; a small creature holds up its paws in alarm. And bringing up the rear is a ferocious old lady in black bombazine – the great-grandmother of the bawling infants, but known to us, of course, simply as Grandma.

Where did they all come from? Giles explains:

All my work for the *Express* up until then had been in the wartime. All the characters were wartime characters – or people caught up in the war. Suddenly they were gone. I had lost them – Hitler, Mussolini, disreputable little Franco was still there, of course – Himmler, Goering, Goebbels . . . I drew the Family as something which could take their place. After that, whenever I couldn't think of anything else I fell back on the Family.

There is no record of Family participation in the war, but they did not escape entirely unscathed. There was for a long time a mystery about the parentage of the twins Ralph and Laurence (named, incidentally, after Sir Ralph Richardson and Sir Laurence Olivier). Ann, the eldest daughter (absent, with her sister Carol, from that first picnic), is certainly their mother; but who is their father? Eventually their creator explained:

Oh yes. It was an American serviceman. No doubt at all. They never spoke about it, but most of them knew. But then girls in those days, after the war, didn't speak about things like that. It was peace – things were different – and they just got on with it.

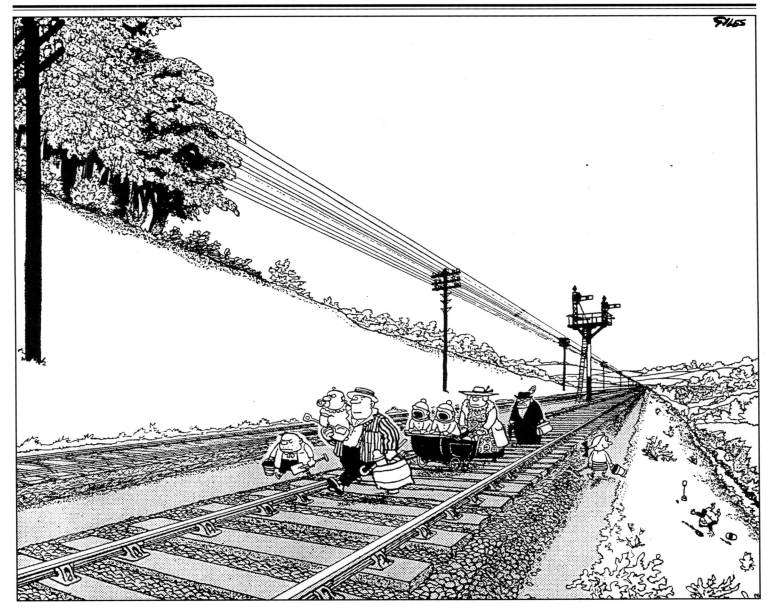

It's quicker by rail.

Sunday Express, Aug. 5th, 1945

Peace descends on the world. Or does it? Here is the first appearance of the Giles 'Family'.

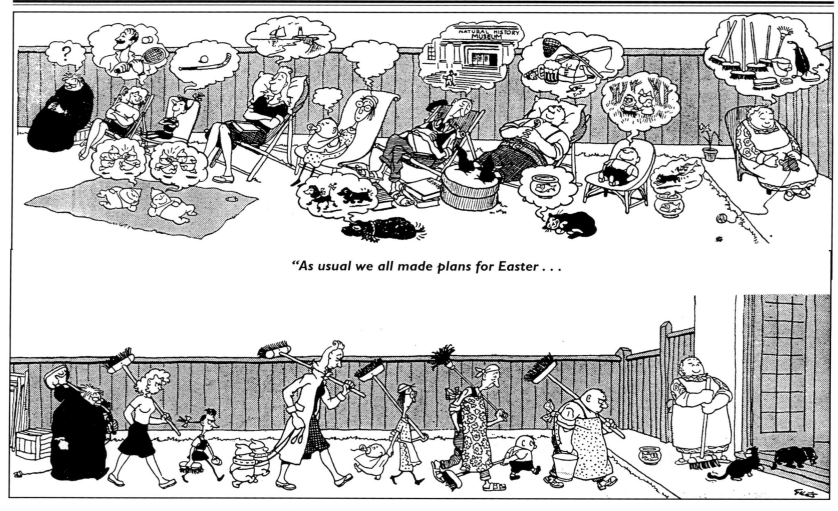

"As usual we all made plans for Easter . . .

and as usual, only Mother's came to anything!"

Daily Express, April 16th, 1949

And here they are – the full cast. From left to right in the lower panel are: Grandma, Carol, Bridget, Ann with her illegitimate twins, George Junior (he doubled as the cartoonist's illiterate spokeschild, Giles Junior, when Giles was indisposed), Vera, George the bookworm, Ernie, Father, Randy the fish (long swum away) – and Mother, shown in an uncharacteristically tyrannical pose. Natalie the cat follows an early, unnamed, Giles dog into the house. Eventually the Airedale, Butch, was to establish himself as the permanent Family pet.

You have to remember that there were a great number of babies after the war whose fathers were back in America. Many of them didn't even know. You often had to wait for the babies to sit up in the pram to see their colour – many were black, some of them were Chinese. When you considered the ethnic mix in the US forces you could expect just about anything.

The legacy of random family additions left by the American servicemen in Britain seems to have appealed to Giles's unfailing attraction to mischief, nowhere more apparent than in the youngsters of his cartoons, young Ernie of the Family and his friends, the malevolent mites who attach fireworks to the cat, who shoot arrows at the ample rear of the neighbour tending her prize marrow, who roll a hapless victim in a barrel down a cobbled hill into the midst of the Saturday morning market, who ambush angelic-faced choirboys with snowballs, who use a traffic warden for catapult target practice . . . Ernie and his friends, with the twins as mute and gleeful witnesses, are always in the thick of it, then as now apparently irretrievably beyond and above the reach of authority and the law.

And always nearby the mayhem being – or about to be – wrought, there is the mysterious little boy with the black spiky hair and the camera, observing and ready to capture on film every catastrophe that his friends set up. Not strictly Family but seldom far away, like all good photographers, Stinker can always see the next stage of the events unfolding and manage to position himself in the perfect spot to capture the drama. Not for Stinker the visual romance of sunsets or the flight of swans; he has much better things to do with his camera, lurking around the corner from where Ernie has set up an elaborate tripwire that is about to empty a tin of paint on to Grandma as she dozes over the racing pages, or hovering in anticipation of disaster as Mother attempts to scale a rope ladder to a tree-house with a tray full of glasses of lemonade.

Giles likes Stinker. 'He was a favourite in a way. The funny thing is that he was called Stinker in the cartoons but the readers started to write in and call him Larry. Independently. I don't know why, but I suppose it was rather a suitable name.

'He's a friend of George Junior who has attached himself to the Family. Like a lot of such friends, no one is quite sure who his parents are or exactly where his home is. He's just always in the house. Or around George. Whatever George is up to, you'll find him there.'

"It's marked quite clearly on the bottle, Vera – 'This wonderful drug from the USA produces a 50 per cent increase in the growth of farm stock. UNFIT FOR BABIES!'"

Daily Express, April 13th, 1950

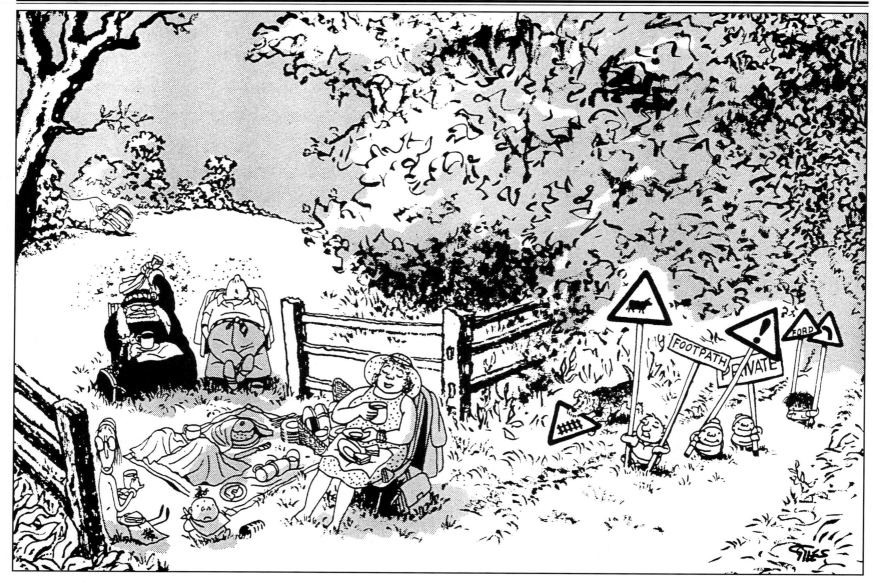

"Well children, did you have a nice ramble?"

Sunday Express, May 28th, 1978

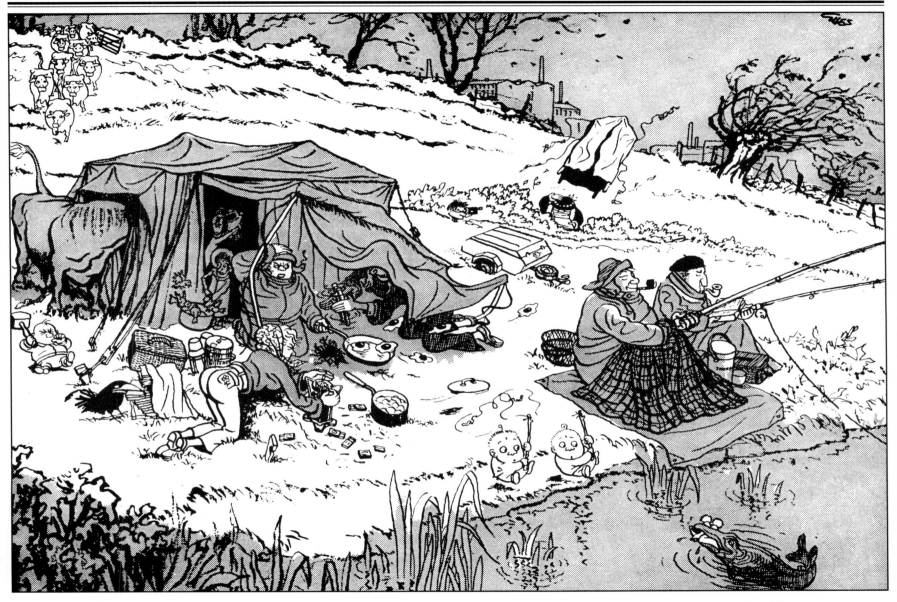

"As a matter of fact we do not think this is better than taking one of those chancy holidays in the Med."

Sunday Express, July 28th, 1974

"I don't think Dad's eight miles to work by bike is saving as much petrol as Mum thinks."

Daily Express, June 28th, 1979

Tantalizingly, Stinker/Larry never utters a word. He has never been given 'a caption'. Too busy observing, perhaps? A strange little boy, certainly, wrapped up in his own perceptions of the chaotic world about him, apparently devoid of any tender-hearted impulse to warn anyone of the disasters about to burst on them, which he is perfectly poised to record . . . if all the little monsters were released from their timeless, ageless state in Gilesland, young Stinker, surely, would be the first to leave suburbia, forget the Family, quickly find employment as apprentice to a famous photographer and one day become a figure of renown in his own right. As did Giles.

There are more mysteries in the Family. Whose, exactly, is George Junior? It might seem from studying the cartoons that he is the son of hypochondriac/neurotic/depressive Vera and bookworm/philosopher/thinker George. Certainly Vera generally has him in

Sunday Express, Oct. 20th, 1963

"This lady claims that your dog has just devalued her Cruft's champ."

Daily Express, Feb. 11th, 1973

rather haphazard tow. But Giles – and he should know – says that this is not the case, and that people should not jump to conclusions. Vera is just 'minding' George Junior – who on occasion uncannily metamorphoses into 'Giles Junior', the celebrated note-taker, letter-

writer, blotter and illiterate who pens a smudged, appallingly spelt and waywardly written missive whenever his creator is laid up or indisposed and unable to provide a cartoon.

Little George/Giles is not the only Family figure to

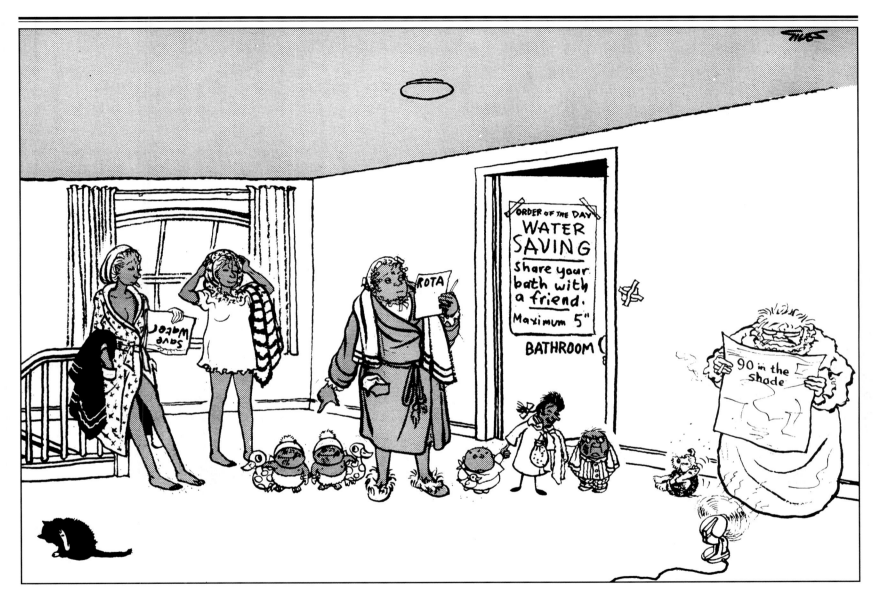

"That leaves you Butch or Grandma."

Sunday Express, Aug. 10th, 1975

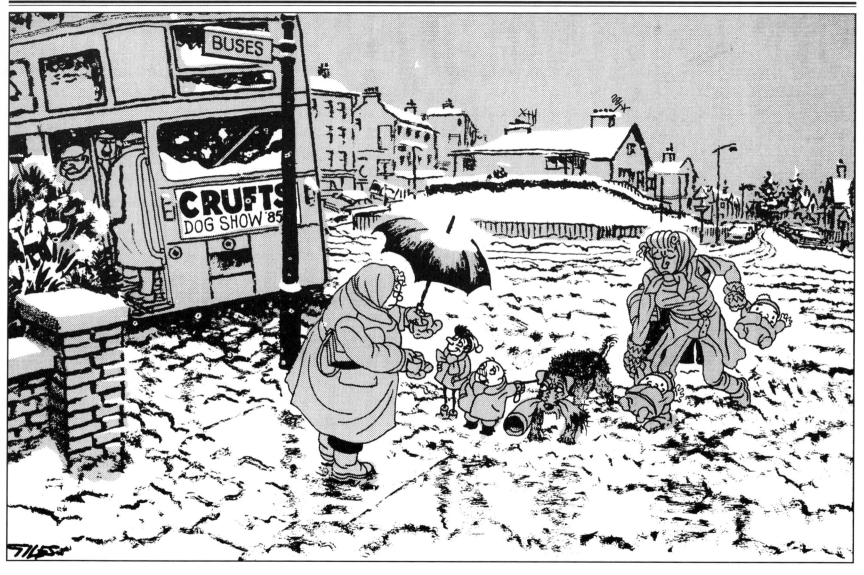

"Butch would have won—but I think he dropped a few points when he took the sleeve out of the judge's jacket."

Sunday Express, Feb. 10th, 1985

swap identities: the sisters of the Family went through a somewhat confusing phase before settling down into their established hierarchy as Ann, mother of the twins; Carol, fending off suitors and prettifying herself; and Bridget, eternally in pinafore and pigtails. At first they were A, B and C, Ann, Bridget and Carol, in that order; then someone at the printer got the letters mixed up and reversed the names of Carol and Bridget. The confusion persisted and eventually the two younger ones swapped places and Carol became the middle sister.

Like Ann and Carol, poor Vera and her oblivious husband George had apparently had other things to do on that day in August 1945 that saw the Family trudging down the railway line on their day out. George, Father's bookish elder son, is never known to raise his eyes from whatever learned tome he is studying, whatever the antics going on around him. Whether this withdrawal into abstract thought is cause or result of Vera's habitual anxiety and unpleasant snuffles is matter for conjecture.

Once up to strength, then, the Family numbered twelve in all – plus Butch, the dog. Butch has all his life – or lives – slipped easily and sometimes confusingly between the Family household of the cartoons and Giles's own household in Suffolk.

It all started some time in the war, when Carl and Joan Giles took delivery of a black spaniel puppy at their Suffolk farmhouse. Various of Carl's jazz-playing black GI friends were staying at the house at the time, and later on that evening, when they all gathered to play at The Fountain, they discovered that one of their number, Butch, was missing. Realizing that he must have been left behind, Giles drove back to pick him up – and found him sprawled on the kitchen floor stroking the puppy. When the party had risen to depart, the little dog had started to whimper; and big Butch, disregarding the move to the pub, had stayed behind to comfort it. Inevitably, the puppy was called Butch.

Over the next fifty years, the original Butch had a number of successors, each taking on the name after the departure of the previous one; the last three have been Airedales, and while dogs of other breeds have made cartoon appearances with the Family, it is the Airedale Butch who is now firmly established.

Perhaps because of his dual existence in Giles's own home and within his cartoon world, Butch was the unwitting cause of something of a fuss in Suffolk when a sculpture was commissioned as a fiftieth anniversary tribute to the artist in his home town. Miles Robinson was the sculptor entrusted with the task of creating in bronze a memorial to Giles's genius. He was honoured; he could not have been prepared for what was to follow.

Miles Robinson's scheme was to depict Grandma, the snuffling Vera, the robust young twins and, lying across the front of the group at the old girl's feet, Butch the dog. Giles had been invited to view and comment on the statue before it was committed irretrievably to bronze, and this prompted him to make one of his extremely rare public outings. Giles despises cameras, microphones and intrusion generally, and scowled and squinted his way past the clamorous journalists who had gathered to watch his reaction. The sculptor could hardly have found it an encouraging experience.

However, approval of a sort was finally conceded and the casting in bronze went ahead.

Then Giles saw a colour photograph of the finished article in the local paper. 'This is nothing like Butch at all!' he exploded. 'I want it out. I want it off the statue. What's his number?'

Whether Giles was expressing outrage at the failure of the statue to represent the real or the fictional Butch was not clear. Whichever it was, the appalled Robinson was mercilessly ordered to remove the dog entirely from the finished sculpture. This couldn't be done, of course – not without starting again from the first fistful of clay.

Giles was eventually persuaded – just – to relent. Reluctantly he called Robinson and said: 'The feeling seems to be that you had better leave Butch in. But I still think it's bloody awful.'

Butch has a much more comfortable life in Suffolk – both in Giles's farmhouse and at Grandma's feet in Ipswich – than in the Family's suburban semi, always either in or about to be plunged into some kind of anarchy. The safest place was often under Grandma's chair, though even that spot was not immune from some kind of terrorist action. At least Grandma took him for walks – indeed, it was only Grandma who paid him any real attention at all.

Night-time must have been a blessed relief for Butch, though it raises another interesting question: where did all these twelve assorted beings sleep? Even if (as Giles suggests), all the youngsters slept in one bed, with just their heads poking above the blanket, and the twins in the middle, that still leaves Mother and Father, the two elder girls, George (and his book?), Vera and Grandma to be disposed somewhere. At the very least, there must have been five bedrooms – any fewer and the Family abode after lights out would have resembled some overcrowded slum, and we know that is not the case. The Family, curiously, was never short of money.

Keith Waterhouse, novelist, playwright, man of letters and working-class Yorkshire-man, thinks that the Family is 'probably a working-class family living a middle-class lifestyle. They are pipe-smoking and pints – not Scotches and vodkas.'

Sculptor Miles Robinson with his bronze of Grandma and Butch. (East Anglian Daily Times)

"Dad—what's it worth if we don't tell Mum you've forgotten Mother's Day?"

Sunday Express, April 1st, 1962

"I told you a small open boat was false economy. We should have had the one with the cabin."

Daily Express, Jan. 11th, 1968

Benny Green, Cockney writer and jazz critic, agrees:

The Giles Family are downmarket for that house. Definitely. Giles got the working class right. Having lived in the back streets, I know. You always saw the Giles lot – or people like them – sitting outside pubs in the evening. There would be Father and Mother – and very often there would be a battleaxe of a grandma looking ferocious.

In the working classes in those days no one had

"I think he's nicer in the mornings since he gave up drinking."

Daily Express, Oct. 10th, 1967

a house, no one had any money. There were families of twelve all living together and there was that complete lack of privacy – just as there seems to be in the Giles Family household.

It always looked to me as though the Gileses were living above themselves. It looked as though they had come good in some way – won the pools maybe. But I must say that they are quite different in some respects. Father and Mother would usually lash out all the time. You would get a

"Message from HQ: 'All SAS men will enter by the back door.'"

Daily Express, May 8th, 1980

This cartoon was inspired by the SAS assault on the Iranian Embassy in 1980.

wallop. A thick ear. You don't see that in the Giles household – maybe they have just been overwhelmed by the sheer tyranny of the young. Then if a couple of kids went missing, that didn't matter too much, there were always seven others. In Giles they are all accounted for.

Giles knew all about moving 'upmarket' – and he didn't much like it. When he was ten, his family moved from their Victorian house in Islington to Edgware. It wasn't a question of escaping the slums, by any means: the Islington house was modest but comfortable, they all had their own beds and no one wanted for anything. Edgware, by comparison, seemed to have little to offer. Commuting became the order of the day: Giles's father took the Tube to his tobacconist shops and Carl had a longer walk to school. ('Different school – same hooligans,' he remembers.)

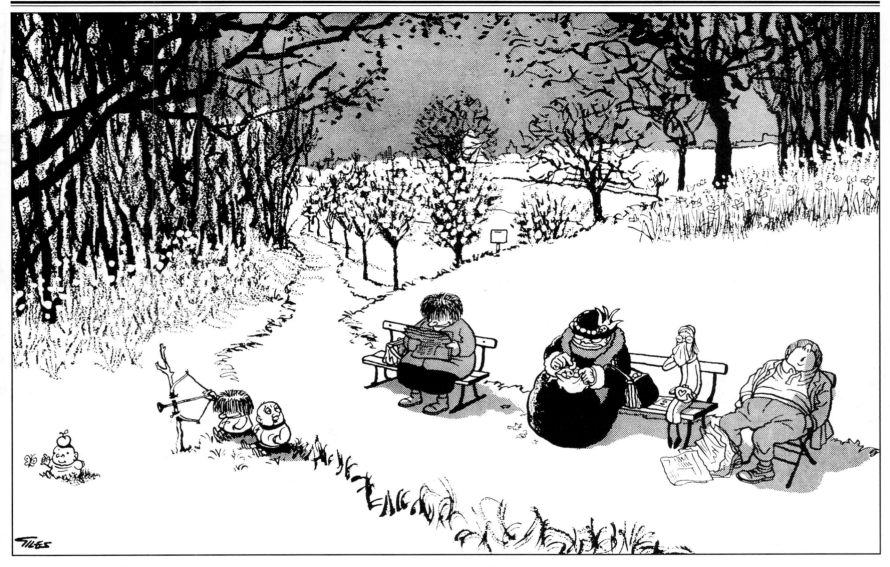

"They can feed me as many sex-educational films as they like—no one's going to convince me that our relatives had anything to do with sex."

Sunday Express, April 25th, 1971

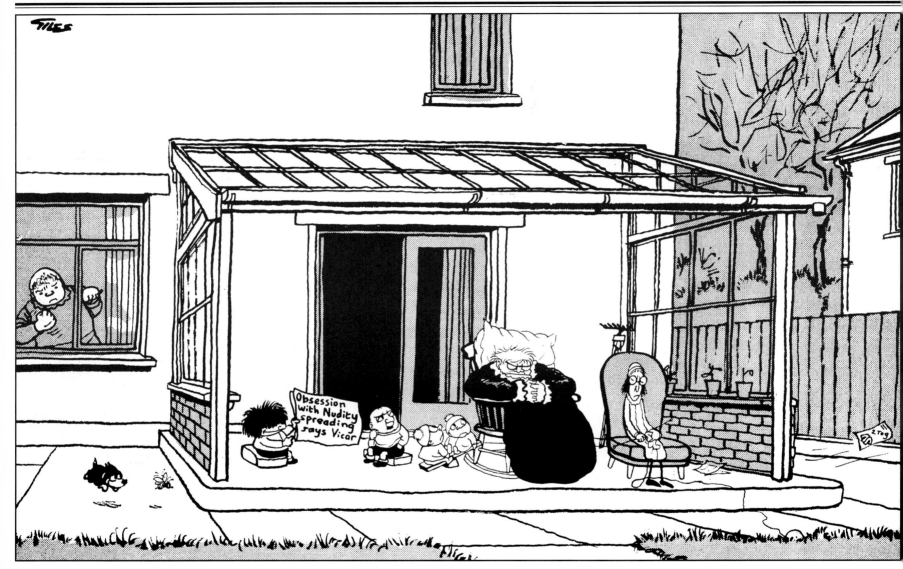

"I hope not. Oh boy, I hope not."

Sunday Express, April 5th, 1970

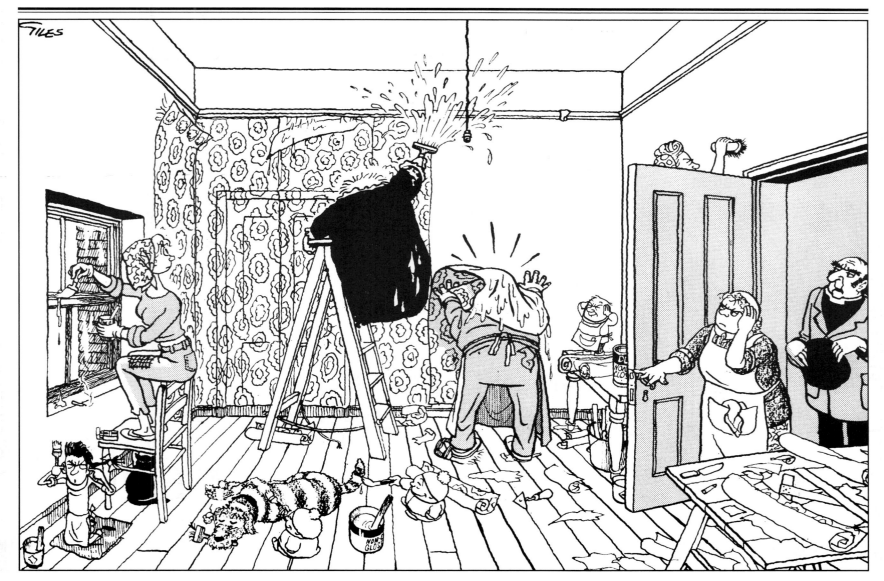

"As a matter of fact I did read that a doctors' journal said that swearing is good for you—but not that good."

Sunday Express, April 14th, 1974

He hated the sameness, the uniformity, the predictability of suburbia after the liveliness and variety of Islington.

In Islington we lived on a square. There was an area of grass in the middle protected by railings. You had a key if you lived round the square and could let yourself in. If you were on your own it was like your own grounds.

There was such a dullness about Edgware. And there was always this comparing of houses. If you had a drive running up the side of your place to a garage then you were something special. If you lived in a corner house, you were in Buckingham Palace.

There was a little patch of grass in front of the house and a bigger, rectangular patch at the back. And there was always a little woodshed, of course. I used to spend a lot of time in there. That's where I learned my DIY. I think I have some of those tools to this very day.

Suburbia, instantly recognizable: here it was that the Giles Family lived for fifty years, unchanging in essentials – though the garden shed, for instance, was to show a bewildering capacity to change its shape and size as its creator required.

The Giles Family has never aged; there have been no births and no deaths. The only evidence of procreative activity is the presence of existing members, particularly of the illegitimate twins, never old enough to begin wondering about their absent GI father – long returned to the States, perhaps to sire other cartoon children? Poor Vera and George the bookworm can surely not be suspected of continuing to enjoy any sort of intimacy – indeed, if we are to believe that baby George is *not* theirs, as surely we must, did they ever? – and while Carol frequently imports some suitor or other – mostly extremely unsuitable young men – one somehow imagines that these loutish figures sprawled

across the settee will never achieve much more than inconclusive fumbling. And Mother and Father are most probably too exhausted by the time their heads hit the pillow after an average day of chaos even to think about it.

For the Giles household is a paradoxical mixture of tedium and anarchy. There is little passion of any kind, bar Grandma's occasional rages; the lives of the Family are entirely absorbed by triviality. As Nicholas Garland, distinguished political cartoonist of the *Daily Telegraph* and lifetime admirer of Giles's work, says:

He deals in minutiae. There are no tragedies, there are no great events. Everything which happens is unimportant. It is all about small domestic issues concerning completely inconsequential figures in whose life nothing happens. It's about getting up and shopping and putting the dog out.

The Gileses live in a dull, boring street in which nothing goes on. But there is this amazing realism. And detail. And humour. And you are fascinated. It was said of Chekhov that he 'held life fluttering in his hand'. That's exactly what Giles does.

To say 'nothing goes on' may well be true on one level; but the other side of this routine existence is the domestic disaster that is invariably about to descend on the household. Inertia is always about to be rudely disrupted by mischief, sometimes chance mischief, more often carefully choreographed by one or more of Giles's little horrors. Take the scene in the Family kitchen during industrial action by electricians in 1954. Mother, pouring the tea for a lady neighbour, explains: 'The electricians' strike doesn't really affect us – Father does all his own electrical repairs.' There is steam hissing out of the radio and a broadcast from the BBC Light Programme coming out of the spout of the electric kettle. As Mother speaks, Father strikes a live wire in the fusebox and Vera, whose finger is on the light switch and who is carrying a twin, also becomes 'live'.

Daily Express, Nov. 7th, 1952

Preparing for the Daily Express *Four Day Rally. As a change from rolling thirty-six feet of mobile studio all over the country, Giles took his fourteen and a half feet of Jaguar XJ 120 on a similar journey.*

Giles Annual *cover 1983.*

Giles Annual *cover 1963.*

Giles Annual *cover 1987.*

"Wait till they get to the bit about peace on earth and mercy mild—then let 'em have it."

Sunday Express, Dec. 9th, 1945

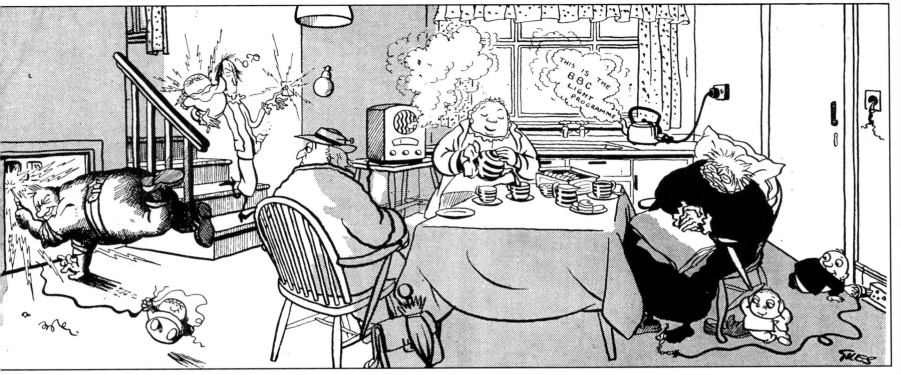

"The electricians' strike doesn't really affect us—Father does all his own electrical repairs."

Daily Express, Jan. 19th, 1954

Father, screwdriver still in contact, becomes airborne while Vera's glasses fly off and the twin emits small lightning bolts.

A casual reader might at this point chuckle and turn the page; but to do so would be to miss the central devilment. Grandma is asleep, the paper folded under her hands on her lap. The demonic partners Ernie and George Junior have stripped a couple of inches of flex and attached the naked wire to the toe protruding from the thick black stocking on her left foot. Ernie, eyes wide with sadistic glee, has the plug at the other end of the wire in his hand and is about to put it into the wall socket. Another second and Grandma will rise into the

air with a shriek, her hair standing on end . . .

. . . In the next cartoon she will be unharmed. As Keith Waterhouse observes,

They all lead charmed lives – like characters in 'Tom and Jerry'. There the cat gets squashed, stretched, impossibly twisted or blown up by a stick of dynamite, but always recovers in seconds. You see a kid sawing away at a branch up a tree on which his sister is sitting. You imagine the catastrophe, though you don't actually see it. However, no one ever has bandages. They all recover remarkably from what in true life would be the

113

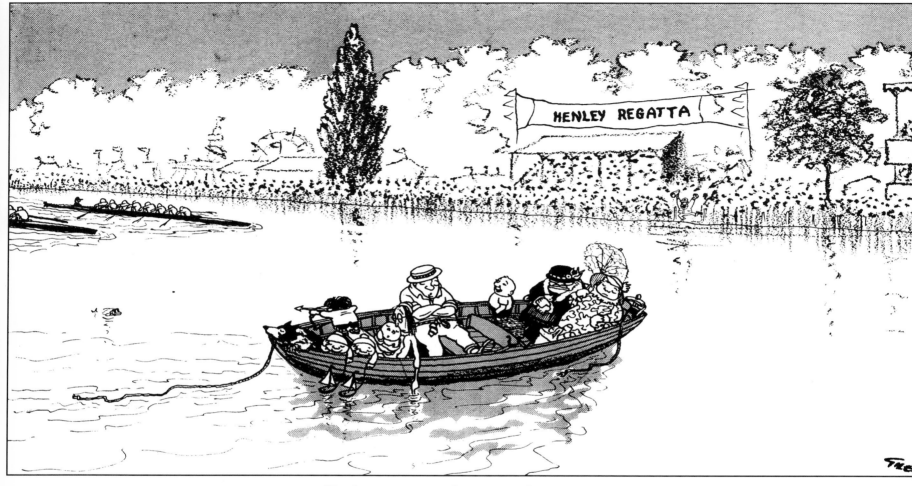

"Dad, as a matter of interest, who tied us up?"

Daily Express, June 29th, 1965

kind of injuries which put you into intensive care or Stoke Mandeville Hospital. Or the morgue. What makes it that bit more horrifying is the realism of the drawing. You really can – in graphic detail – imagine the scene. And then hear the sound of the ambulance coming down that road in Slough or wherever it is.

And see in the mind's eye Stinker, camera at the ready, waiting to freeze the moment.

Grandma

Grandma can be violent, wicked, cynical. She reigns by misrule. She turns everything on its head, though she is an old lady whom you cheer on.

'She routs thugs. She is tough. She doesn't have a romantic view of anything.'

Thus Nicholas Garland, political cartoonist of the *Daily Telegraph*, on perhaps Giles's best-loved character – the redoubtable matriarch of the unparalleled, unchanging, chaotic suburban household of the Family.

Grandma would sell her soul to the Devil, if he hasn't already got first refusal on it, for the winner in the 2.30 at Kempton. If she knew where the bank robbers had hidden their cash, she'd be there at three in the morning with her spade to retrieve it and down at the bookies with it a few hours later. What's more, she'd do the robbery herself if she could get away with it. She once even kidnapped the Chancellor of the Exchequer.

Entirely without scruples, Grandma has an unerring instinct for self-preservation (she'd have to, to have survived for so long among the hellfire youngsters of the Family): when a suspicious missive arrives for her in the middle of a letter-bomb scare, she puts a helmet on, settles herself behind a pile of sandbags and sends frail, snivelling Vera off to open the post.

Vera, indeed, seems to have a peculiar predilection for the company of this cantankerous, riotous old lady; surprising in view of the fact that one of the few things that can crack those granite features into a smile is Vera's discomfiture.

So why do we love this extraordinary old bat? One reason is her undoubted physical energies and endless display of surprisingly youthful skills. She is a confident horsewoman, quite prepared to get into the saddle herself to make sure that her fancy for the Derby gets a good start, and a pole vaulter of Olympic pretensions; she rides a motorbike like a Hell's Angel, sails a boat like Captain Bligh, can probably drive a tank, can almost certainly fight a bull, and can definitely toss a caber as far as a Highland giant.

All this activity naturally produces something of a thirst, and Grandma is the first down the Bricklayers' Arms to quench it with a quantity of Guinness that would lay a coachload of Irish punters out for a week.

But Grandma is also a patriot and a Royalist, sometimes the defender of the ordinary man (and woman) and frequently the scourge of petty bureaucracy, puffed-up authority and bourgeois sensibilities. No respecter of persons, she will lay about her with her handbag among the judges of the Chelsea Flower Show as readily as among officials in pursuit of parking fines or the poll tax. There is no fear in Grandma, and no humbug.

And yet she is also a domestic soul, often seen snoozing, with Butch the dog at her feet, snug by the fire. She even goes to church (though she is not above a spot of petty larceny come Harvest Festival). What's more, she has a few kindred spirits scattered about these islands: a Family visit to Blackpool has her bounding off,

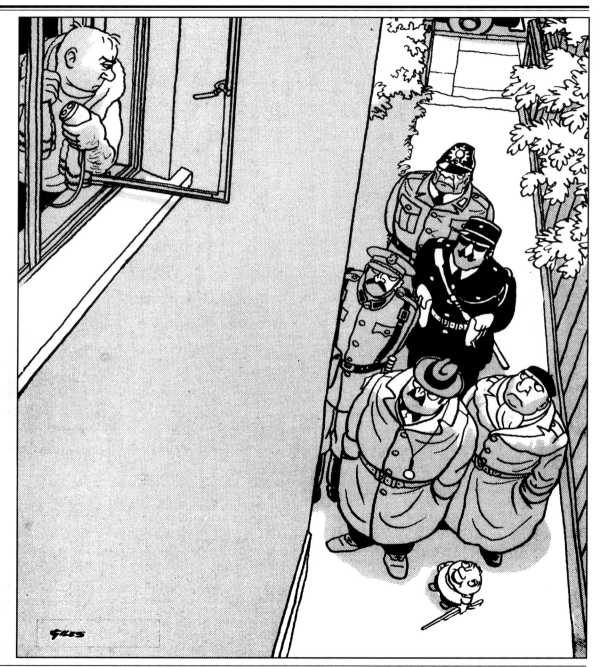

"Dad—Interpol want Grandma for hopping off from Spain without paying for her deckchair in 1926."

Daily Express, Sept. 10th, 1963

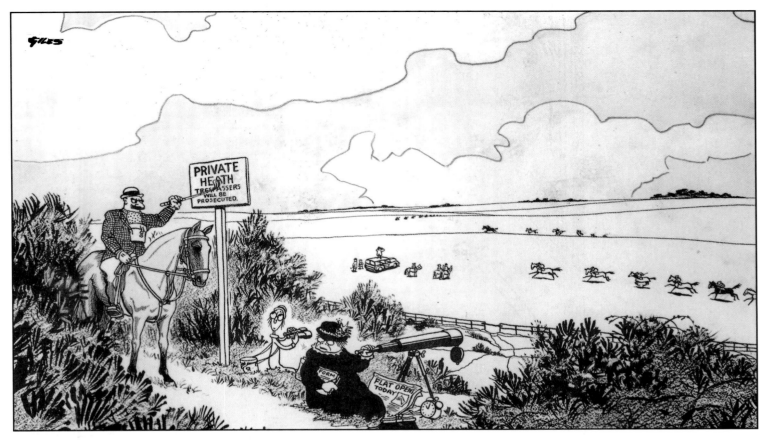

"Spying? You'd do some spying if you'd lost your old-age pension every week during the steeplechase season."

Daily Express, March 16th, 1950

umbrella gleefully aloft, to meet two identical (though umbrella-less) Grandmas scurrying out of a sidestreet to greet her. And there is an Irish Grandma, too – who could probably take the honours in the matter of Guinness consumption.

Where did Grandma come from? What are we to make of her?

For the cartoon genesis of Grandma we have to go back some way before the *Express* days, to a time when Giles was still drawing cartoons for *Reynolds News* – in particular, to a drawing of two flummoxed Tommies trying to explain to their officer the trouble they are having with a small, round, beaming, black-coated lady planted firmly between them: 'We say to her: "Friend or Foe?" and all she keeps saying is: "Foe!"' As the years passed, the white pinny over the coat went, as did the ingenuous smile; the face became reduced to a pair of National Health specs squeezed in between a ruffled white collar and the brim of the flat black hat, yanked on with force sufficient to keep it in place when

117

"Watch 'im Vera—he'll have your heart out and shove it in Mrs Harris before you can say Happy New Year."

Daily Express, Jan. 4th, 1968

This drawing touches on one of the more remarkable achievements of the century. A month earlier, surgeons led by Dr Christian Barnard had carried out the first human heart transplant at Groote Schuur Hospital, Cape Town.

"Anybody here ride the last horse in the last race?"

Daily Express, March 22nd, 1960

cheering home the winner of the 4.10. The flowers on the hat soon got flattened and were joined by a small cloth bird. The handbag took on stouter proportions and a padlock, and the armoury was completed by an umbrella of impressive proportions with a bird's head for a handle. It might be a duck, it might be a parrot, but whatever it is, its beak is quite large enough to cause actual bodily harm.

Many have asked about the inspiration for this awesome evolution. Did Giles ever know such a person? Surely not . . . All Giles will say is that there is a bit of both of his grandmothers in her.

At first sight even this seems improbable. Giles adored his family, and his grandmothers were no exception. The real Grandma Giles was a dignified, hansome Victorian matriarch, magnificently arrayed in a

"Nothing serious, Doc—that large bump on your right side is only your wallet."

Daily Express, June 7th, 1979

"Stand by for a fab bout of Blackpool hospitality, daddyo—here come two of Grandma's northern sisters."

Daily Express, Dec. 2nd, 1963

This is the genuine Grandma Giles whose husband, a jockey, had ridden for Edward VII. She was a fine woman, stern on occasions, but kind. She expected good behaviour and got it. However, when she was confined to a wheelchair and needed propulsion down the street she usually regretted asking grandson Giles to do the honours. He and a chum used to reach speeds for which the conveyance was not designed nor its passenger prepared.

"We say to her: 'Friend or Foe?' and all she keeps saying is: 'Foe!'"

Oct. 27th, 1940

This little lady, according to Giles, is his prototype Grandma. This cartoon was drawn for Reynolds News *in the early part of the war.*

bustle with white lace at her wrists. Typical of the best of her time, she was a lady of both grace and strength of character, with the combination of authority and kindness that commands affection and respect – and, on occasion, fear. Sadly, it seems the breed is now extinct.

Grandma Giles's husband Alfred, a jockey who rode for King Edward VII, had died at the age of fifty-three, and in Carl's youth she lived with two spinster daugh-

ters in Myddelton Square, not far from Islington. All the family dwelt within walking distance of each other.

'You behaved yourself,' says Giles. 'You wouldn't even think of trying anything on.

'Grandma Giles was a churchgoing lady and didn't drink, although she would have the odd brandy and Guinness for medicinal purposes. She was very strict but compassionate. She had a lovely gentle, slight smile.

Grandmother Clarke – known in the family as Nanny Clarke – was altogether less formal and a much jollier woman than Grandma Giles. Nanny Clarke, who was Giles's maternal grandmother, lived in Norfolk and her home was frequently visited by young Giles. There is not much about Nanny Clarke which could easily be spotted in the cartoon Grandma. Still, Giles insists that Grandma contains ingredients from both of these fine ladies.

"My Grandma says hang everybody."

Daily Express, July 3rd, 1956

And she was always Grandma Giles. You would never, never call her Granny. You respected her and you certainly never took a chance with her.'

Not, at least, when she was in her prime; when she grew older and less formidable, and was confined to a wheelchair by arthritis, the young Giles unashamedly took advantage of her weakened physical state. He was often asked to push his grandmother's chair from her house to one of her relatives', and this he did at great speed, sometimes making unnecessary extra trips round the square; Grandma Giles's knuckles would turn white as she gripped the arms of the invalid carriage, but 'She never complained,' says Giles. 'She was tough, one of a breed. She was proud and was not going to show any weakness to us little devils.'

Giles's maternal grandmother was a very different person – cosier, softer and jollier. Nanny Clarke, as she was known in the family, lived in Norwich, married to a quietly spoken, peace-loving insurance salesman – another vanished breed – in a house that constantly bustled with aunts and uncles, cousins, nephews and nieces. Carl would travel up from Islington to visit, and enjoyed it so much that he stayed there for long periods, even going to a local school.

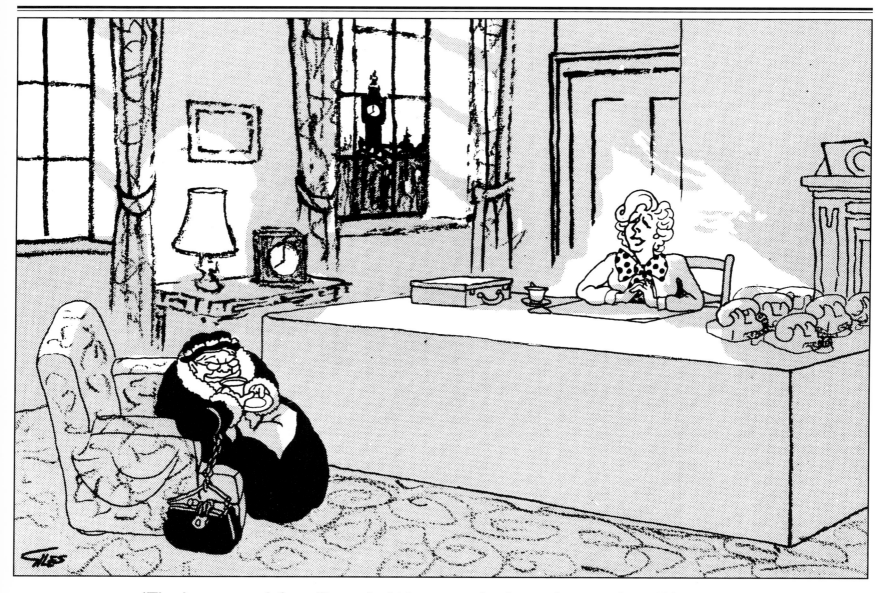

"Thank you so much for calling and advising me on the changes I must make in 1987. Now hop it."

Daily Express, Dec. 30th, 1986

Grandma gets short shrift from prime minister Margaret Thatcher in her prime.

Nanny Clarke was the kind of grandmother who was always making beds and cooking pies, puffing up cushions and mending holes in socks and jackets, washing and ironing, feeding and cossetting. She liked a social drink too, and enjoyed the sense of occasion when friends came to call. Giles remembers:

'She was far more extrovert than Grandma Giles and she had such a happy little house.'

But she too could be strict: 'Everything had to be done correctly and everyone had to have good manners and always go out properly dressed.'

Some suggestions of the Family's Grandma are here, it's true; but still, it's hard to see much of either of these two splendid ladies in the full glory of Giles's creation.

There is another theory.

'I have no doubt at all,' says Johnny Speight, the artist's friend and creator of his own monster in Cockney bigot Alf Garnett. 'Giles is there in Grandma, all the way through. She has his spirit and his mischief. She's the scourge of everything which Giles hates, after all – everything from VAT inspectors to traffic wardens get walloped. Of course he's Grandma.'

It's a notion worth considering. In some ways, in some moods, Giles even *looks* a little like Grandma. He has short white hair, glasses and a set of the mouth which can alter from impious merriment to ferocious disapproval within seconds. And he is no stranger to invective. He has a loathing of all the minor, pompous figures of authority who torment us all, from gas inspectors to traffic wardens – especially traffic wardens – to local officials, and a particular hatred of travelling salesmen. He regards anyone who comes uninvited to his door, be it a prospective Member of Parliament or a pale boy selling brushes, as a vile intruder. Sitting in his wheelchair in later days, he would send them about their business with a curse; Grandma would take a swing at the hapless invader with her handbag, a capacious satchel that some believe to contain knobs of church roofing lead.

Giles's many talents include proficiency in the saddle,

under sail, on a motorbike and behind the wheel of a car – just like Grandma. He likes the races. As does Grandma.

Most significantly of all, Grandma – for all her anarchic behaviour – represents an indefatigable toughness, a dogged determination, a peculiarly British stubbornness and refusal to be pushed around or done down: characteristics all shared, along with that taste for mischief, by the man who created her.

Giles has indeed had much to be stoical about of late years. At the age of seventy-six, long-standing circulatory problems meant that he had to have both legs amputated below the knee. Most men of that age, suffering such appalling misfortune, would have given up: not so Giles. There was much cursing during the period of therapy, and had Giles had Grandma's handbag at his disposal he would no doubt have aimed it at some of the heads around him; but he fought his misfortune and has now regained some mobility with the aid of a pair of artificial legs. Cussed, difficult, sometimes thoughtless, frequently bloody-minded: Giles and Grandma alike may not be the easiest of companions; but they will not be defeated.

Grandma won't even be beaten by Giles. Some years ago, her creator, like Dr Frankenstein, wanted to kill his monster off. He had actually said so, though he hadn't worked out how it was to be done.

The very thought was appalling. What could he have done? There was the time when she was nearly flattened by horses, tumbling and cartwheeling through the runners in the Grand National as she scampered across Aintree after a betting slip; but Grandma wouldn't be finished off by such a consideration. Lost at sea, perhaps? There is the cartoon of an ill-fated Family boating trip, where George is about to be decapitated as the mismanaged barge heads for a low bridge arch, and beside the boat a familiar hat is seen floating on the water, its cloth bird still jauntily undamaged – but hat and Grandma were soon seen reunited.

The scene in the funeral parlour defies description.

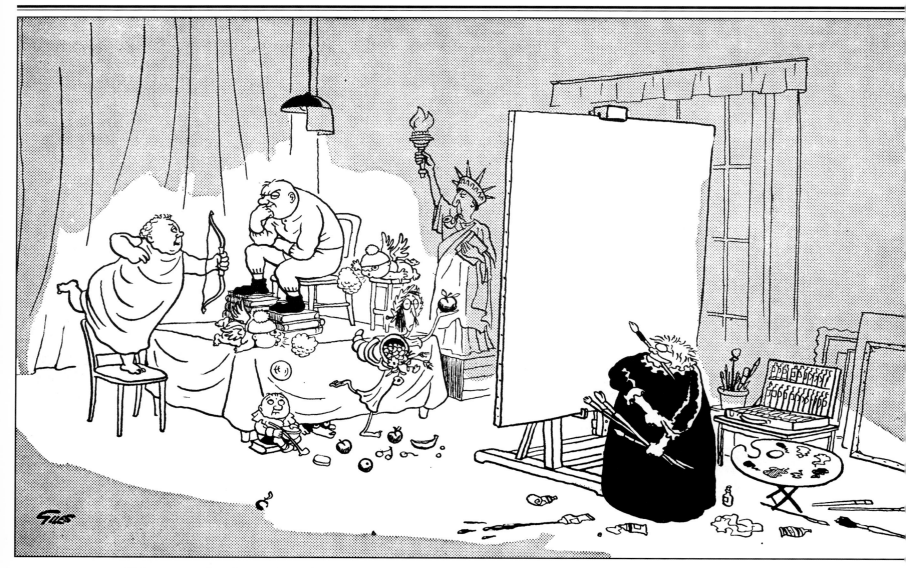

"That was a bright stroke telling Grandma there is a famous Grandma-artist in America who is 100 years old and didn't take up painting till she was 77."

Daily Express, Sept. 6th. 1960

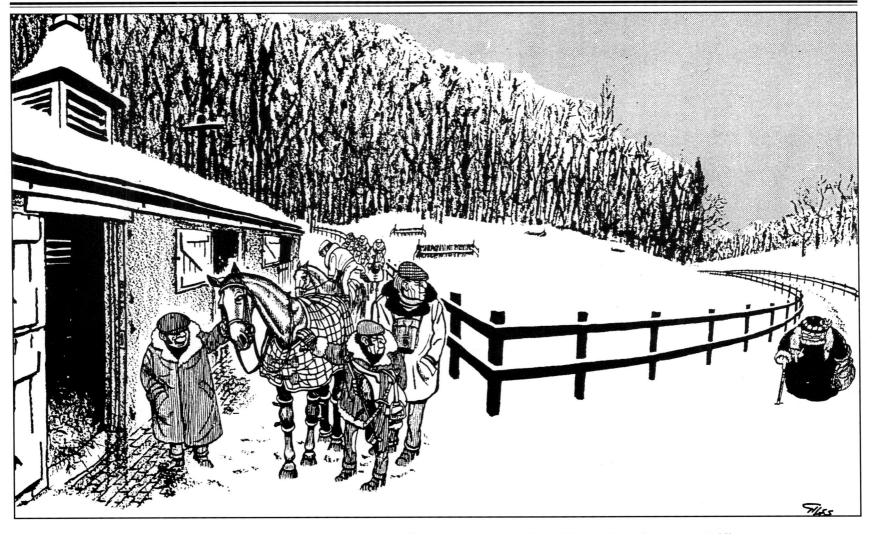

"Here it comes again—they didn't call off racing just for a bit of frost when she was a girl."

Daily Express, Feb. 20th, 1978

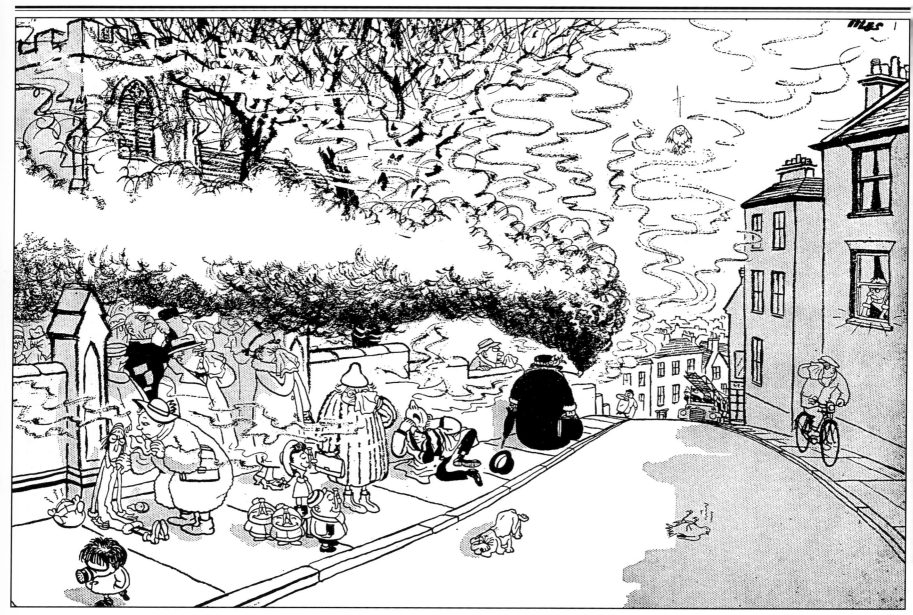

"Grandma, forty cigarettes a day for the last sixty-odd years haven't done you any harm—why change now?"

Sunday Express, March 11th, 1962

"Mum! Grandma's gone down behind the piano."

Daily Express, Dec. 28th, 1974

"I suppose you can even remember what they had before Coronation Street, Grandma?"

Daily Express, June 3rd, 1980

And what would have happened on the day of the interment? (Grandma would certainly not have been cremated.) There would have to have been a period of lying in state; but just imagine the mayhem that would have been created under the bed, under the coffin trestles, perhaps even (heaven forbid) *in* the coffin . . .

And the funeral itself? One can only speculate. Perhaps, like her hero Churchill, she would have made her last journey down-river, on a magnificent barge (better driven, one hopes, than the Family manage on their watery holidays). The Queen would have worn black . .

But it was not to be. The news of Grandma's impending demise caused outrage. There was an outcry, followed by a reprieve. Grandma lives on to terrorize Gilesland with renewed energy.

EPSOM

'Bloody Women'

Carl Giles is an artist: a brilliant draughtsman, an inspired cartoonist. A joy to be with when in full and merry flow in convivial company, a fascinating, charming and hilarious observer of the world, a magnificently generous host – and also often appallingly crotchety, sometimes a dark and snarling beast, letting off steam and energy in a shout of rage, a sudden, ferocious burst of bad language. A genius.

It is one of Giles's great good fortunes – and his fortunes have been fairly extreme, of both kinds – that he found the most suitable partner and lifetime supporter imaginable in the strong, practical, loving, steadfast, courageous Joan Clarke. She was there almost for ever, since they grew up together as cousins and friends; and from the time when Giles, then in his seventies, suffered the amputation of both legs and was confined to a wheelchair, to Joan's death in 1994, he was totally, utterly dependent on her.

'JOAN!' he would bellow. The whole house would seem to reverberate; birds rose, calling, from a neighbouring spinney. And from somewhere a few rooms away would float over the reassuring: 'Coming, Carl.'

Carl was wont to say of Joan: 'She transports me.'

'Why?'

'Because she is my elevator.'

Giles did not always speak of, or indeed to, his wife in tones of such lyrical appreciation. As war approached in summer 1939 Carl and Joan – at that stage still just friends and cousins – were both working

in London, Giles drawing cartoons at *Reynolds News*, Joan as a secretary with the *News Chronicle*. Their discussion of how Giles rushed the news of the outbreak of war to his parents would take a characteristically irascible turn.

'I ran all the way to Edgware,' he would recall proudly.

'What utter nonsense,' Joan would say from the kitchen door. 'It's ten miles.'

'I tell you I ran,' her husband would shout. 'And it's not ten miles. What do you know?'

'You drove, Carl,' Joan would insist, waving her teatowel in frustration. 'You had a small sports car. You drove.'

'What would you know about it, woman?' he'd yell grumpily. 'Bloody women.'

Joan's head would appear round the kitchen door again.

'Because I was there.'

In the early years of the war Giles was prevented on medical grounds from joining the fighting forces abroad, having half-deafened himself in a motorcycle accident, so contented himself with service in the Home Guard alongside his daily work in Gray's Inn Road. After work he and his mates from the paper – Alan Hutt in his beret; Monty Slater in his huge, enveloping raincoat; opinionated Gordon Schaffer – would congregate at one of their favourite drinking holes. And at some point in the evening the pub door would open briefly and into

"Your Missus would give you 'Vive La Belgique' if she was to come round the corner."

Daily Express, Oct. 11th, 1944

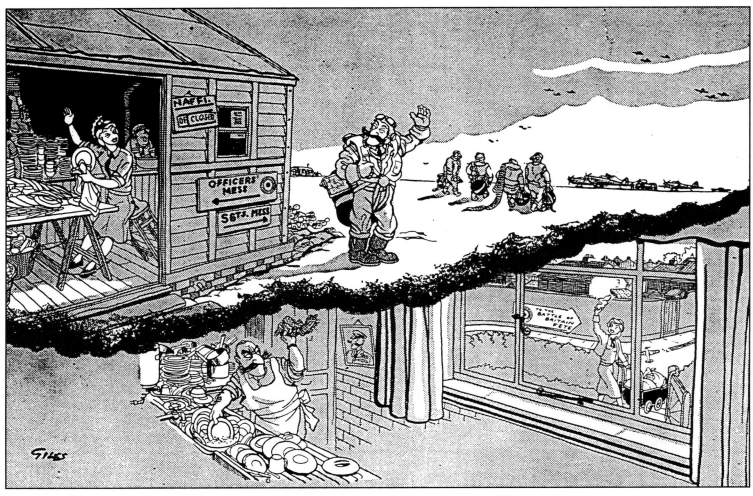

1940 . . . Battle of Britain Week . . . 1951

Sunday Express, Sept. 9th, 1951

the fug would slip a slight figure in her early twenties: to Giles, 'the prettiest girl I ever met in my life'.

Joan used to describe how, every day after work – except when she was on the late shift – she would don her coat, tidy her hair, put on a touch of lipstick and make her way, ducking and diving if a raid was in progress, up Gray's Inn Road to the pub where Giles and his cronies were to be found. Bombs and incendiaries were not going to keep her from the side of the man she wanted to be with; she had idolized him as a child, adored him as a teenager, and now loved him as a romantic partner.

Giles described Joan as 'the prettiest girl I had ever seen'.

'Romantic partner!' scoffed Giles from his wheelchair, when the two were discussing this period. He called out to her: 'In the Blitz, were we romantic partners?'

Silence; Joan was outside.

'Where is that bloody woman?' growled Giles.

Joan returned. 'Yes, Carl, what do you want?'

'Were we romantic partners by the Blitz?'

She laughed. 'Well, I think we were by then.'

Giles considered this for a moment. 'Well, I know you drank like a bloody fish.'

This was so patently ridiculous that Joan simply laughed again, shook her head slightly and went back to whichever part of the daily routine she was about when summoned.

At any event, no one who knew the pair at the time was in any doubt that Carl Giles and Joan Clarke were very much in love. However, their romance very nearly didn't make it to the altar.

Both Carl and Joan lived and worked in one of the most dangerous areas of London, outside of the docks. Joan's home in Great Percy Street, where Giles's aunt frequently put him up, and the offices of *Reynolds News* just a few hundred yards away, were both in the almost straight line that joined London's main railway stations, each a primary target for the Luftwaffe.

On 16 April 1941 Giles was working at his desk in the office near King's Cross as the first wave of German bombers approached. That night, five hundred aircraft were to drop 100,000 bombs on the capital in one of the worst raids of the entire war. Giles worked on, engrossed in his task and, like his colleagues, resolutely refusing to take any form of cover. A stone's throw away, Joan, by now engaged to marry Carl, was attempting to sleep on the ground floor of her mother's house. In the basement flat, taking shelter under a table, were Joan's mother Agnes and three of her aunts. As the bombs shook the foundations, Agnes called upstairs and persuaded Joan down to join them.

All of this, of course, was nothing new. By this time people had established their routines; the Clarke/Giles family, like so many others, would sleep if it could and if it couldn't would pass the time playing cards and extracting as much fun as possible from life in such constrained circumstances. When he wasn't working,

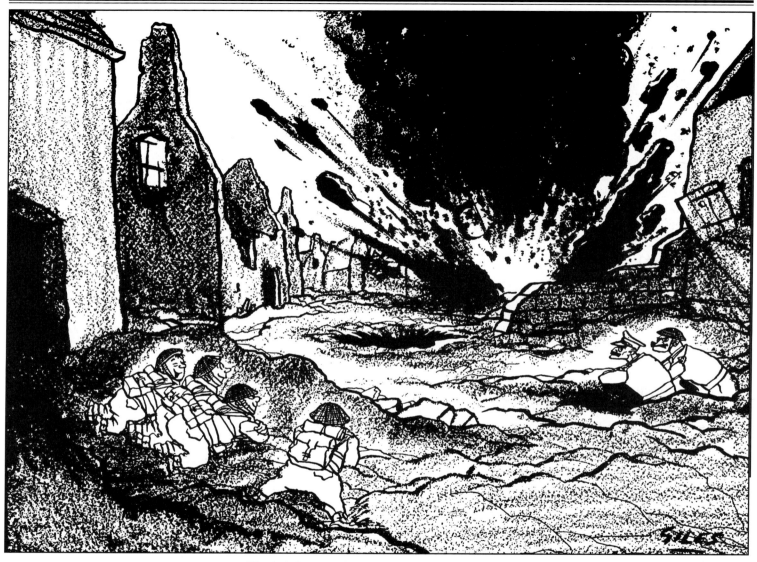

"Bang! And there goes the officers' mess."

Sunday Express, Nov. 5th, 1944

"Catch, Eddie!"

Daily Express, Aug. 8th, 1945

Giles would often join the women in their late-night card parties, enlivened by much laughter and even modest gambling. Giles recalls:

'I can remember Joan's mother – a marvellous little woman and very, very funny – sitting under the table when the bombs got a bit close, and keeping her hand up on the surface so that she could protect her little pile of money from any rival hand which might shift a bit of it round the table-top.'

'Little' is one of Giles's favourite terms of endearment, denoting something that arouses both affection and amusement. However, on this particular night even Giles would have found it hard to be amused by what happened next. The crashes of the falling bombs got nearer and nearer, becoming terrifyingly loud. They were coming down the street.

Two of the bombs fell either side of the Clarke home, one in the back garden, one in the street. The house was demolished. Masonry, timbers, bricks by the ton cascaded down the floors on to the cellar ceiling.

When Joan was alive her own memories of the disaster were clear. 'I was protecting my mother's head,' she would recall. 'I had obviously just grabbed her as the bomb hit.' The five women were shocked, shaken and covered in dust, but otherwise unharmed. That was one stroke of luck. The second was that the blast had blown open the door of the room; the mains had burst, the cellar was rapidly filling with water, and but for that they would all have drowned.

Joan, Agnes and the others scrabbled their way up into what had been Great Percy Street. As Joan would recall, 'There wasn't really a street there any more. The sky was lit up with all the fires and the bombs were still falling.'

"We chained Grandma up to celebrate the Suffragettes anniversary and Butch has swallowed the key."

Sunday Express, July 2nd, 1978

"What d'you mean 'Everyone will laugh at 'em?' May I ask just who the hell's going to see 'em?"

Daily Express, Dec. 12th, 1974

"Mum! Cyril's wrote a wicked word."

Daily Express, Nov. 14th, 1950

The Korean War had begun.

"If we're going to have this performance every time you canvass the discos we're going to forget capturing the younger votes, my boy."

Daily Express, April 17th, 1979

Air raid wardens helped them over a bomb crater, some planks having been ripped from a ruin to make a precarious walkway, and ushered them away to an area of relative safety. Deeply shocked but staying calm, the women walked down Amwell Street into Lloyds Square and with relief found themselves outside the reassuring door of the local convent.

The caretaker, who knew Joan, answered their knock and invited the shivering little group inside. An instant later there was a swish of robes, announcing the arrival

"Ah! There you are Harold—the new Minister for Marriage has popped in to see us."

Daily Express, Feb. 1st, 1979

on the scene of an imposing nun, presumably the Mother Superior.

'Who are these people?' she demanded.

The caretaker began to explain.

'Well, they can't stay here,' pronounced the woman of God.

And so the ladies were ushered back into the street. Eventually they found refuge with a relative.

At *Reynolds News*, Giles had realized that this was a particularly bad night, and that Great Percy Street had been in the path of the bombers.

'The thing was you usually got used to it,' he says. 'I

144

Giles Annual *cover 1990.*

Original artwork for Giles Annual *cover 1977.*

Giles Annual *cover 1984.*

Giles Annual *cover 1989.*

Giles Annual *cover 1956.*

Original artwork for Giles Annual *cover 1980.*

"I bet Ringo's dad didn't make him practise down the bottom of the garden."

Sunday Express, Feb. 23rd, 1964

mean, it happened every night, and you could set your watch by them. You would say: "They're ten minutes late tonight." But that particular time it was bloody terrifying. Eventually I left the office and made my way slowly to Joan's house, ducking and diving in doorways.'

In the morning, the women returned to what was left of their home. Joan tried to telephone Carl, but the lines were down.

'We sort of bumped into one another,' says Giles, 'almost by accident. There she was in the street looking awful. I'd seen the remains of the house and felt they must have all been killed. There was no one you could ask – they were all too busy looking after themselves.

'Joan wasn't hurt, as it turned out, but the doctor said she was suffering from nervous disability. But then that covered anything in those days. Her nails went black, I remember.'

As for what Carl said to Joan when he found her alive and relatively OK –

'Oh, I don't remember,' Joan would say, 'something rude, I expect.'

Carl readily recalls the comical aspect of that morning, as the family scraped together what they could of their belongings from the rubble.

'I was looking into a hole in the pile of bricks and thinking of going in,' he says, 'and suddenly I saw this little figure coming out. It was Joan's mother, Agnes.

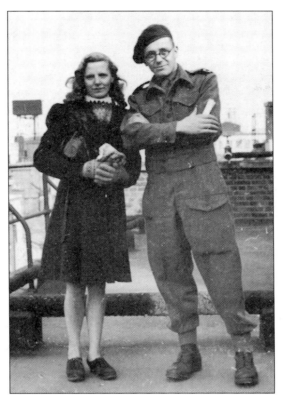

There was no photographic record of Giles's and Joan's wedding. The snaps didn't come out. But here is a picture taken on top of the Daily Express *building in Fleet Street of the couple at the time that Giles was sent off to war.*

She really was a very little woman. She was a jockey's daughter.

'They had hoarded lots of tins, and they were all down there in the water. So the labels had come off. You can imagine, all those tins and not knowing what was in them. You had tomato soup when you wanted peaches. For months.'

Agnes was not to be daunted by her smirking son-in-law. She emerged from the debris with whatever she could retrieve, and asked each of the others to take what they could. The odd little group then went in search of a room to let. Agnes had bought some lengths of string which she tied up from wall to wall as makeshift washing lines; on these their possessions, mostly drenched and filthy, were hung up to dry.

'There was no point, really,' Joan used to say, 'But my mother wouldn't be beaten.'

After this catastrophe had broken up the Great Percy Street household, Joan and Agnes stayed for a while with Joan's brother Terry in Enfield, north London, before moving to a new flat in Finchley. Giles continued to live with his parents in Edgware; the couple occasionally stayed together in one place or the other, all parts of the Giles/Clarke family offering open house to all the others as they had always done.

On 14 March 1942 Carl Giles and Joan Clarke were married at St John's Church, East Finchley. From there the single extended family of the bride and groom made its way to Agnes Clarke's home for a noisy reception

145

"Grace Kelly's got one thing at her wedding I'm glad I didn't have at mine—you in a top-hat."

Daily Express, April 11th, 1956

Giles was invited to the Monaco wedding of actress Grace Kelly and Prince Rainier.

where Home Guard soldiers and Finchley neighbours mixed with left-wing journalists from *Reynolds News*; then the couple were driven to Liverpool Street Station to catch the train for their honeymoon destination, the Great White Horse Hotel in Ipswich, the town near which they were to live in one place or another for the rest of their married life.

Even the honeymoon hotel had its air of Gilesland absurdity: 'We stayed in the Dickens suite,' Joan would recall. 'I remember it had two four-poster beds.'

Two and a half years after their wedding Joan had to wave goodbye to her husband as he set off for the

Front as war correspondent for the *Express*. Their parting was not an emotional one; their relationship wasn't like that. Joan, a perfect example of that archetypal British woman of the thirties and forties, waving stoically, never shedding a tear in public, said: 'Take care.' And that was that. But they missed each other.

It seems somehow fitting that Giles should have married within his own family, for he had always been happy there. With all its various branches, all its confusion of uncles and aunts, nephews and nieces, first, second and third cousins, there is no suggestion of real

"Cheer up, Vera—America'll soon come up with one bigger than that."

Daily Express, Sept. 16th, 1964

acrimony, of any bitterness or genuine hatred, anywhere. What there was, though, was a rich variety of characters spread out before the budding artist, offering material for some of Giles's most endearing creations. Vera, for one: the thin, bespectacled, put-upon daughter-in-law of the Family, married for some inexplicable reason lost in history to Father's bookish son George, always visiting the chemist for pills and potions, ointments and expectorants, lozenges and mixtures, seems to be a combination of all kinds of suffering ladies from the cartoonist's youth.

'You basically identify Vera with aspirins,' he says. 'You always remember women like that from your childhood who were taking aspirins – for everything, it seemed.

'But they were also women who smelt of surgeries. Wintergreen ointment, I remember, was a particularly powerful smell. And whenever you went past you would smell other things – embrocation and camphorated oil.'

Vera, it will be noticed, always takes her pill bottles back to the chemist to be refilled.

'That's what I used to have to do,' says Giles. 'Take empty pill bottles back for filling up by the chemist. It was always for aunts. No one else.'

Giles was born into a well-ordered household where love and discipline ruled jointly in a rare and admirable balance. He adored his parents, whom he remembers as 'quiet and decent and loving'.

This is not, of course, to say that everything was endlessly peaceful, certainly not where Giles was – or is – concerned. It sometimes seems that he has spent a happy life putting all of those he loves, especially the women, to regular and exquisite torture.

Consider his little sister, Eileen, younger than Carl by six years.

'I remember when Eileen was born,' says Giles, recalling the days in Islington in the early twenties. 'My mother would be breast-feeding her and I would howl the place down because I couldn't have the other one. I used to resent this priority always given to my little

148

Giles as a baby.

sister. My mother used to fight me off – my father used to be called in to pull me away.'

Eileen paid for it later. Giles put all her toys, all her dolls and teddy bears, through the household mangle. No sooner had each precious new addition to her toybox made its appearance, at Christmas or birthday, than it would reappear, mercilessly and monstrously flattened by the rollers. Tubes of paint suffered the

E.M.G.

circa-1922-1930.

This charming illustration was commissioned by the government for a mental health booklet in 1955.

same fate. Eileen, horrified, remained mute.

'She never told anyone,' recalls Giles, still hugely entertained by the memories, 'because I made her believe that I was a friend of God, and that if she told Mum, God would tell me.'

There was more.

'When we played I didn't want to be bothered by her, so I put her up on top of one of those red pillar boxes in

(ABOVE LEFT) *When young Giles went out into the Islington streets to play with his chums, he was invariably followed by his worshipping sister, Eileen. Inconvenienced by her toddling presence, he would place her on the nearest scarlet pillar-box. She was unable to get down, of course, and would remain there in mute terror.*

"Which goes to prove that even if you don't think they're all little Florence Nightingales don't let them hear you say so."

Sunday Express, July 11th, 1971

the street. It was too high for her to get down. She just sat there with her flat teddy bear. She never objected. She never even cried. She knew God was watching.'

When she was old enough, she would be sent shopping with her brother. On the way home, Carl would throw the carrier bags and packages of meat and sausages into any garden where there appeared to be an unfriendly dog. Every time Eileen would bravely retrieve the food, often just escaping back over a hedge or wall with slavering jaws nipping at her bottom.

Nor did the torments cease with adulthood. When Eileen gave birth to a daughter, Giles marked the event

150

"I don't think Henry was wise to say now they've got extra pay he will expect extra service."

Sunday Express, June 13th, 1965

with an outrageous private cartoon showing Eileen's four-year-old son swiping his new sibling into the air with a cricket bat.

And yet, over sixty years on, Eileen and Giles are clearly still deeply attached to each other. Eileen lives quite close by with her retired husband and comes over regularly for tea. As often as not she will find her brother in grumpy mood, typically complaining about a door-to-door salesman.

'Women, they're all the same,' he will say.

'What have women got to do with it?' says Joan, pouring milk into the teacups. 'It wasn't a woman, it was a man.'

'Well,' says Giles, 'if it wasn't for you bloody

151

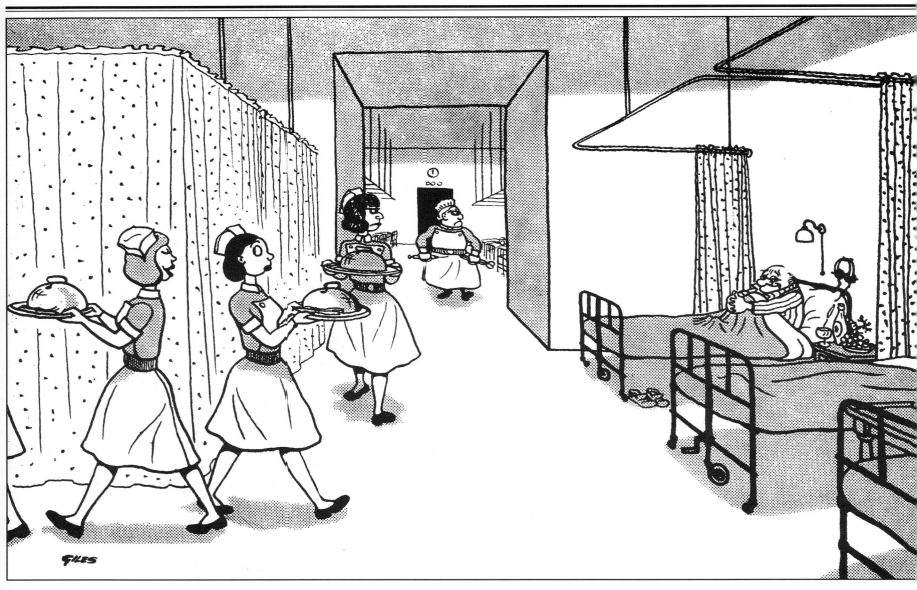

"In the event of power cuts watch out for Lover Boy in the corner."

Daily Express, Jan. 10th, 1963

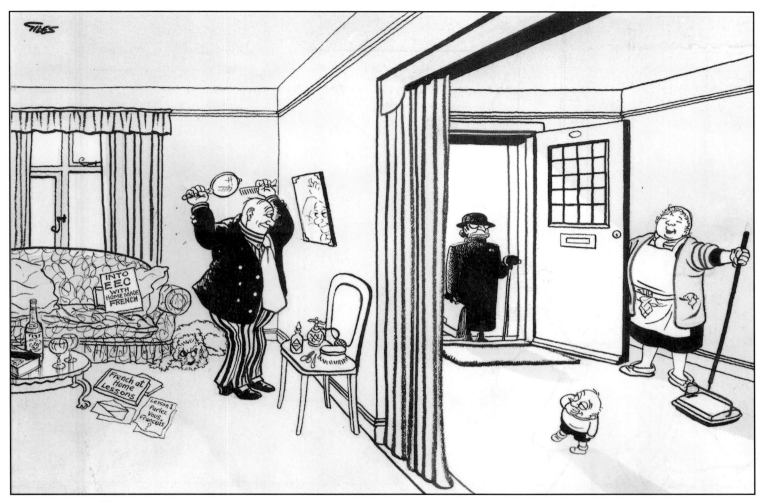

"Allee Oops! Mademoiselle Suzie de Pompadour is here to begin your 'Learn-French-at-home' course."

Sunday Express, Nov. 14th, 1971

women, these people wouldn't bother to call in the first place.'

Eileen places a hand on Carl's shoulder, surprising him. He looks round, his poor eyesight causing half a second's delay in recognition. Then he grins with pleasure. 'Hello, mate,' he says.

Eileen is an attractive, well-groomed lady who smiles a lot. Like all the other women in Giles's life she has such a deep affection for the man that she is prepared to put up with almost anything – although, like Joan, who had to put up with more than most, she is quite able to assert herself unobtrusively if necessary.

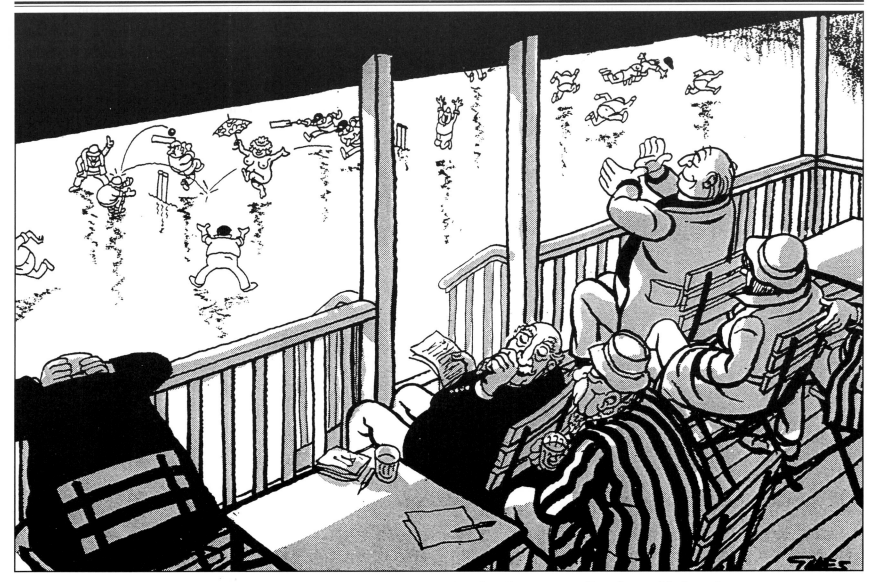

"Heaven knows our game could do with a streaker, but I'm not sure Vicar's good lady wife
is quite streaker material."

Sunday Express, June 8th, 1986

The streaking vicar's wife causes mayhem on the pitch.

Giles will be cheerful and amusing for a while and then, without much warning, turn to venom. At one such teatime he takes it into his head to inveigh against nurses. This is a surprising choice of target; in his various brushes with the medical profession he has had much cause to be grateful to the nursing staff, and they are drawn with affection in many of his cartoons.

'What is it about the British, always going on about nurses – they're useless half the time,' he rages from his wheelchair by the French window.

'They've done a lot for you, Carl,' Eileen says.

'Done what for me? What do you know? You're all the same. Women. Bloody nurses, you'd think they were all without fault . . .'

Tea arrives and Carl continues to complain. He turns his ire on Joan, accusing her of jabbing him in the stomach with his teatray. Eventually, Joan picks up a jug of thick cream and asks sweetly:

'Do you want me to pour this over your head?'

Now Carl, quite suddenly, is smiling broadly. Eileen sips her tea.

'Honestly, what a fuss,' she says.

'You watch it, mate,' says Carl, pointing a teaspoon at her. 'Just remember that you're under the same contract now as you were when you were two.'

Eileen doesn't look much alarmed at this, but it is clear that she remembers the terrors of childhood with no difficulty at all.

Carl can be short-tempered, impatient, unreasonable and, on occasions, absurdly intolerant and self-indulgently hostile – not only towards the women around him, it is true, but it sometimes seems that they come in for more than their fair share. But he is a man with an immense and generous capacity for love. He may not show it very well, for he is not a demonstrative man in that sense; but he has a natural, deep and ineradicable affection for those people who have proved their worth, and a deep love for the best in humankind; even, at moments when he can overcome his inclination towards atheism, a profound desire for faith.

'I would just so love there to be a God,' he says, 'so that I could have someone to thank. There is so much to be thankful for.'

And, as he knows only too well, dominant on the list of what he has to be thankful for are the 'bloody women'.

For Those Set in Authority Over Us

One evening in the early days of the Second World War, Giles was driving his black Humber along the Suffolk roads near his home, headlights reduced to mere slits of yellow in accordance with blackout regulations. Suddenly he became aware of a figure stepping out of the shadows into the road the other side of Tuddenham bridge. As he approached it, he recognized Cyril Girling, a drinking mate of his and now Tuddenham's new special constable; he had seen Cyril earlier that same evening in The Fountain, preening himself in his smart new uniform and drumming his fingers importantly on the bar.

Cyril was now waving his hand at the car, palm downwards.

'The bugger was flagging us down,' says Giles. He recalls how, with a mixture of curiosity and irritation, he stopped the car beside his friend. The new special constable slowly unbuttoned his tunic pocket and removed his notebook and pencil. He then licked the end of the pencil, observed it with deep satisfaction, and pushed his face close to Giles's.

'Name, please, sir.'

Giles was dumbstruck.

'Identification, please, sir,' persisted the special constable.

Giles found his voice. 'But you know who I am, you silly sod!' he yelled.

'I'm sorry, sir, but it is my duty to ... '

'Bugger off!' shouted Giles, gunning his engine, squealing his tyres with ferocious indignation and shooting off into the wartime darkness.

As Joan would recall, 'You were really ruthless with him.'

'Silly sod,' repeated Giles, his fury unabated even half a century later.

The one thing above all else that has always driven Giles to rage is the misuse of petty authority. His cartoons bristle with this indignation, whether in the form of Grandma laying about some pettifogging bureaucrat or in the Tommy's revenge on the colonel, finally settling with especial venom on that quintessence of minor officialdom, the traffic warden.

By the time Giles joined the *Express* in 1944 his impatience with pomposity had already been fuelled by several years in the Home Guard. Wartime, of course, offered almost unlimited scope to those who took a uniform of any kind, topped with a helmet, as reason to assume all sorts of airs and graces. On the Home Front, all sorts of hitherto humble individuals suddenly found themselves possessed of such awesome paraphernalia as a whistle and a notebook, and lost no time in acquiring the officiousness to go with them.

Giles, who in these early days of the war divided his

"Forgive the correction, but I'm NOT a — Monte Carlo Rallyist cluttering up the — highway.
I'm an examiner and this is Mrs Farquharson-Smith about to fail her test."

Daily Express, Jan. 23rd, 1958

"Ahoy there, men—abandon ship."

Daily Express, Jan. 8th, 1970

time between London, a family home in his beloved East Anglia and, after his marriage to Joan, a farmhouse outside Ipswich, was attached to the Middlesex Regiment of the Home Guard. Here he came across men who should not have been in charge of a bicycle

shop, let alone the men charged with defending the nation from invasion.

He recalls: 'There was this funny little man called Lewis with glasses and what looked like a First World War moustache. He had no rank at all, but he loved

"We're parked on a double yellow line."

Daily Express, Dec. 29th, 1970

dressing up in his uniform. Some of us thought he might sleep in it.

'Whoever you were you had a chance to lead the platoon. And Lewis couldn't wait for his turn. Off we would go, with Lewis shouting orders from the front as if he was changing the guard at Buckingham Palace.

"Byyy the riiight!" he would yell. "Quiiick march!" He would then march us all round Edgware. It took hours to get back because he kept leading us the wrong way up streets and would get lost. Imagine being lost with a platoon in the middle of Edgware.

'He wouldn't admit he was lost, dismiss us and let us

The Royal Commission on the Police reports that there is insufficient readiness on the part of the public to help the Police.

Sunday Express, June 3rd, 1962

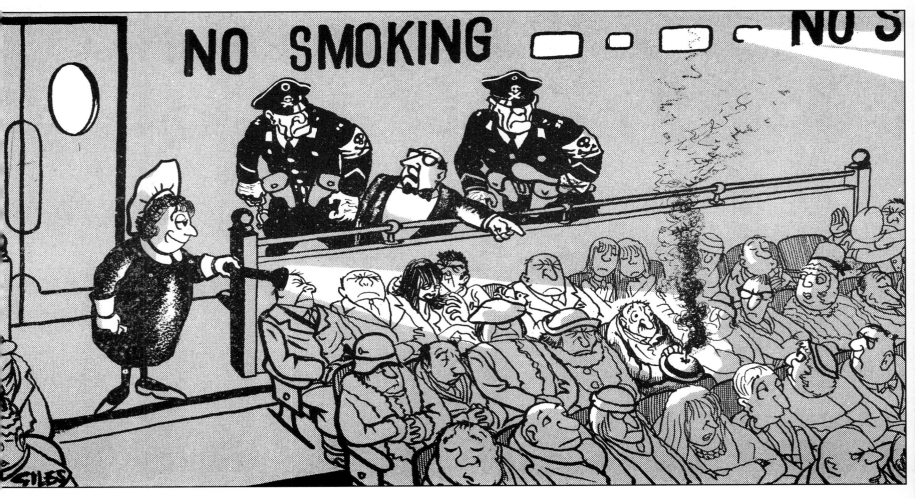

"Take him away! The one with the smoke coming through a little hole in his hat."

Daily Express, May 7th, 1964

Giles has always had a deep loathing for uniformed authority figures.

all find our way home for some tea. We just marched on and on, often passing the same row of shops three times in a period of half an hour. "Riiight turn!" he would be shouting all importantly, and he wouldn't have the faintest idea where he was off to.'

Not all of the buffoons of the Home Guard, of course, were ridiculous out of overweening self-regard, and Giles, as ever, had the compassion to tell the difference between the puffed-up and self-important and those who simply weren't up to their new role. Among

161

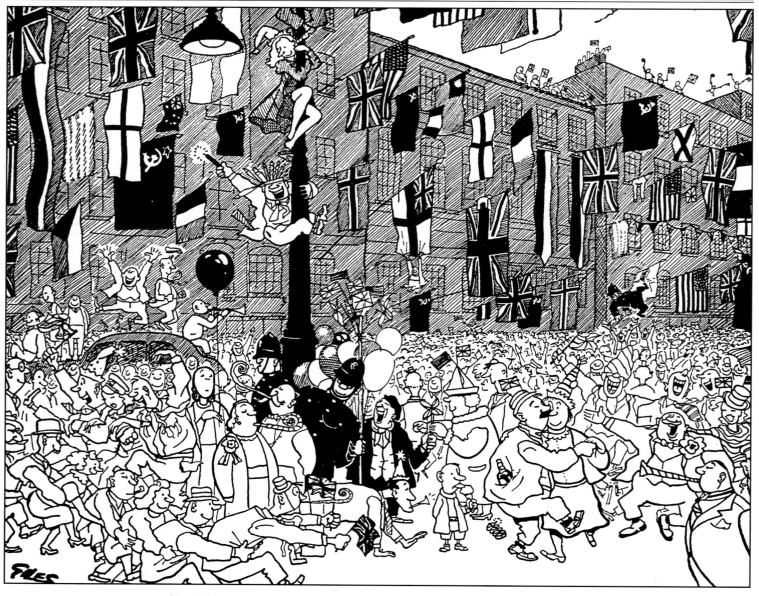

"Be funny if the siren went now, wouldn't it?"

Sunday Express, Aug. 19th, 1945

London celebrates VJ-Day (victory – the final victory of the Second World War – over Japan).

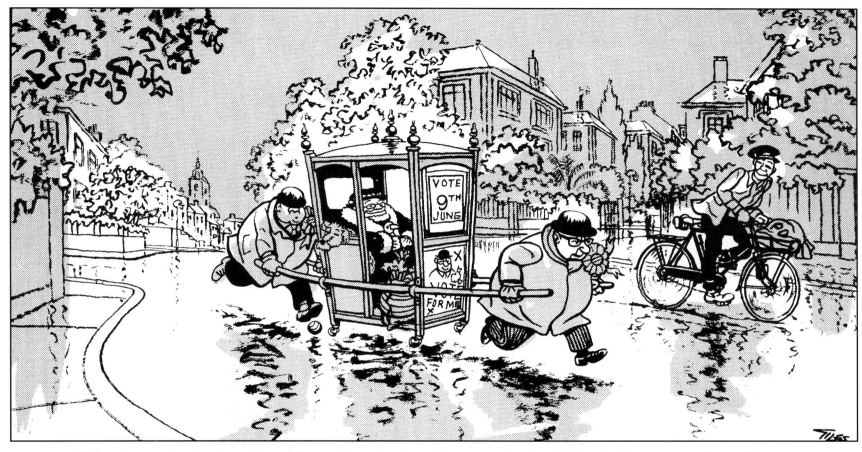

"After lugging her backwards and forwards to the shops for a month, the old bag had better vote for me!"
Daily Express, June 7th, 1983

the latter he remembers with affection old Reg Hill, not only the local sergeant but also the diligent and kindly insurance man of Agnes Clarke, Giles's aunt and soon to be his mother-in-law.

It fell to Reg to take his men on regular training exercises, which involved quite hard physical work – pack drill, running, press-ups – to prepare them for the worst. Reg tried his best; but the obstacle course was just too much.

'We had to charge with full pack and rifle and quite literally run up this vertical wall,' recalls Giles. 'Reg was a wonderful insurance man, but this particular challenge was quite beyond him. He was supposed to show us the way, but every time he ran at the wall he just sort of crashed into it and fell down in a heap. Meanwhile, there were some old boys leaping over him and running up the thing like gazelles, vaulting over the top with the ease of teenagers. Reg, our leader and inspiration, just kept on crashing and blundering about on the other side.

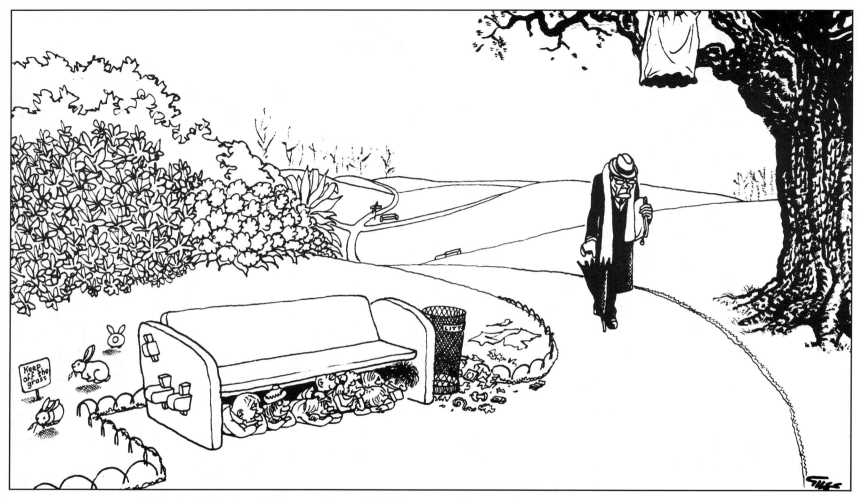

"I don't think there'll be much trouble kidnapping him—it's whether you'll get anything for him."

Daily Express, March 26th, 1981

'I felt terribly sorry for him, but it was funny, really, when you saw people who normally wore suits and raised their hats to old ladies in the high street stumbling about with packs and rifles, with eyes popping and red faces. That was old Reg. He was much more at home in a suit sitting at a desk scratch-ing away slowly and conscientiously with a pen.'

For right and proper authority Giles had always had a healthy respect. He had, after all, been brought up in a strict but loving family where things were done prop-erly, where elders were obeyed and discipline was kept. But from the beginning he had an unfailing nose for the

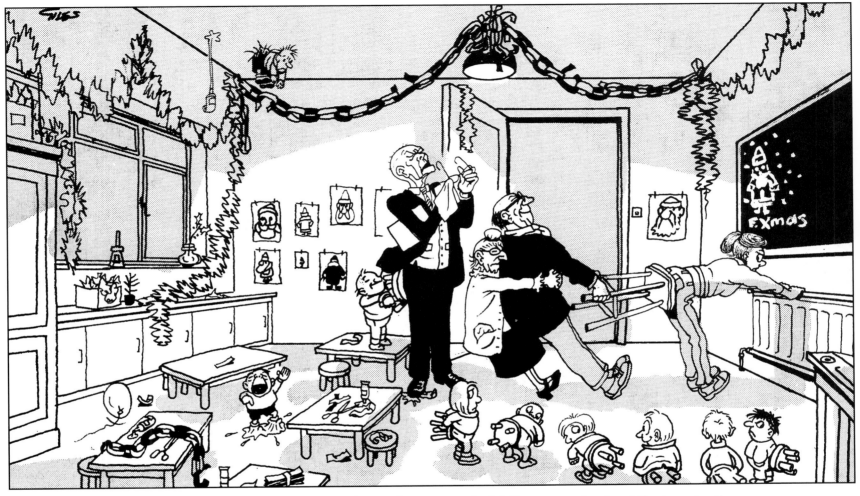

"Introducing Super Glue for the paper chains shows a marked failure to understand the imaginative workings of the modern child's mind, Miss Winslow."

Daily Express, Dec. 13th, 1979

vulnerabilities of those in power, and even if they weren't vulnerable at the time they soon became so once Giles picked up his cartoonist's pen.

As a schoolboy – extrovert, cheerful and mischievous – at the local Barnsbury Park School he was to come across a figure of absolute power on whom he later wrought perhaps the most terrible revenge ever achieved by pupil upon teacher. This was Mr Chalk, the master who presided over the early years of Giles's education – and the unmistakable model for one of his most enduring cartoon characters, the cadaverous schoolmaster Chalkie.

"I wonder, could it be that some mean, despicable, underhanded individual has spread
a false rumour that I shall be on strike today?"

Daily Express, Nov. 13th, 1969

"This wasn't a very nice petition to send to the Queen—'Please bring back hanging and hang Chalkie.'"

Daily Express, Feb. 20th, 1969

"Will the gentleman who endowed the new biology mistress with the undesirable term 'Sex Kitten' kindly step out here."

Daily Express, Jan. 5th, 1967

Giles was not cut out for scholarship, but he could draw like a dream from the moment he could hold a pencil – not that this ability was going to impress anyone in such a school and at such a time. 'It was no

168

good talking about being an artist,' he says now. 'What was an artist? There was mention from time to time of commercial art, but that was about it.' So Giles, who had quickly jettisoned his Christian name of Ronald in

"I have heard that you do not believe there is a shortage of teachers, and that in your opinion there is, in fact, one too many in this class."

Daily Express, Sept. 20th, 1973

"Who switched my team's pep pills for sleeping pills is what I want to know."

Daily Express, Sept. 8th, 1964

favour of Carl – derived from Carlo, or Karlo, after Boris Karloff, once his friends had decided that his shorn head made him look like Frankenstein's monster in the film – doodled at the back of the class and tried to avoid drawing down on himself the ire of Mr Chalk.

'He was a tall man, like a skeleton, and he had a head like a skull,' recalls Giles. 'He lived in the country,

Potters Bar – that was the country in those days – and he was always going on about it. And he was always going on about his daughters – we used to mimic what we thought they were like. But what one really remembers about him was not so much the cane but his sarcasm. He was a sarcastic bugger.

'Mind you, you knew about it all right when he used

"If he ad-libs once more and says 'How goes it with the Three Wise Guys?' something's going to happen to that wire."

Sunday Express, Dec. 17th, 1961

the cane. You got six on the palm and you couldn't use your hand for weeks. It was the same with the girls. And in those days you didn't go running home to tell your mother. If you did that you'd just get caned again.

'The funny thing was that he had a good reputation. He had been a head teacher.'

In all fairness to the academic sensibilities of Mr

Chalk it should be acknowledged that Carl and his mates were not the kind of pupils to gladden the heart of an ex-headmaster reduced to teaching general subjects to a mixed class of forty. If Mr Chalk's tyrannical reign gave birth to the memorable character of Chalkie, Giles had only to look back at his own behaviour and that of his chums to find the inspiration for the squad

of little horrors that people the Family cartoons, shooting arrows at the neighbour's parrot and tying fireworks to the cat under Grandma's chair.

But Chalkie – Mr Chalk – had their measure.

'On the first day of term my little mob – a real dreadful lot – would come in and sit in a gang, clustered in the same area at the back of the class. There was Mott, Gomm and Fletcher and Georgie Smith. My God, we were frightened of Smith. He lived in a rougher road than I did. They styled you by the street you came from.

'Chalkie would look at us all and he'd take his glasses off and hold them up and slowly clean them. "Oh, yes, yes, yes, yes, yes, yes, yes, yes," he would say. "How very nice. Are you all comfortable?" His voice was so silky and friendly. Then he would shout: "GET UP!" And we would all jump. And then he would redistribute us round the class.'

Giles also remembers an example of deliberate malice on the part of his teacher.

'I was good at the violin,' he admits. 'I liked it. And I played in the school orchestra.

'One day we were to give a concert to the governors of the board. I was in the classroom and I had my violin under the desk and we could all hear the orchestra tuning up in the assembly hall. I was too terrified to ask Chalkie if I could get up and leave the class. I wanted to say: "Can I please go into the hall, sir?" And he knew.

'The headmaster then came in and asked: "Where's Giles? He should be playing in the concert." And Chalkie said: "What concert? I don't know anything about a concert." So when I went out I had to go up on the stage and tune my violin all by myself when the others had finished. The instrument was flat for the whole recital and the conductor kept glaring at me.'

But, characteristically, he also tells a tale of unexpected kindness.

'We had a flower show in the school. It was one of those things where all the parents come to see the exhibition.

'I had grown a sweet william in a little pot – a tiny little pot. It was just poking up out of the soil. I was very proud of it and kept walking round and looking at it.

'One day after prayers we were in class and Chalkie looked at my little thing and said: "Ladies and gentlemen, we have *an* horticulturist in our midst" – he loved saying "*an* horticulturist" – "It is Mr Giles." And there was my little sweet william poking up. And then he said: "I must show Mr Giles what a sweet william should really look like." Then he brought out this beautiful flower which he had grown in Potters Bar. He handed it to me and said: "You can take this home with you."

'I took it home and told everyone it was mine. They were all impressed. Chalkie had done me a kindness.'

Undoubtedly the schoolmaster had a lasting effect on at least one of his pupils; Giles's recollections of over sixty years ago are as clear as if he were describing events that happened last week. And Mr Chalk has remained with him, a ghost with a skull face and long bony fingers and a terrible way with sarcasm – but not without redeeming features. Referring at once to two of his most celebrated grotesques, he says: 'I like to think that there is even a certain warmth to Grandma. And Chalkie.'

But not, perhaps, to your average traffic warden – and certainly not to the upper echelons of the armed forces as caricatured in countless cartoons of the war years and after. Giles remains solidly on the side of the bloke in the street, the family next door, the unstuffy, the unpretentious. There is a strong element of 'us' and 'them' in his outlook. The copper on the beat is OK – mostly – but he's not keen on the inspector. Any suggestion of humbug, elitism, snobbishness or what he perceives as Tory attitudes and you're straight into the firing line.

His depiction of class differences, always hilarious, was especially acute in his drawings of the army. Look at any one of them and you see on the one hand the cheeky face of the Tommy, the foot-soldier, cheerful

"Faster, Bert—he's gaining on you."

Sunday Express, Dec. 19th, 1967

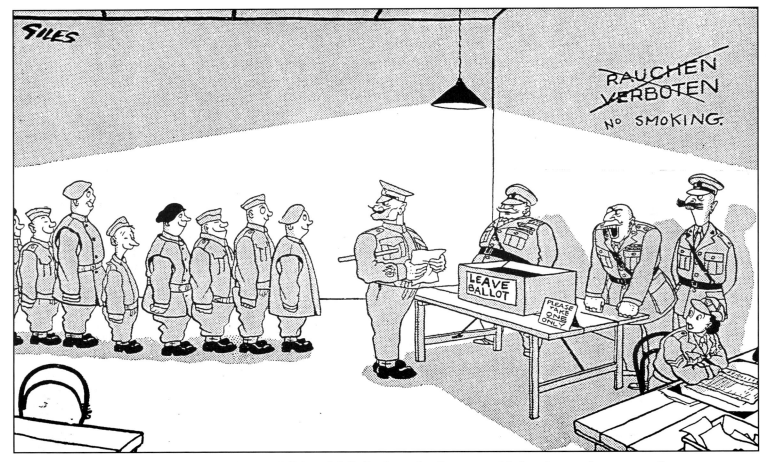

"Fall out the man who said 'It's a fiddle!' when the Sergeant Major drew a leave pass."

Daily Express, Dec. 7th, 1944

and lopsided, and on the other that of the colonel, with no chin at all and precious little of anything else: just a long sharp nose from which are suspended an absurd moustache and a set of prominent teeth. A twit.

Did Giles draw such figures of authority with amusement or distaste? 'A combination of the two,' he says.

The sergeant-major is all right, of course: unshakable, indeed, indestructible in his integrity, this is a figure of monumental solidity, possessor of a massive chin – eyes obscured by the peak of the cap – a powerful chest, and a spine constructed of that sturdy piece of gun-cleaning equipment, the ramrod. No nonsense here; no humbug either.

This attitude to authority, which may perhaps be described as an increase in suspicion with each step up the hierarchical ladder, could make Giles a less than

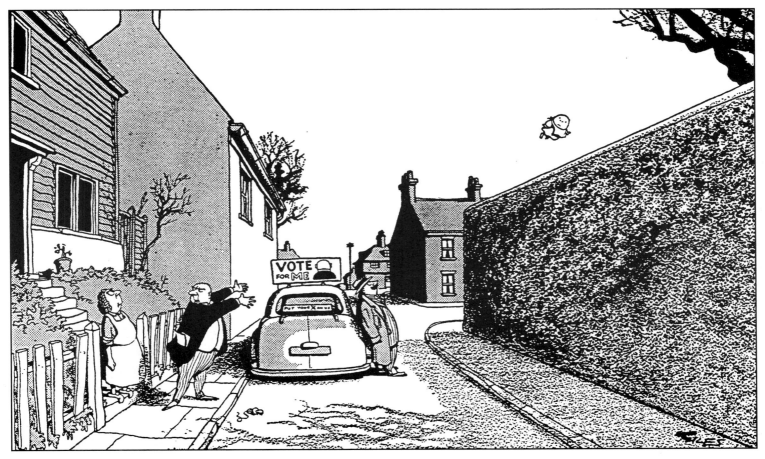

"Well, Madam, if you have definitely decided not to vote for me what am I doing nursing your baby?"

Sunday Express, Feb. 12th, 1950

comfortable colleague. Ask certain newspaper management men. He has given them a dreadful time over the years. They are insensitive wretches who do not really understand him or his work. They are idiots preoccupied with schedules and balance sheets and train times and office hours and 'new ideas' and budgets. They don't understand, they don't see the point, they seem to exist merely to obstruct, harass and irritate.

There was a production man on the *Daily Express* whom he nicknamed, with deep and hostile feeling, 'Slasher'. For 'Slasher', if he was short of space, would simply chop half an inch of sky off the top of a Giles cartoon. Carl would be reduced to a state of mute rage, agitation and, above all, frustration: for what was to him an act of unspeakable barbarism against a work of art was to Slasher simply making the page fit by cutting

"He's as happy as a pig in straw with his Valentine from Miss Whatsit in the corner. Actually I sent it."

Daily Express, Feb. 14th, 1963

out some 'empty space'. Slasher was one of 'them'.

The frustration was by no means all one way. Arthur Christiansen – 'Chris' to his colleagues, and Giles's editor on the *Daily Express* – wrote affectionately of the artist in his autobiography, *Headlines All My Life*.

Here is Giles, the great Giles, in eruption on the tele-phone. He is the apple of Lord Beaverbrook's eye since the proprietor spotted him drawing for *Reynolds*, the Co-op Sunday paper, and persuaded John Gordon to sign him up for the *Sunday Express* at twenty guineas a week. 'What's the matter with you, Carl? Want to come up to London to discuss things? All right, but don't be late – I'm busy.'

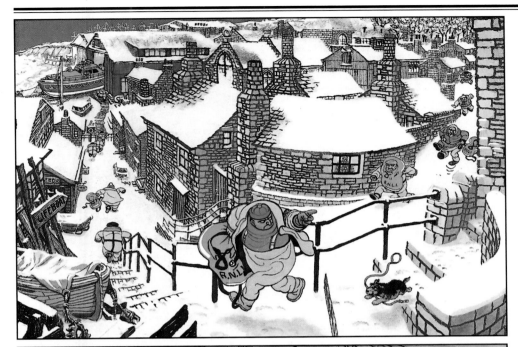

Christmas card drawn for the Royal National Lifeboat Institution 1984.
(*Reprinted by permission*)

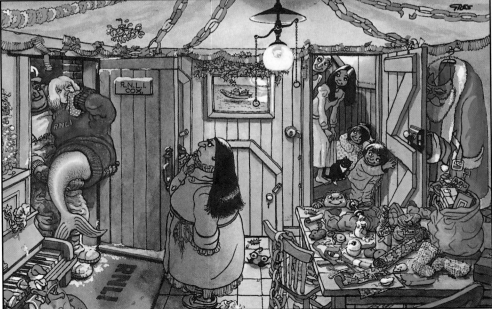

RNLI Christmas card 1988.
(*Reprinted by permission*)

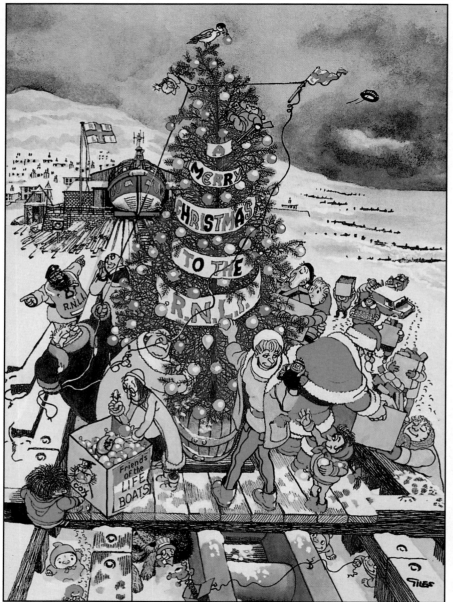

RNLI Christmas card 1989.

(*Reprinted by permission*)

RNLI Christmas card.

(*Reprinted by permission*)

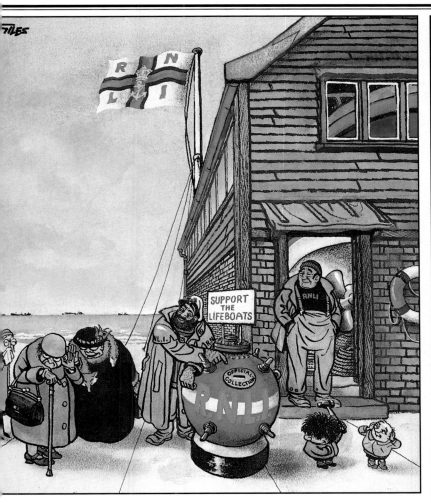

RNLI Christmas card.

(*Reprinted by permission*)

RNLI Christmas card

(*Reprinted by permission*)

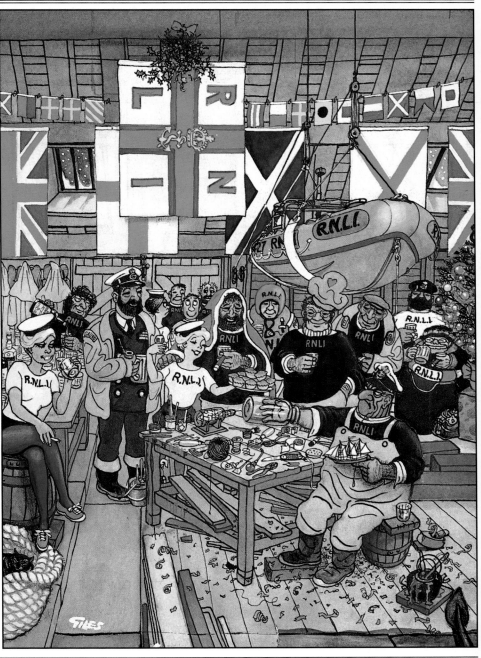

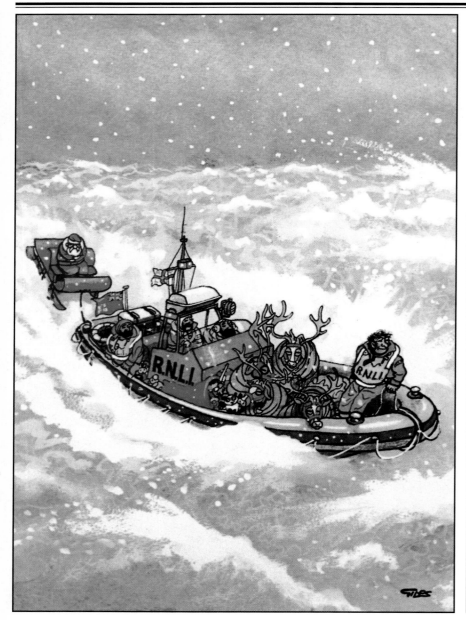

RNLI Christmas card.

(Reprinted by permission)

Daily Express *Christmas card 1987.*

World Wildlife Fund card.

Christmas card 1974.

These cartoons were drawn for the jacket of a book which marked the visit of the Queen to Suffolk in 1961 – the first time a monarch had visited that county since Elizabeth I's time.

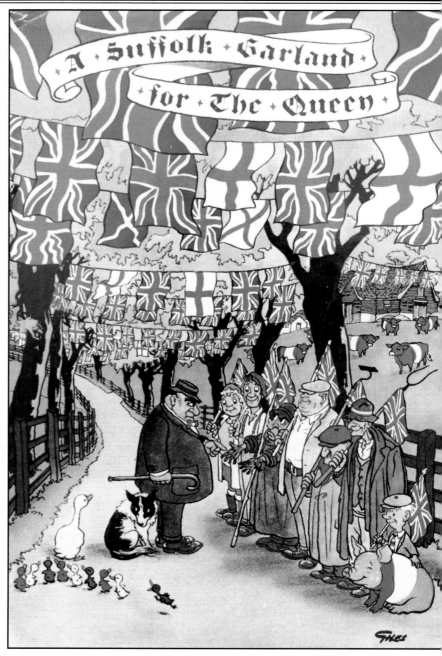

Christmas card drawn for the Game Conservancy Trust.
(Reprinted by permission)

Illustration from a 1951 Daily Express *calendar.*

Game Conservancy Trust Christmas card.

(Reprinted by permission)

Game Conservancy Trust Christmas card.

(Reprinted by perrnission)

FAN MAIL FROM DR. MARIE STOPES

Sir,

For some time past I have been increasingly disgusted, like many people, by the cartoons you publish by Giles. They degrade humanity and are very seldom funny, and their injurious effect is corrosive.

I am cancelling my order for the *Daily Express* and shall not take it again so long as you poison it with Giles' productions.

MARIE C. STOPES.

Norbury Park,
Dorking,
Surrey.

REPLY

Very well, Marie, if you're not going to take the *Express* any more because of my cartoons, I'm not going to read any more of your little books.

Giles is not late, but by the time I am ready to take him for lunch, he has disappeared.

This was something of a crisis between the two men; but Giles could deal with the high authorities of the press with as much mischievous good humour as he could on other occasions with ill-natured non-cooperation. Chris once admonished Carl in a telegram as being 'brilliant, but unpunctual, unreliable and unbusi-nesslike'. It was the accusation of unpunctuality that really unsettled Giles, who responded with this short missive: 'Dear Pot, Thank you for your telegram. Kettle.' After one abortive lunch arrangement when he had kept Giles waiting for over an hour, Chris received a cartoon showing two panels of the same scene outside his office door. The first panel featured a self-portrait of the bespectacled artist sitting quietly in his overcoat outside the frosted glass door marked EDITOR. In the

"You say Georgie Smith was showing you how to make H-bombs in the tool shed?"

Daily Express, Feb. 7th, 1950

second panel he was still there, but the figure in specs and coat was a skeleton.

On this occasion, having once extracted Giles from his chosen drinking den, Chris then lost him again. Later that same day the proprietor himself, the great Lord Beaverbrook, phoned down to the editor: 'I hear Giles is in town. Send him along to see me.' Once again, the pubs of Fleet Street had to be trawled for the missing artist. No luck; panic set in. Unnecessarily, as it turned out; Giles was eventually run to earth in the photo-engraving department, arguing with the overseer about the making of line blocks.

"Why do you always have to be awkward, Grandpa—telling that smog inspector that you're 97, lived here all your life and love it?"

Sunday Express, Nov. 28th, 1954

Christiansen recalled: 'He reappeared in my room like a genie-out-of-a-bottle and I am so happy he is found again that I forgive all the chaos he had caused me . . .

'Two days later, a souvenir to commemorate this day is delivered. It is a full-size cartoon for my private collection, and it shows me sitting at my desk, my brow furrowed, my aspect grim. Around the door a tiny, shrinking nervous figure which does not reach up to the doorknob gazes at me apprehensively. This is Giles as he sees himself and he is saying: "Tell me, Mr Christiansen, why are you not always cheerful?"'

Giles even communicated with Beaverbrook, as he did with everyone in a position of power, by cartoon. He sent the 'Beaver' a humorous drawing as a birthday greeting, eliciting the following note in response from

"What you got—a warning from the Ministry saying we mustn't use our hoses?"

Sunday Express, Jan. 7th, 1979

"Thanks to you deciding not to strike today, we've had to cancel a very important 18 holes."

Daily Express, Jan. 30th, 1979

Beaverbrook's home, Cherkley, in Leatherhead:

May 26, 1963

My dear Giles

I have received quite a lot of birthday cards. Some are quite beautiful. Some are not so beautiful. They are in a salver in my house here.

But I am not putting your letter in the salver. For any Giles original is much too precious to be treated in such a way. And this is a particularly excellent one.

I enjoy you in reproduction regularly. Now I have this greeting for my private pleasure and amusement. And I send you my warm thanks.

Yours sincerely . . .

181

"From outer space—one unidentifiable object."

Sunday Express, Oct. 29th, 1967

"Tell them to forget about the ladies at the Commonwealth Arts Festival dancing in their birthday suits—on jumpers at once!"

Daily Express, Sept. 14th, 1965

By this time Carl had long since established his talent and value to the extent that he could treat his employers much as he wished. And get away with it. As Bob Edwards, twice editor of the *Daily Express* in the sixties and thereafter deputy chairman of Mirror Group Newspapers, said: 'Editors treated Giles as a genius. Certainly, there was not one of them who thought of himself as grander than Giles. To risk losing Giles was unthinkable. It would have been a catastrophe.'

So Carl was honoured in all manner of ways. Where other cartoonists, even such luminaries of the art as Michael Cummings or Sir Osbert Lancaster, would approach their editor's office with a number of rough ideas and hope that one would catch their master's fancy, Giles would simply do one sketch. Sir Osbert, Bob Edwards recalls, was so nervous about this process that he would stand about outside the editor's office, eventually pressing his bewhiskered and livid features against the frosted glass to indicate that he was awaiting an audience. Carl would draw his cartoon in the privacy of his Ipswich studio, without prior consultation as to the subject matter, and send it up to London at the last minute, always with the reluctance of the perfectionist who can never quite consider the work completed. In the early days it went by train, but later on this proved unreliable and taxis were used instead. Even so, it would usually arrive beyond the deadline, a time zone in newspaper offices akin to some dreadful state of Limbo.

That this byzantine process was allowed to continue for half a century is a measure of the extraordinary esteem in which Giles was held.

Edwards remembers, as does every other editor of the *Express* papers, the electrifying tension that accumulated in the production area as the hands of the clock moved inexorably round and 'the Giles' was nowhere to be seen. Over the heads of the nail-biting staff among the strip-lighting hung a huge green plank, like a guillotine, ordered there by Beaverbrook himself and bearing the legend in tall white letters: 'MAKE IT ON TIME.'

'When the Giles eventually arrived,' says Edwards, 'we would have to put it into the first editions in halftones, because it was a quicker process.'

Lord Cudlipp, former chairman of Mirror Group Newspapers and, as plain Mr Cudlipp, managing editor of the *Sunday Express* in those days, has similar memories: 'It would be a Saturday night and there would be this huge blank space on page three waiting for the Giles. Carl would have called and told us it was on the 2.10 from Ipswich. At four or five o'clock it still won't have arrived.

'Carl would have said: "Send a messenger. The guard's got it. He's a friend of mine." The cartoon somehow always made it – no one knew quite how.'

Those whose professional lives depended on the arrival of the cartoon simply had to keep their nerve, and wait.

Carl himself didn't make any of this any easier; indeed, he made editors very agitated indeed.

'I recall him standing there,' says Bob Edwards of the occasions when Carl would actually visit him in his office. 'He would have his head on one side and could be rather irascible.'

And it wasn't just the timing of the work's arrival that gave the press executives cause for unease. Giles's mischief sometimes took the form of hiding in his cartoon a small but shocking detail. A nursery scene, for instance, might include in some corner the *Daily Express* children's character, Rupert Bear, hanging from a gibbet. Or, famously, and extremely alarmingly for editors, the small square envelope of a condom packet would appear, as if dropped in passing by one of the GIs who populated so many of the cartoons of the war years. Far from being a common subject of public and private conversation as they are now, condoms then were unmentionable in decent society. For a family newspaper to show one, however innocuously packaged, anywhere in its pages would have drawn down obloquy upon its collective head. Yet despite the best efforts of the night editors with their magnifying glasses, a number of Giles's mischievous little packets slipped through.

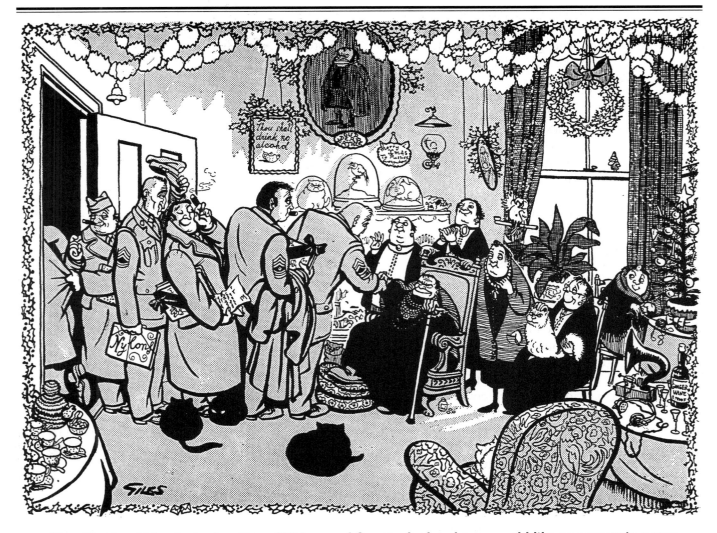

"Just like it said in the invite, Tex—'Widow and five single daughters would like to entertain party of American soldiers for Christmas'."

Giles would torment his various editors by tucking rude things away in his drawings. Rupert Bear, loved by all Express readers, would occasionally be found hanging from a gibbet in the corner of a nursery. In his GI pictures the artist would place the odd French letter packet – a tiny square envelope – somewhere in the drawing. Often they appeared to have fallen from a GI's pocket. There are two such packets in this wartime picture which escaped the editor's vigilance. It takes some searching; but they are clear enough.

"Nice start, Charlie boy."

Daily Express, Nov. 25th, 1968

"We've been here hours. I hope those Security Officers who took all our luggage for a check WERE Security Officers."

Daily Express, June 27th, 1970

Carl remembers with glee the then legal manager, Andrew Edwards, whose job it apparently was to keep watch on taste as well as legality. 'I used to love keeping him in a state.'

And Giles's colleagues put up with all the states in which he kept them – because they knew he was irreplaceable. They knew how good he was. As did countless other admirers of his work, among whom one of the most perceptive was the late prima ballerina, Dame Margot Fonteyn:

'Very few men can see clearly all the imperfections of face and form in the world around yet still retain an indulgent affection for humanity.

'Such a person is Carl Giles. He must be a very compassionate man.

'Anyone else with his needle-sharp eyes would find it

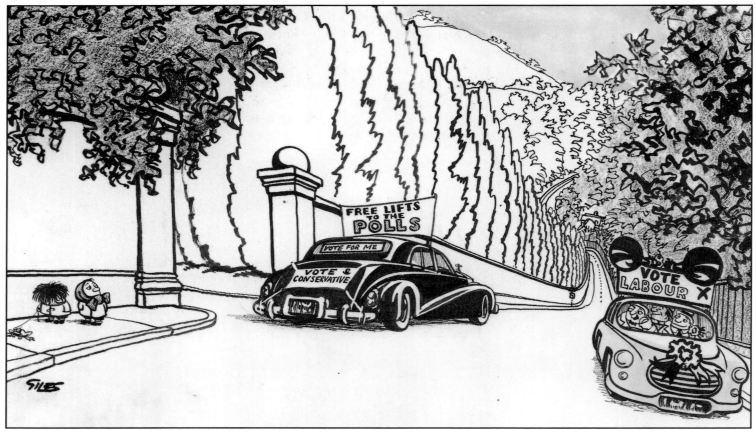

"What's it worth for two certain small boys to open the door of a certain big black car and slip the handbrake?"

Sunday Express, May 22nd, 1955

hard not to be biting in the humour, but he mocks us only very gently. Even his most horrible characters are to some extent endearing.

'We laugh at them but also more often *with* them and sympathize with their plight. We can feel for all of them even when they are absolutely humourless and stupid . . .

'Although we love the situations and captions of his cartoons, they are not really so important as his superb revelation of our absurdity.

'Let us all thank him for helping us to laugh at ourselves; it is the hardest lesson to learn and far the most valuable.'

And yet it is also worth considering, with Giles the scourge of pettifogging authority in mind, what Nathaniel Gubbins, a colleague of Carl's on the *Sunday Express*, had to say in the fifties:

'From Dean Swift to Giles the men who have made you laugh most have been savage men.

'Thoughtless people have lumped them all together

under the title, humourist, which would include knock-about comedians, jugglers and clowns.

'But the laughter-makers who have been remembered, and who will be remembered in the years to come, are the satirists – the men who hate.

'Among the things they hate are stupidity, injustice, intolerance. If they have suffered from any of these, or all, so much the better for their art.

'This hatred, combined with a possibly subconscious desire for perfection in an imperfect world, produced men like Giles.

'I don't know what it is that Giles hates most. Maybe it's ugly and wicked children. Maybe it's hunting squires and hard-riding women. Maybe it's ancient aunts in hideous hats who always arrive for Christmas, or whenever there's a picnic or a free holiday.

'Whichever it is, cartoonist Giles has had his revenge on them all.'

Revels and Royals

Much of Carl Giles's life has been unashamedly devoted to pleasure. It has been a joyful, gloriously successful hedonistic odyssey, interrupted on the way, but never long diverted, by door-to-door salesmen, traffic wardens, newspaper production executives and Chalkie-faced tax inspectors. Visiting Fleet Street was just a regular brief episode in a hectic schedule which involved motoring, yachting, amateur film-making, DIYing and, on a daily basis, merrily doing the rounds of the back-street bars, country-lane alehouses and waterside taverns of Suffolk, all the way from Ipswich to Felixstowe and back – and there and back again. The final foray of the day would usually start about mid-night and perhaps draw to a close sometime around 2.30 a.m., often with a convivial group of companions serenading the moon and ambling vaguely in its silvery light up to the Giles front door, where Joan would usually be up at their approach to put the sausages under the grill.

But it was also in Ipswich that Giles had his meticu-lously planned and equipped studio, where his relentless pursuit of off-duty fun was punctuated by six- to ten-hour periods of intense, disciplined, creative concentra-tion. From this one brightly lit room above Ipswich High Street were dispatched over a period of half a century – usually late and, in the artist's perfectionist eye, incomplete and unsatisfactory – over 7,500 car-toons. By the end of even the first of those fifty years their creator was established as the twentieth century's

most celebrated artist of the people. He has been described as a benign Hogarth; his characters have become permanent, universally recognized institutions.

And every ten days or so he would descend on the capital – not to deliver his work, which made its own way down by train and taxi, to the chronic anxiety of successive editors and production staff, but with the express and determined purpose of having an extremely good time in selected drinking establishments. The choice was a wide one, and Giles had spent some years enjoyably narrowing down the possibilities. Essentially a gregarious soul who revelled in good company, he could always hold his own, whether with wild and incoherent drunks or with the most sophisticated and clear-headed of intellectual imbibers.

Back in the *Reynolds News* days, wartime days when the latest raid was just another reason to be off to the pub, Giles and his Communist mates would regularly make for the King's Head and the Pindar of Wakefield, both hostelries with a long and proud tradition of wel-coming generations of journalists, the former near the old *Daily Worker* headquarters in King's Street, only a minute's stroll from *Reynolds*, and the latter, a some-what grander establishment, in Gray's Inn Road itself.

In the Pindar or the King's Head the cartoonist would be found, one hand in his pocket, the other nursing glass and cigarette, his specs glinting in the smoky yellow light. Here too, in those early years of the war, his childhood friend, later sweetheart, soon to be

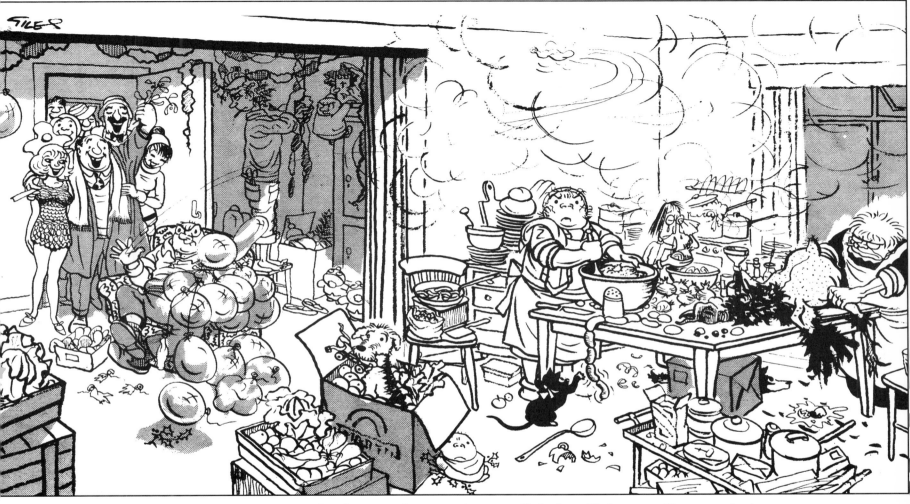

"Hi, George! We've just popped in for a quick one with your wife before Christmas—like you asked us at the party last night."

Daily Express, Dec. 22nd, 1966

his wife, Joan Clarke, would join him after her own day at the office.

Later on, out of all the pubs of Fleet Street, from the Albion on Ludgate Circus all the way up to the Strand via the Punch and the Eight Bells nestling beneath St Bride's, the Street's own church, Carl homed in on Poppins, a strange little one-horse saloon in Poppins Court, tucked in beneath the shadow of the *Express* building itself, and the famous El Vino, nearly opposite the law courts.

"Morning, Froid—we hear you're the only boy who did his homework instead of watching football last night."

Daily Express, Nov. 19th, 1981

The original Poppins, or Pops – it was actually called the Red Lion – is now long gone. It was a seedy little place, narrow like a train corridor with the patina of nicotine coating everything within its doors. In this Hogarthian dump the famous got drunk with the infamous, great headlines popped like genies out of tumblers – and at least one famous political commentator used to sleep on the floor among the fag-ends and the large, important shoes of those who went on drinking and roaring with laughter above him.

Giles loved Poppins and could usually be found there on his trips up to 'the office' from Suffolk. It was from

A drawing of the Artful Dodger done for the Humour of Dickens *in 1952.*

Poppins that Arthur Christiansen had to attempt to extricate him when the cartoonist had given up waiting on his editor for a lunch engagement. As Chris wrote in his autobiography:

'He has gone to Poppins to buy drinks for Anne Edwards, Eve Perrick and Drusilla Beyfus. When I catch up with him he is in high good humour; the girls make a great fuss of him and he is snorting incoherently to express his pleasure . . .

'My arrival at Poppins does not dampen anyone's spirits, and I have the utmost difficulty in getting him to leave the place. The girls go reluctantly, and other customers buttonhole Giles and buy him "just a small one for the road". "Now you see why I hate coming to London," he grins into his glass.'

If he wasn't in Poppins, the next establishment in which to look for Carl was El Vino, the so-called wine bar which for a century or more, until the disintegration of Fleet Street as the hub of the capital's newspaper activity, was the daily rendezvous of senior pressmen. Now a forlorn place, then it was the twentieth-century equivalent of the old coffee-houses, where diarists, columnists and editors – and the occasional Great Thinker – would gather to gossip with alcoholic fervour about great events and little rumours, and, more often than not, the peccadilloes of their colleagues. The old El Vino offered a raucous but usually articulate conviviality. It was a gentleman's club for heavy boozers where the inevitable few drunks were held upright by sheer force of numbers. Spirits – Scotch and soda, with very little ice and even less soda, and vodka and tonic, with exceedingly little tonic – were always served as doubles. A single had to be specifically requested, and the order was not likely to be received with much favour as it meant that the barman had to calculate the price of half the standard drink and divide the tariff by two on the ancient till.

El Vino regulars would tend to arrive at lunchtime, around one o'clock, and would stay until swept out with the fag-ends towards ten past three. Assuming the purchase of one round every quarter of an hour, this meant that each spirit drinker had swallowed at least eight, probably nine, large tots of almost undiluted whisky, vodka or gin. Thus fortified, the imbibers would return to their offices, sit at their typewriters and hold forth to the world. Next morning those pickled words would appear for the edification of fifty million people. No one ever complained.

The evening routine was broadly similar.

"Great for our public image—the nick bunged full of drunk and disorderly birthday revellers."

Sunday Express, Sept. 30th, 1979

"It's a summons from a burglar who broke in and stole half a bottle of Grandma's home-made wine and has never been the same since."

Sunday Express, Sept. 26th, 1982

"Nothing like a Home Office probe into jail conditions to bring out the old flannel in 'em."

Daily Express, March 18th, 1969

Giles frequently illustrated programmes for annual dinners, local Suffolk carnivals and sporting events. Even East Anglian darts matches were graced with his artistry. He loved drawing for Suffolk amateur boxing evenings. Here are two from the many which he drew over the years.

Into this civilized debauch, from time to time, stepped Carl Giles. Mike Molloy, for ten years editor of the *Daily Mirror* and later editor-in-chief of Mirror Group Newspapers under Robert Maxwell, remembers him: 'Carl used to stand surrounded by admirers, a bit pissed, legs slightly apart, jangling coins in his pocket. In some ways he was like a well-to-do farmer who had come to visit London for the day. He always enjoyed himself tremendously.'

Sir John Junor, august columnist and editor of the *Sunday Express* for thirty-two years, comments plaintively: 'Eventually Carl would go back off to Ipswich leaving us all in the most terrible state.'

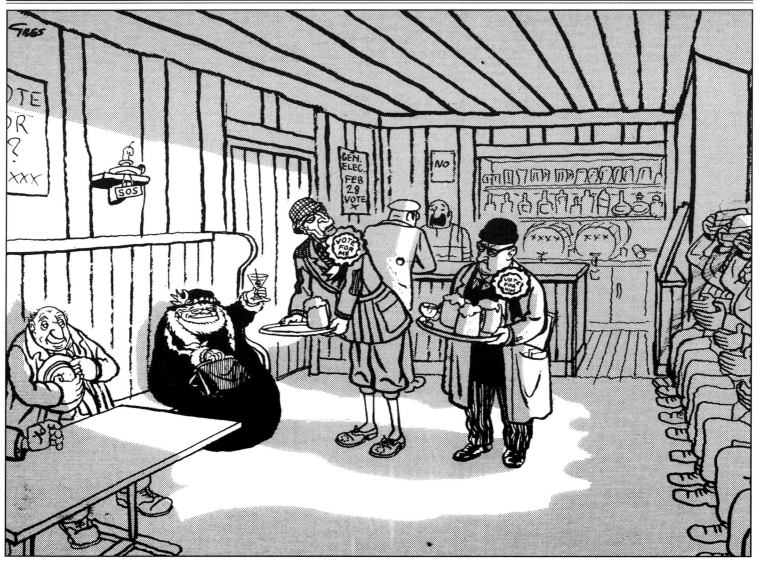

"That's one large Martini down the drain—she said 'Thanks comrade.'"

Sunday Express, Feb. 24th, 1974

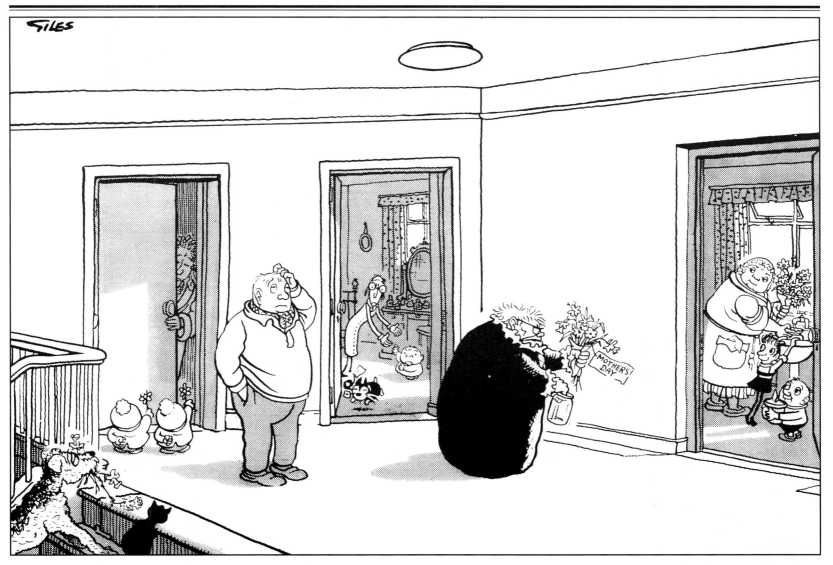

"*Damn flowers—never a bottle of Scotch.*"

Sunday Express, March 21st, 1971

"I suggest a small increase in salary for Ivy might keep the Industrial Tribunal off our backs, M'Lady."

Sunday Express, Oct. 31st, 1982

"I knew that registrar would bungle two dozen Easter weddings at the same time—here comes your bridegroom now."

Sunday Express, April 22nd, 1973

"Mum! Dad's just given the carol singers a cheque for five million pounds."

Sunday Express, Dec. 23rd, 1963

Hold it, Mr Giles—that's not exactly what Mr Williams meant.

Daily Express, March 31st, 1964

Rearranging the world with journalistic drinking chums was one thing; talking to journalists in their professional capacity was quite another. He was fond of the late Jean Rook of the *Daily Express*, an affection he demonstrated by mocking her in his cartoons. However, even Jean was met by a rather dampening lack of enthusiasm when she attempted to interview him for their own newspaper.

'When I asked The Master for lunch,' she wrote, 'he forgot the date twice and turned up once at the wrong restaurant.'

Even Fleet Street's celebrated lady inquisitor Lynn Barber suffered similar torment.

'My day started badly on Ipswich station when he said he really wasn't meeting me at all – he'd changed the appointment.' Persevering, Lynn did manage to conduct some sort of dialogue, but gently bemoaned the

fact that she could only prise out one nugget of useful information every half hour or so. Carl, while quite happy to converse about the virtues of other artists, shied away from discussing his own work. Lynn revealed some of the difficulties she had in the *Sunday Express* colour magazine:

'But come on, Giles, what of Giles? This isn't supposed to be a seminar on twentieth-century cartoonists; it's an interview. "Grk," he goes. "Humph." Whenever you ask him any questions about himself, he suddenly turns deaf and grumbles like a wounded seagull, "grk, grk . . ." When I asked which of his cartoons he most liked he grked like a whole flock of seagulls and insisted that I have some pudding.

'Later, on the way out to his farm, I was rash enough to praise Grandma while we were stuck at a roundabout – he put the Range Rover into reverse and hurtled backwards towards a line of traffic. I learned not to ask questions about Giles while he was driving.'

One television film did get made, in good faith and with the subject's grudging approval. Entitled simply *Giles*, and intended as a half-hour biographical profile, a simple documentary tribute, it consists largely of a series of talking heads, the heads belonging to those who have been associated with Carl, telling us what a splendid person he was, and is, how he liked a drink and what wonderful cartoons he drew.

At just one point in the film a close-up shows Carl at work in his studio, characteristically half leaning over his drawing. The camera has evidently intruded: Giles looks up, very irritated, and goes: 'Grk.'

To call Giles 'a private person' on the strength of this reticence would be foolish. There is nothing private about the way in which he has enjoyed himself in the taverns and homes of Suffolk and London and on his travels elsewhere, and he is not coy or bashful, secretive or timid. He just doesn't want people whom he hasn't invited prodding and poking about in his life and his work; doesn't want intimacy proffered by strangers; doesn't want to discuss his work with people he can't be

sure will understand what he is on about, and in any case would rather let it speak for itself.

Consequently there is little evidence of any journalist ever persuading him to say anything on the record whatsoever. Except 'grk'.

Apart from the regular three cartoons a week for the *Daily Express* and *Sunday Express*, the Ipswich studio also saw the genesis of the colourful yearly Christmas cards for Giles's beloved Royal National Lifeboat Institution – of which he is life President – amusing menus for the charitable luncheon and dinner club, the Saints and Sinners, and innumerable personal cartoons created for friends, editors, police inspectors – and indeed the Sovereign herself.

Giles was awarded the OBE in 1959, and during the following decade found himself being gradually adopted by the royal family as a kind of cartooning court jester. He would send them sketches to mark various incidents and events, and would receive delighted notes in return. These would begin 'The Queen has commanded me to thank you . . .' and the Sovereign would then continue, through dictation to her private secretary, in an often jauntily informal manner, joining in the joke.

In the summer of 1962 Giles was invited to lunch at Buckingham Palace, though he was lucky to keep his head, let alone the invitation, after the way in which he initially received the honour.

At the time, Prince Philip had ruffled feathers in Fleet Street by publicly calling the *Daily Express* a 'bloody awful' newspaper, and in response Carl had drawn the now famous cartoon showing Lord Beaverbrook being hauled off to the Tower. The royal insult had caused much amusement throughout the land, and anyone who worked for, and was proud of, the butt of the Duke's tongue was having a very hard time of it. At a Licensed Victuallers banquet in Felixstowe Carl was teased mercilessly throughout the evening; not one speech passed without reference to the 'bloody awful' newspaper, and those sitting around Giles would lean towards him, faces rosy with fine claret, and observe, with more enthusiasm than originality: 'We

"The Express is a bloody awful newspaper," said the Duke. **"Ah, well,"** said Lord B., as they trotted him off to the Tower, **"at least he takes it or he wouldn't know it was a bloody awful newspaper."**

Daily Express, March 22nd, 1962

Carl's drawing of his boss, Lord Beaverbrook, being led to the Tower of London caused immense amusement, both at the Daily Express *and at Buckingham Palace. Prince Philip had called the* Express *a 'bloody awful newspaper'.*

Giles poked fun at the situation, confident that he would not be sacked for cheek. Beaverbrook roared with laughter. And there was a request from the Palace for the original.

"Those woollies you sent for the Royal Baby—they've sent them back."

Daily Express, March 30th, 1982

could have told Prince Philip that years ago.' Carl became less and less amused. The *Express*, after all, was his stage, his Palladium.

The following day, back home at the farm, the telephone rang. Giles picked it up. A voice announced: 'Hello. Buckingham Palace here.'

Giles immediately assumed that this was yet another wag calling to make the most of the royal jibe.

'Fuck off,' he said, and slammed the receiver down.

Half an hour later the phone rang again. This time the voice on the other end sounded slightly nervous: 'Hello. It's Buckingham Palace here.'

The receiver had almost crashed down again when something stirring at the back of Carl's mind recommended caution. 'Hello,' he said carefully.

The voice on the other end turned out to belong to the Queen's man himself, and he was somewhat intimidated by his unexpected reception; he had obviously never before been thus abused in his whole life. 'He probably didn't know what it meant,' mused Carl.

"If I was your Fred with an appointment on Monday about his contract I wouldn't have clobbered the Chairman first ball."

Sunday Express, Aug. 16th, 1981

Having established safe conduct on the telephone, Her Majesty's equerry explained that he merely wished respectfully to ask Mr Giles if Her Majesty might have the original of the Beaverbrook/Tower of London cartoon to remind her of one of her husband's 'more glorious indiscretions'. Furthermore, would Mr Giles like to join the Queen, some short time in the future, for luncheon?

Carl accepted, of course. But while he was happy to establish an informal relationship with the royal family through cheeky cartoonery, the prospect of actually meeting the Queen in person – for lunch at the Palace, to boot – was quite terrifying. 'I have never been very

207

"We sent the man next door a note saying we're holding his son hostage, and he sent one back saying 'Thanks.'"

Daily Express, Jan. 22nd, 1981

good in the presence of the great,' says Carl. 'I was filled with absolute dread.'

The fateful day having arrived, Carl found himself peering apprehensively through the windscreen of the taxi as it bore him down the Mall. There ahead of him was Buckingham Palace, an edifice he knew well as a piece of architecture, having drawn it, often, in characteristically immaculate detail, with guardsmen at their

posts, corgis peering out of windows, the royal standard flapping lazily against its pole. This was a building you saw on paper and postcards, not somewhere you went for lunch. It certainly wasn't a destination for a former pupil of Chalkie's class of '28.

'I went to a side entrance and was met by this very courteous man who led me along endless corridors and showed me into this small circular anteroom overlooking

"What's the sense in striking while we're on holiday—answer me that?"

Daily Express, March 23rd, 1961

"Natural History Museum? We have photographic proof of another monster—colour mostly black, fur round neck, powerful flippers ... "

Daily Express, Nov. 24th, 1975

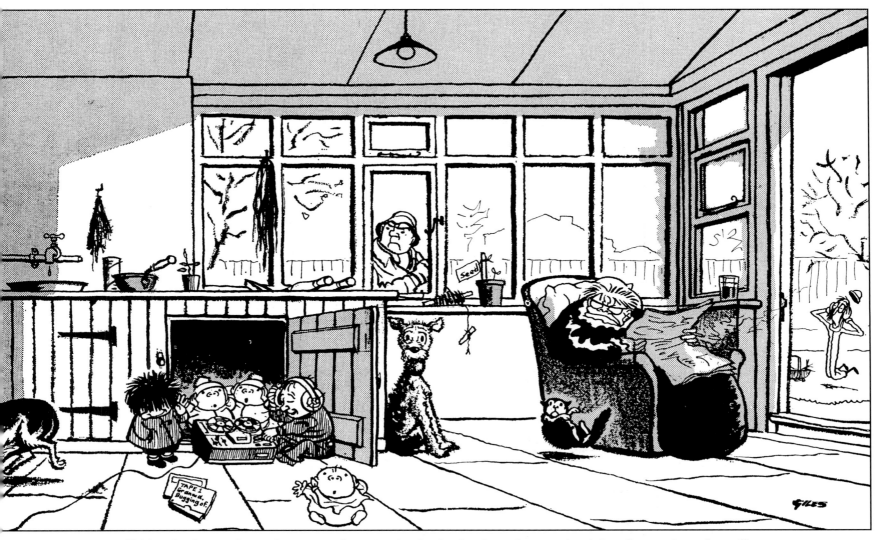

"I like this bit—where she stopped singing in the bath when she caught sight of our microphone."

Sunday Express, April 29th, 1973

the gardens at the back. There was a group of people and we were all given drinks just as if we were at home.
'Then the Queen came in with Prince Philip.'
Carl admits to being mute with terror at first. But:

'As soon as she started to talk I was put at my ease. She took off one shoe while she was talking – just like women do – and rubbed the other ankle with her instep.'

"Knocked off for breaking and entering, if you must know."
Daily Express, Dec. 27th, 1963

"I'm afraid you'll find Sir Edward a little touchy—our young visitors dressed him up for VJ day and we can't get it off."

Sunday Express, Aug. 26th, 1945

213

This is an intriguing recollection. Almost anyone who has met the Queen in similar circumstances makes the same observation. It seems almost as if the monarch uses this carefully calculated piece of suburban body language to banish fear.

'There were about half a dozen corgis running about,' Carl went on, 'in a completely uncontrolled state. They were everywhere about your feet. Suddenly the Queen shouted, very loudly, "HEP!" It was like a bark from a sergeant major. It made me jump. The corgis immediately stood to attention. Then filed out of the room.'

Back in the safety of his Suffolk farm, Giles drew a private sketch showing the ankles of the day's luncheon guests with torn and tattered trouser-bottoms, savaged by disrespectful corgis. He sent it to the Queen. Only a court jester might expect to survive.

Carl received an answer from the Palace in which Her Majesty expressed pleasure at the fact that 'to the best of her knowledge' Mr Giles had not lost so much as 'a shred' of his trousers. She was, it concluded, 'as delighted to possess the drawing of what didn't happen at the luncheon as she is relieved that it didn't in fact happen'. Giles's role as jester was, it seemed, established.

Thereafter, the royals were to receive Giles originals regularly – never published anywhere and destined to hang on the walls of private apartments – to mark various events and celebrations. One drawing of members of the family was accompanied by a note from the artist to Martin Charteris, the Queen's private secretary, concerning the precise accuracy of the caricatures. Charteris replied on behalf of the Queen and passed on the message, placed in quotation marks to signify direct reporting of her words, that HM thought them 'not half bad' – an example of how the Queen loves to slip into what she regards as a colloquial, informal manner of speech.

The notes sent from the Palace to Carl in acknowledgement of his drawings were never of the formal, impersonal kind but always dictated personally and often containing a joke, or at least a royal attempt at one. The cartoon sent by Carl to commemorate the Queen and Prince Philip's silver wedding party at Buckingham Palace featured a present from Grandma of spoons stolen from British Rail, on which the initials 'BR' figured prominently. Prince Charles, who had hosted the party, wrote back:

'It was a great problem explaining the significance of "B.R." to members of the Foreign Royal Families who have not had the good fortune to travel by that exquisite mode of travel . . .'

The royals, it is well known, regard the railway as the most impeccably dignified way to be transported around the kingdom.

Nor is it just Carl's private, dedicated sketches for the monarch and her family that adorn their apartments: between them the royals have thirty-six originals of published cartoons, all personally requested.

Three have gone to the Queen herself, the best of them depicting the royal barge gliding towards the jetty of some tropical island from the royal yacht *Britannia*, visible at anchor some way off. The deck is bristling with snappily saluting sailors. An able seaman has just thrown the bowline towards the jetty – and missed. Another tar is seen remarking out of the corner of his mouth: 'HRH is in one of his doom-watch moods this morning – hear that rude little word from below when you muffed that?'

Princess Margaret, perhaps the nearest of the royal family to Carl Giles in gregarious temperament if in nothing else, was particularly fond of the cartoonist, though he was never a member of the personal court of artistic people she gathered about her. He didn't dance or act, he didn't stand on his head or set the table on a roar; he was simply the fellow who kept on producing brilliant cartoons to the lasting hilarity of the nation and the especial pleasure of the royal family.

It is interesting to contemplate the root of this royal predilection for Giles. Most of his work involved the ordinary people of their country, and it was almost as

"HRH is in one of his doom-watch moods this morning—hear that rude little word from below when you muffed that?"

Sunday Express, Oct. 30th, 1977

The Queen has this one in her collection.

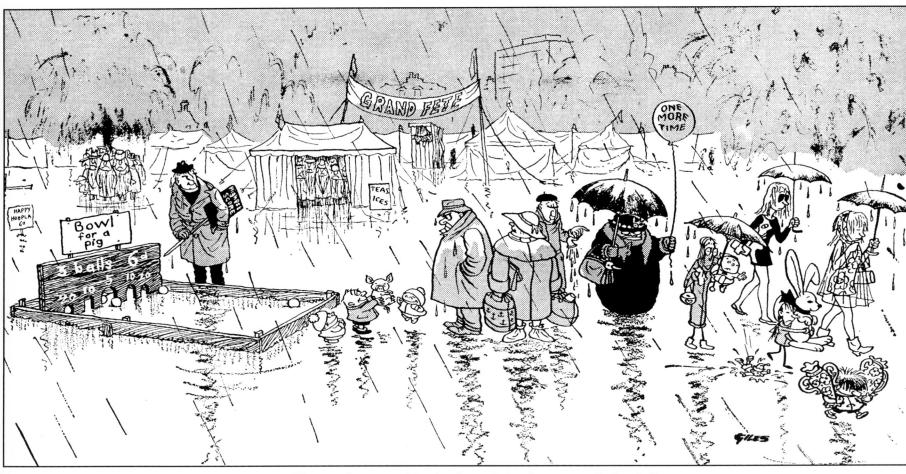

"You might try and look pleased they've won a little pig."

Sunday Express, Aug. 7th, 1966

if, when he featured the royal family in his cartoons, they felt privileged to be included.

They certainly didn't hang back in asking for the originals of cartoons that took their particular fancy, and Carl was always happy to release them – even though it had become apparent very soon after he joined the *Express* that the drawings would one day enjoy a very substantial value.

In November 1970 there was a threat of strike action by, of all people, racehorse owners. Carl drew a cartoon, published in the *Express*, which showed a procession of militant-looking toffs dressed as if for the Royal Enclosure at Ascot; the first and sixth in the line are Lord Rosebery and HM The Queen. There followed a letter from the Queen's press secretary, Bill Heseltine:

'I am writing on behalf of the subject (only subject is,

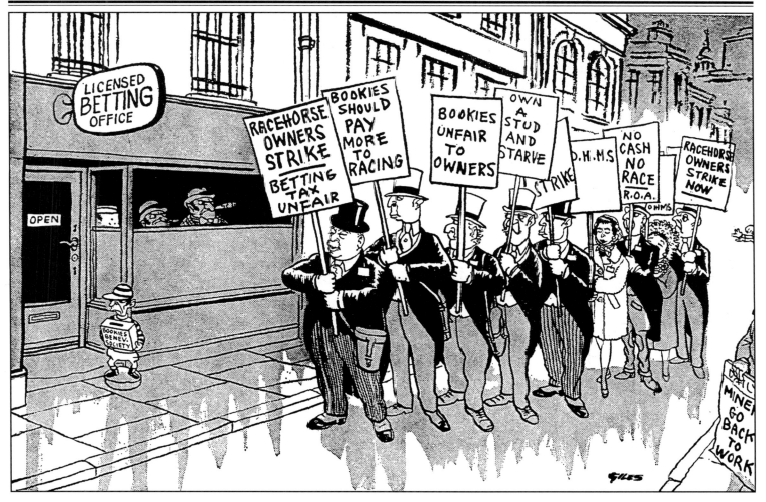

"The show must go on ... "

Daily Express, Nov. 19th, 1970

The Queen was delighted with this cartoon and wrote to Giles to say how amused she was. The country was suffering from more industrial unrest than it had since the General Strike and even the bookies were threatening action. Here, Giles presents the imaginary outrage of horse-owners 'coming out'. Celebrated owner Lord Rosebery heads the picket. The sovereign is sixth in line. The original hangs in the Queen's apartments.

on reflection, *not* the right word) of your cartoon depicting the strike of racehorse owners . . . If you have not promised it elsewhere, the Queen would very much like to have it.'

It is hard to imagine Carl, or indeed anyone else, writing back saying: 'Sorry, Ma'am, but I'm saving it for a bloke at The Fountain.'

Perhaps oddly, given his expressed views on the paper in which they appeared, the most avid royal collector of Giles originals was Prince Philip, who amassed fifteen of them.

Among his favourites is the drawing of 5 October 1961, produced in response to the rather startling twin news stories that photographer Lord Snowdon, then married to Princess Margaret, had taken to going on shooting parties and that Prince Philip had taken up photography. It shows three young grouse, featherless and scowling, staggering back into a clearing in the heather, one of them angrily addressing the parent birds thus: 'We popped our heads up to have our picture taken by Prince Philip and got two barrels off Lord Snowdon.'

'Just for that,' declared the Duke, 'you can give me the original.'

Carl was amused by Prince Philip. The Queen's consort seemed to indulge in a furtive anarchy, a kind of fantasy rebellion against the frequent absurdities of the position he held. He gave Carl the impression, when they met, that he often saw the situations about him in just the same cartoon terms as Giles might.

During one garden party he nodded towards the slow-shuffling, polite yet eager throng of councillors, lollipop ladies, church worthies, school nurses, local press grandees, blimps, engine drivers and charity ladies. The vista was one of several acres of swaying, undulating finery and pink hats. Prince Philip, glancing up at an angry June thunderhead behind the Palace roof, said wickedly: 'Wouldn't it be marvellous if it just chucked it down right now.'

Carl also speaks with admiration of the time that the Duke turned a garden hose on the press at the Chelsea Flower Show. Kindred spirits, in a way.

The same could not be said, of course, for the Duke and the *Express* itself. No one was ever quite sure why he regarded it with such loathing. Of course, he hated all the tabloids, but the *Express*, essentially a royalist paper, seemed to touch a particular nerve. It did tend to poke fun at Prince Philip in a rather barbed fashion and it may have been that he was aware of a more than token lack of respect. But then, he was a good target. His crude, much-publicized exhortation to the nation to 'pull its finger out' elicited a drawing by Sir Osbert Lancaster, the greatest pocket cartoonist of the age, in which his upper-class Mayfair lady Maudie Littlehampton asks of her upper-class Mayfair companion: 'Out of what is it, exactly, that Prince Philip wishes us to pull our finger?'

Yet Carl remained a fan of this prickly royal and held him in high esteem – though his favourite description of the Duke might not have suggested as much: 'He always looks,' says Carl, 'like the man who had come to see about the smell on the landing.'

Giles on the Move

1: Wheels and Sails

Giles was perhaps unusual among the denizens of Fleet Street and Suffolk drinking holes in that his pursuit of pleasure took him as often to the great outdoors as into the great indoors of The Fountain and El Vino. A bold and talented sportsman – he was no mean horseman and an enthusiastic sailor – he early embarked on a long and expensive romance with fast and glamorous machinery. Especially machinery that would go from one place to another as rapidly and as flamboyantly as possible.

This passion very nearly ended in disaster in the first flush of its fulfilment. In 1933 Giles acquired a motorcycle, a Panther 600, kicked into action by a violent thrust of the right heel and ridden in gauntlets and goggles reminiscent of the First World War flying aces. It made an ear-splitting racket and lesser creatures scattered from its path as they heard it coming. Giles loved it.

And it nearly killed him. One day, tearing round a corner near the Isleworth studio where he was working at the time, oblivious to all except the thrill of the banking machine and the wild song of the engine, he went straight into the grille of a huge lorry outside the studio gates.

He remembers nothing. He was incapacitated for almost a year, during which time his cousin Joan tended him in his plaster, frame and straps in hospital and soothed him in his convalescence. It wasn't the last time

he was to rely on her care and loyalty in extremis. This time, he had fractured his skull, done lasting damage to his hearing and, most seriously from the career point of view, seriously hurt his drawing hand.

But he hadn't damaged his enthusiasm for engines and the beautiful machines they propelled. By the time war broke out he was driving to work at *Reynolds News* in one or another sporty car, precious possessions which he guarded jealously from the envious attentions of marauding youth.

'I always had open cars,' he says, 'and whenever I looked down I would see a kid sitting in it at the wheel. I would go racin' down the stairs and usually couldn't catch 'em.

'Once I did, and I grabbed the little bugger and dragged him into *Reynolds News*. I had intended to give him a clip round the ear he would remember for the rest of his horrible life, but he made so much noise that I just let him go.

'I discovered later I had frightened him so much that he peed in my car.'

Another object of Giles's mechanical affections in these years was the tram. He loved drawing them, and they appear frequently in his cartoons for *Reynolds News* and the *Express*, every detail rendered with impeccable accuracy. He remembers how they squeaked and clattered round the eight-line junction outside his home

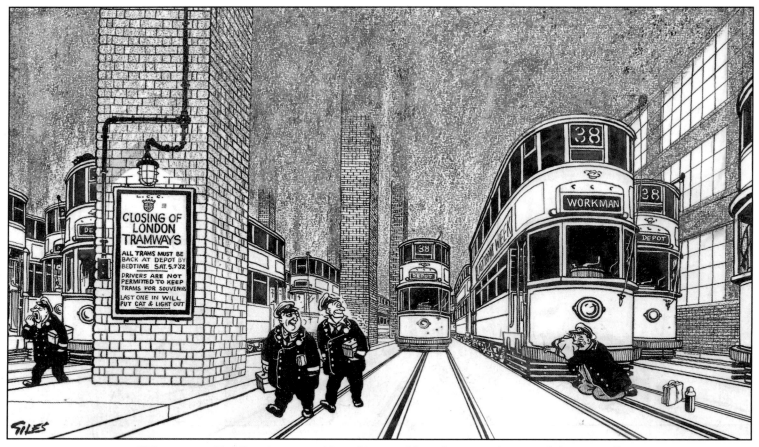

"If you saw Fred's missus you'd understand him being in love with his tram."

Sunday Express, July 6th, 1952

in Islington: 'Oh, and the smell, when you got a shower of rain on the dusty streets and the smells came up like an orchestra, the trams and the oil on the rails and the electricity transformers. Lovely, lovely!'

In July 1952 Giles drew a cartoon for the *Sunday Express* to mark the news that London's tramways were to be closed. It shows a weeping driver on his knees bidding farewell to his beloved tram; the figure could have been Giles himself.

After he had swapped wartime London for Belgium in the last year of the fighting, Giles's fascination with cars led to a new object of desire: the jeep. There may not have been anything particularly stylish about this conveyance, but it would elicit in Giles a reaction reminiscent of Toad in *The Wind in the Willows*: he had only to see one rattling past and he would be on the verge of shouting 'Poop poop!' For a time in the war he had one for his own use, along with a driver, and such

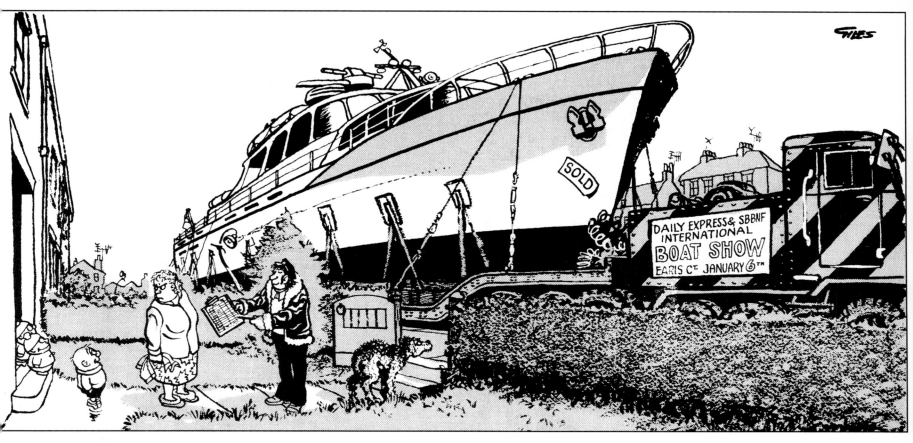

"That's not bad going—the man promised me immediate delivery, and we don't have to pay until the end of the month."

Daily Express, Jan. 6th, 1977

was the attachment he developed for these vehicles that he was later to terrorize his home county of Suffolk in one very similar, bouncing round farm and village in a manner reminiscent of his beloved GI friends.

By the war's end, he could do better than a jeep, however. 'Helping yourself', the somewhat coy euphemism for looting, was rife, if not universal, among the troops advancing into defeated Germany; now it sounds shocking, but at the time it was simply custom-

ary: you just took what you could find.

'I nicked a whole lot of cars,' admits Giles. 'I had a lovely little open sports Mercedes for a while – it was late spring and the weather was glorious – but that was nicked back by another German, the sod. So I just found another one – but it was no real replacement.'

Giles evinces no jot of shame concerning these informally acquired trophies of war. And it wasn't just cars, either:

221

"I can't tell you exactly where you are, lady, but if you stop on that road and about thirty of them hit you up the rear you'll know you're on a motorway in England."

Daily Express, Oct. 17th, 1944

'Oh, I had everything,' he says. 'I had the most expensive camera you could imagine. And watches and binoculars and radios and antique objects and even a violin from a bombed-out house. In fact I had so much that when I eventually got back to the coast, they refused to take me on an aircraft and suggested that I go back by boat. Which I did.

'One of the most important things I got hold of were a pair of beautiful shoes which I found in a shop. I got them for Joan.

'You wouldn't believe what happened. There was this little fart from Reuters called Doon Campbell – a little sneak of a man – and he pinched the shoes when I was asleep. I knew he had done it the next morning. I could tell by the look on his face.

'I went straight to his kitbag and took the buggers out.'

Back in Suffolk, at Hillbrow Farm, to which he and Joan moved in 1946, Giles set about living his life to suit himself. Dispatching his cartoons to the *Express* three times a week by train or taxi, he farmed his pigs, drove his American jeep around his domain and acquired the first of many sleek and beautiful cars – later to be joined by sleek and beautiful boats. And he built the vast workshop from which was to emerge in due course the famous Family caravan.

The pig farming element of the set-up may seem somewhat out of kilter with the rest of what is generally known of Giles's lifestyle. Not so. It is all of a piece with his practical, functional approach to getting things

"Lady, don't ask me why they always have to have pictures of pretty girls to sell their cars—just go eat your sausage roll somewhere else."

Daily Express, Oct. 18th, 1962

223

"It's the garage, Dad—the 'Happy Motorist Car Washer' you've bought Mum for Christmas is in."

Daily Express, Dec. 19th, 1972

"At the risk of running into trouble with the Sex Discrimination Act, your presence is required in yonder meadow."

Daily Express, Dec. 30th, 1975

done. What Giles cannot abide is any sentimentality towards animals. This attitude has on occasion given him a reputation for harshness, even cruelty. One notorious episode concerns a private film project of his. The film was to be called *The Ugly Duckling* and was largely shot in and around Hillbrow Farm; but there was one sequence he wanted to do in London. This was to show a duck walking from one side of Fleet Street, outside the *Express* building, across the busy street, around and under the flow of cars, taxis, Number 73 buses etc., and

safely on to the pavement on the other side. Carl, anticipating a high mortality rate among his feathered actors, had brought along to the shoot a number of identical ducks. Not all survived the location filming.

It isn't a very comfortable anecdote; it even suggests a worrying link between Giles himself and his fictional monster children who attach fireworks to the cat's tail. But those who suspect Giles of being capable of deliberate cruelty towards animals are probably being led astray by mischievous remarks prompted by his impatience with

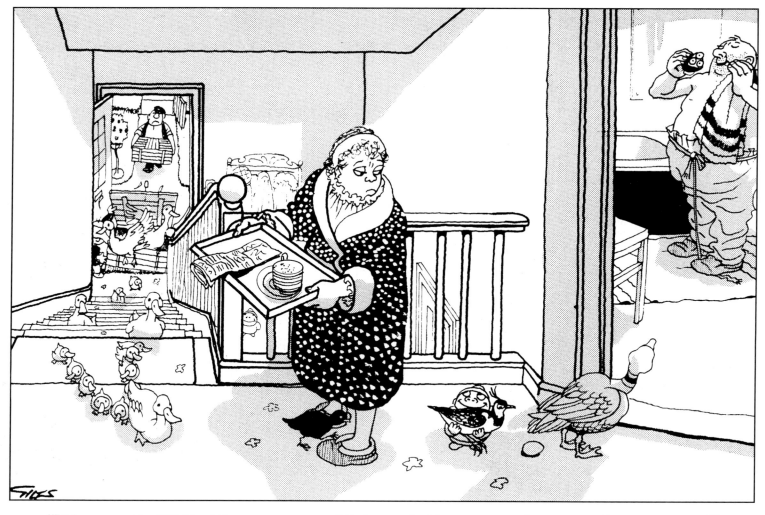

"Did you see the Wildfowl Trust suggest we all 'adopt a duck' to preserve the species. Can you imagine?"

Daily Express, July 26th, 1979

sentimentality. Asked by Arthur Christiansen's wife Brenda on a visit to the farm how he managed to keep the ducks so still for the filming, he replied wickedly: 'I break their legs.' Brenda was appalled.

Carl's long-standing friend Michael Bentine explains.

'No, he's not cruel. He just tells these stories to shock. It's slightly dark humour. He didn't really break a duck's legs; he just wanted to see the reaction when he said he did.

'What you've got to understand about Carl is that he

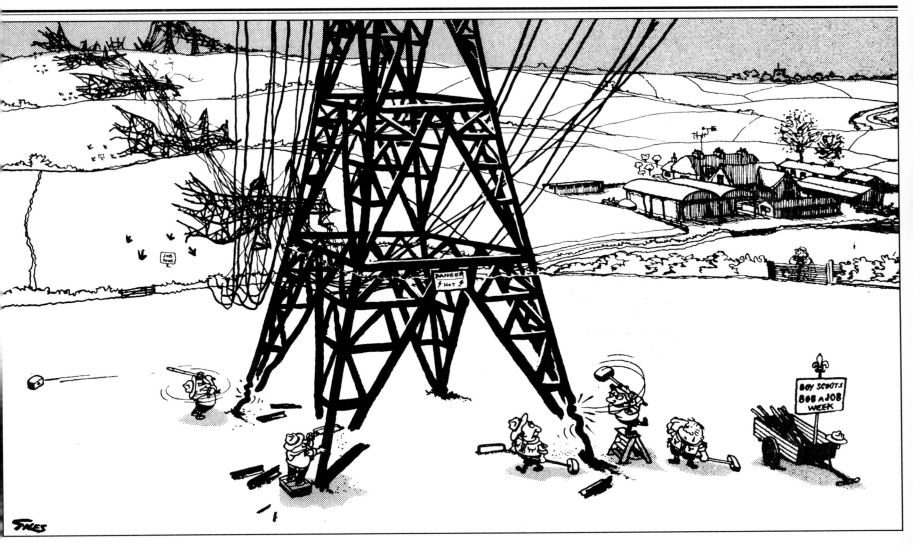

"I hope this client knows what he's doing—giving us a bob for every pylon we knock down on his farm."

Sunday Express, April 18th, 1965

During the mid-sixties a double line of pylons came stomping over the horizon like those Martian machines in H. G. Wells's War of the Worlds *and right across* Hillbrow Farm. *There they stand with their feet planted in one of Giles's meadows, a hundred yards from the house. Giles fought a fierce battle, but lost.*

is a countryman. What he's reacting to is what he perceives as town people's view of the countryside. You know the kind of thing – 'ere Mrs Stapelly-Farmyard, you 'ave a nice cuppa kindly tea now and 'elp yerself to another piece of nithering cake. The plan fact is that country people are chicken-stranglers, horse-knackerers, pig-slaughterers and sheep throat-cutters.

'He's not really cruel, but he can't stand sentimentality about animals. He hates the idea that anyone would spend more on pet food for cats than they would on starving children. He loathes the idea of pampered pets, but loves gun dogs. He likes the idea of animals behaving naturally, and in their natural habitat. If they have to be shot because they're being a ruddy nuisance, then that's it.'

And Giles is happy to get on with shooting the ruddy nuisances himself, even from his wheelchair. The very sight of rabbits on the flowerbed calls forth a bellow of 'Get my gun!' directed at the nearest helper.

Another aspect of this robust view of animals was the recognition that they often had a great deal more dignity than people. One cartoon shows a pair of clean, happy pigs in a clean, tidy field, decorated by a row of clean, tidy piglets, gazing with smiling derision over their fence at the litter of old cans, packets, chip papers and empty bottles scattered over the neighbouring picnic site. The caption: 'Yet it's us they tag "dirty".' Giles the pig farmer knew what he was talking about.

A similar impatience with humbug is evident in his equestrian cartoons. Giles was an accomplished horseman – his paternal grandfather had after all been a jockey to King Edward VII – and had himself ridden in point-to-point races. He had no illusions about the dangers of the sport and no time for those do-gooders who wanted to stop it. In a cartoon of a cross-country riding event which seems to have resulted in a large number of loose horses, their riders unceremoniously dumped in the water, a pair of town-dressed worthies bearing placards declaring 'Jumping Unfair to Horses'

and 'Ban Badminton' are addressed plaintively by one of the drenched jockeys: 'Lady, you don't happen to have one about horses being unfair to riders?'

And perhaps only someone who had ridden in races himself could have thought up that cartoon of Aintree's fearsome Becher's Brook, the airborne horse casually enquiring over his shoulder: 'What's it worth if I let you stick on?'

Increasingly, though, as the years passed, the artist's pursuit of excitement and speed involved cars and boats. Giles shared a passionate love of sailing with the son of his patron, Lord Beaverbrook – Max Aitken, celebrated Battle of Britain pilot and heir to his father's business empire. The two men enjoyed one another's company and Carl, who later owned yachts of his own up on the River Deben in Suffolk, occasionally crewed for Aitken down in the Solent. Here he would stay at the Aitken home in Cowes, a former tavern called the Prospect of Whitby, and on his host's invitation would take part in offshore races. A hardy enough soul himself, Giles nevertheless found these experiences as unsettling as they could be exhilarating.

'He was a brilliant sailor,' says Carl, 'but he was an absolute bastard of a skipper.' Anyone who has scrabbled about a deck tilting this way and that with hundreds of square feet of sail thunderclapping overhead while attempting to respond to the bawled orders of an irascible helmsman will sympathize. 'He was a Captain Bligh,' says Carl. 'I hated sailing with him.'

More fragile temperaments took the kind of abuse dealt out by Captain Aitken deeply to heart and fretted over it for weeks. Carl took a deep breath and returned to normal. And he reaped his reward – though no doubt primarily for his artistic excellence and value to Express Newspapers rather than for dogged determination under the lash of a nautical tongue.

In the more civilized environment of dry land Aitken and Giles would lunch together regularly at the Hyde Park Hotel, a prestigious establishment of the Beaverbrook empire at the end of Piccadilly. On one

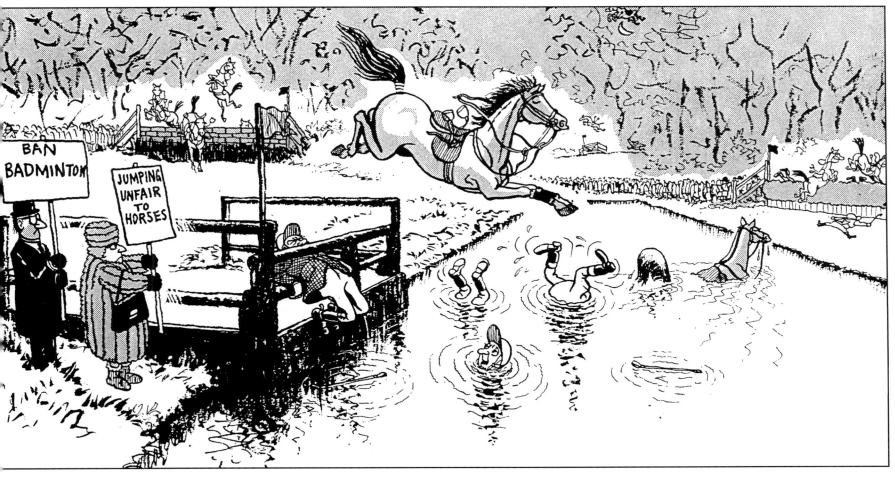

"Lady, you don't happen to have one about horses being unfair to riders?"

Daily Express, April 30th, 1974

Giles loved horses and was himself a skilled horseman who had once given professional lessons.

such occasion, Aitken asked Carl to go for a walk with him after their meal. This was nothing unusual; Lord Beaverbrook was for ever whisking one employee or another off to walk with him in the park, and his son was maintaining the family tradition.

'I went along,' said Carl. 'Max insisted it was good for you. So I had to. But I couldn't see much point in walking when there were better things to do.'

The pair eventually found themselves outside Jack Barclay's famous Piccadilly car showroom, behind whose plate glass basked in tasteful splendour the world's most beautiful – and expensive – motor cars.

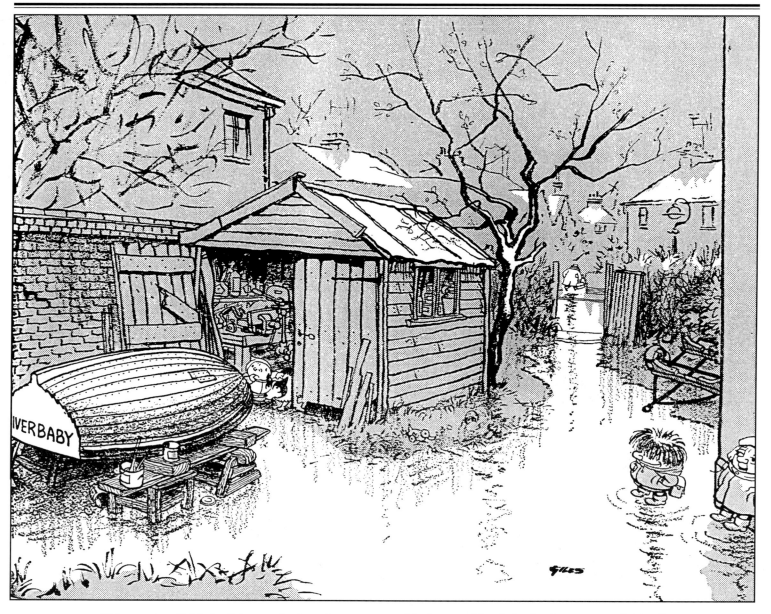

"He spent all his holiday painting the name on his boat—I hadn't the heart to tell him."

Daily Express, April 12th, 1966

"The ref's blown for offside—you can tell by the bubbles."

Sunday Express, Oct. 24th, 1982

"To think we didn't go to the seaside because of oil on the beaches."

Sunday Express, March 26th, 1967

'We went in,' recalls Giles, 'and I left Max talking to Jack Barclay while I wandered around looking at the cars. Then Max called me over and said: "If you were to choose one for yourself, which would it be?" I pointed to a black Bentley Continental. "That would be my choice, Max," I said.

'Max then said: "Have you got a return ticket to Ipswich?" I told him I had. "Give it to me," he said. I did so. "Right," he said. "I'll keep this and you go home in that." And he pointed at the Continental. He then just walked out and was gone.

'I didn't believe it was happening.

'Then Jack Barclay said: "You're a very lucky young man. He's just bought it for you."

'I remember arriving back in Ipswich and visiting every pub I knew. Later, as I drove slowly round one corner, two policemen actually raised their helmets as I went by.'

It was around this time, in the sixties, that Hugh Cudlipp was attempting, fruitlessly, to lure Carl over to the *Daily Mirror*. It is impossible to know whether Max Aitken's sailor's nostrils had picked up the faintest whiff of combative interest from the rival establishment, and whether, if they had, the magnificent gift of the car had anything to do with repelling boarders; in any event Giles turned out to be unpoachable. 'In the end,' says Cudlipp, 'there seemed to be nothing that would persuade him to leave the *Express*.'

Not all of Giles's sailing cronies were as intimidating as Aitken on the water. Sometimes, indeed, the boot seemed to be on the other foot. His friendship with Michael Bentine was based in part on their mutual love of boats. According to Bentine, 'He was a brilliant sailor and I was useless. But we used to really do it properly. He just had that same magical feeling about yachts and boats and barges. We loved the mystique of it all. We weren't the sort of yachting people who shouted out "Hello there, ahoy, what a spanking good breeze," we really sailed the bloody things.'

And they had their lighter moments. They once collected a vicar from Felixstowe in order to sail him to a 'blessing of the assembled boats' up the River Deben. The vicar stood on the prow as the vessel progressed along the coast, his surplice flapping in the persistent offshore breeze like a supernumerary sail. This being a Giles trip, it was punctuated with visits to a number of shoreside taverns, and in between stops powerful beverages were handed up to the minister from the galley.

By the time the man of the cloth had been delivered to his bobbing congregation he was three sheets to the wind, his swaying on the prow only partly due to the movement of wind and water, and as he raised his hand to give the sign of the cross he looked almost as if he was about to cast himself upon the waters.

Giles's aquatic activities were a thorn in the side of the land-bound at the *Express*'s London offices. Occasionally one of these worthies would find cause for concern in some detail of a cartoon. They would call Hillbrow Farm, only to be told that Carl was 'at sea'. The Suffolk coast pubs would be alerted and a watch set for Carl's vessel. Eventually a pair of binoculars would pick it up and someone would be dispatched to the shore with a loud-hailer to bellow: 'Carl, could you please call the *Daily Express*?' This would elicit much cursing from the sailor, who would eventually nudge his boat alongside at a nearby landing point, grudging the interruption of his voyage in order to deal with some hateful newspaper official who had probably never seen a yacht from closer than a cable's length.

Even in more recent times, when confinement to a wheelchair set a severe restriction on his activities, Giles still frequents the coast he loves. Tenderly manoeuvred in and out of wheelchair and car by his friend Louis, to the accompaniment of the latter's unceasing refrains of 'Bootiful' and 'Loverly', he will be ferried out to the old waterside inns and taverns they have both known nearly all their lives.

An especial favourite is the Maybush, a pub on the estuary just outside Ipswich where Carl used to moor his own boat. Boats of all shapes and classes are still

*"As long as you share his great British passion for sailing, its beauty and its horizons—
you should have a reasonably happy marriage."*

Sunday Express, Jan. 4th, 1981

"She says we made Dunkirk in 1940, so we can make it again to pick up her sister, Florrie."

Daily Express, Aug. 19th, 1980

pulled up into the adjacent yard, and the nautical ear is gladdened by the constant sound of halyards slapping against aluminium masts from the vessels dipping and swaying at their moorings outside the picture window of the saloon bar.

The first group of drinkers Carl and Louis pass as they enter the bar are fresh from the sea, downing much-needed pints; the men have beards and the women have tousled hair and bright red cheeks, and they are all standing with their legs apart as if to balance themselves on a pitching deck. They wear polo-necked sweaters and lanyards trail from their pockets. Their feet are clad in

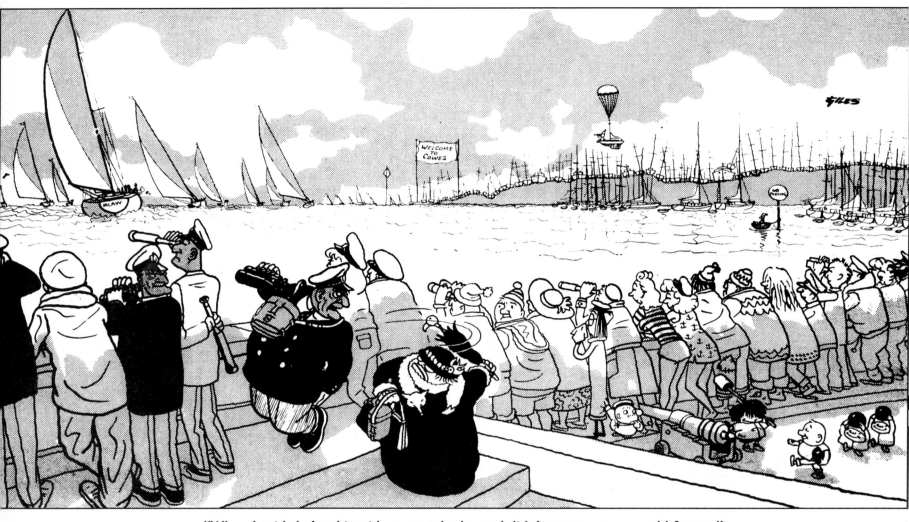

"When I said she's a bit wide across the beam I didn't mean you, you old faggot."

Sunday Express, Aug. 1st, 1965

deck boots – sailing wellies – and their bright yellow oil-skins squeak as they raise pint to lips.

It's not hard to see where Carl looked for the rich and hilarious detail which brings his sailing cartoons to life. And indeed, there is a Giles cartoon hanging on the wall of the Maybush, a regatta scene so hectic with activity that it takes a good twenty minutes to absorb.

There is one cartoon which captures in a single drawing much that is characteristic of Carl's life and adventures in Suffolk. It shows a yachting party in a

236

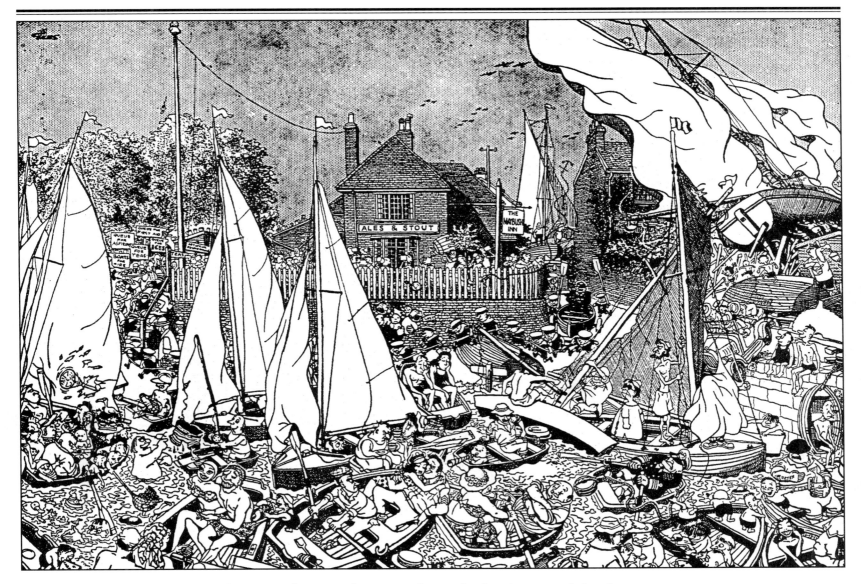

I must go down to the sea again, to the lonely sea and the sky ...

Sunday Express, July 20th, 1952

This cartoon features the Maybush Inn near Ipswich. The waterside pub has for a long time been a favourite of Giles's. It is often full of sailing types in oilskins and rubber boots.

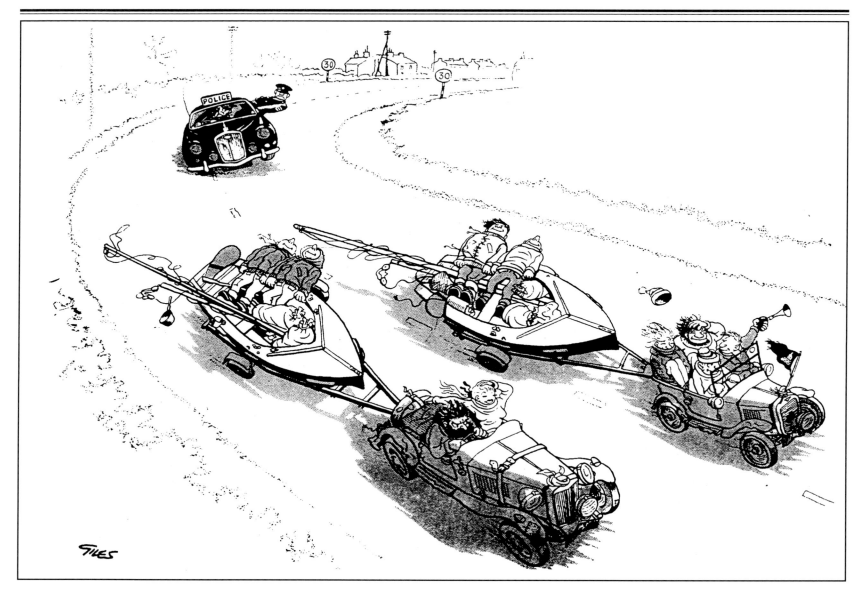

This surreal drawing shows a combination of the pursuits which Giles loved best: motoring, sailing and keeping the constabulary on its toes.

couple of car-towed dinghies speeding round a corner, pursued by irate police. The sailors are all hanging out of their boats as ballast in the traditional fashion, to prevent their craft from keeling over – and the policeman in the following car is doing the same.

Carl likes this picture. It's all there – the exhilaration of speed on the highway, the boats, the mischief, the summer, the fun, the police to be outwitted . . .

Carl was a highly responsible sailor, much respected by his peers, but on the road he liked speed. He was a good driver, but a fast driver, and his encounters with the East Anglian constabulary were legion. A pair of bobbies would be dozing quietly in some Suffolk layby when all of a sudden there would be a roar and a piece of expensive metal would rush past in a blur. The policemen would adjust their caps and set off in pursuit.

Some time later, the face of the law, contorted in mock anguish and long-suffering, would appear at the window of Carl's latest high-performance roadster.

' 'Ello, Mr Giles, in a hurry to get our cartoon to the train again, are we? Got to catch our deadline, 'ave we?'

It was the same everywhere. In 1948 he took Joan to America on a trip funded by Lord Beaverbrook – a driving visit, coast to coast, from which the artist was to send back his impressions in cartoon form for the paper.

America, for Giles, was glorious – a movie come to life. The police, in particular, were so like the figures that he had seen in the cinema, looking and behaving in exactly the same way and apparently reading from the same script, that he found it difficult to take them seriously. Until they politely compelled him to.

There was one particular encounter in the Midwest that he recalls vividly. He had driven straight across a main intersection, contriving to avoid collision with any of the huge trucks pounding past but not to avoid being spotted by the Highway Patrol.

'The bike came up in my rear view mirror with its siren going and a light flashing,' recalls Carl. 'The policeman got off very slowly and walked to my car. He was one of those with a cowboy hat on. He leaned down and looked at me in a good-humoured kind of way, took his hat off and scratched his head slowly and thoughtfully with the same hand. After quite a long while of studying me he said: "D'you know, sir, that you just went through a stop sign?"

'I hadn't seen any stop sign. The trouble is that their signs are little round things, like saucers, at the top of a very high pole. I don't know how anyone sees them.

'I said to the policeman: "I didn't see any sign." He said: "Will you come this way, sir?" So the two of us crossed this six-lane highway to get to the sign on the other side. It took us ages, with all this heavy traffic going by. When we got to the other side we both squinted up at the top of this great, long pole.

'The policeman asked me: "Can you see anything up there?" I said: "Well, I can see a little sign, but not even you could read that." He didn't say anything and we walked all the way back across the highway to the car. As he was writing out the summons he said: "Now, you will remember that sign, won't you, sir?" He must have thought that I looked doubtful, because he gestured to me with his index finger and we did the whole thing again, walked across this great interstate highway and back to the post with the little sign. "See that sign up there?" he asked me. "Yes," I said. "Can you read it, sir?" "Yes," I said. We then walked all the way back to the car again. Joan had just been sitting there.'

On the occasion of one of Giles's most unnerving experiences in a car, he was not the driver. This was in the late fifties, and he was in the back seat of a Ford Anglia driven by his dear friend Clifford Clarke, an Ipswich tailor.

Swinging round a country bend, the car lost its grip on the road. Leaving the tarmac, it jolted up onto the bank, just missing a tree; then it rolled back onto the road and came to rest, steam hissing from the radiator and bits of glass and metal tinkling down to the ground. Carl slowly untangled himself in the back seat, wondering if he was hurt. He became aware of a

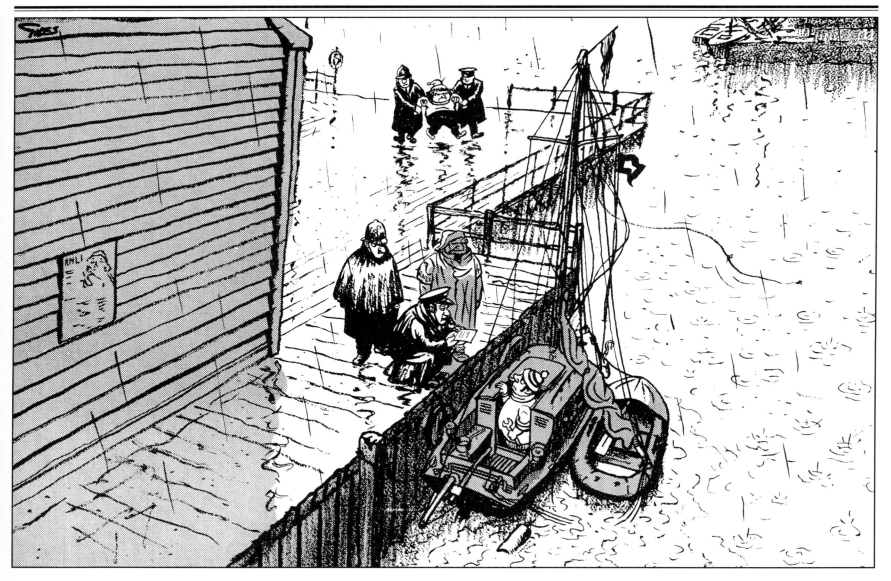

"This anonymous note saying you have a bomb on board—we have reason to believe it was sent by your wife who isn't very keen on sailing."

Sunday Express, May 30th, 1970

"Madam, because there happens to be nobody aboard, it does not mean this ship is abandoned, and what you have there is not salvage—it's loot."

Daily Express, Jan. 6th, 1983

stickiness at the back of his head and gingerly reached round with his fingers. Horrified, he felt them sink into a warm mush, in which they touched small, sharp fragments, loose and moving about in the goo. Skull and brain. He was done for. There was no pain; oblivion could be only seconds away.

But it wasn't. What had in fact happened was that the impact had smashed the back of his head into a paper bag full of eggs – eggs from his own chickens, which Cliff had put on the ledge by the back window. After that, even though the car was a write-off, it was hard to feel too bad about it.

"This gentleman complains that you flew low over his nudist camp and stuck a parking ticket on him."

Sunday Express, Sept. 2nd, 1979

Catastrophe was to come even nearer later on as a result of Carl's insatiable curiosity about things mechanical. The taxi service that took him to his country lunches with members of the royal family frequently took the form of Tommy Sopwith's helicopter. Tommy, son of one of the country's greatest aviation pioneers and a friend of Princess Alexandra, would bring the whirring machine down into Carl's meadow, scattering chickens right and left, and run over to the house to fetch him.

On one such occasion, Carl became so intrigued by the controls that he was unable to resist discreetly – and utterly recklessly – twisting a knob down by his co-pilot's seat which bore the mysterious labels 'Increase' and 'Decrease'.

This was the handle which controlled ascent and descent. The helicopter, only just above the fields at the time, had still not cleared the pylons and high-tension electricity cables which straddled the farm. As Carl twitched the knob, the nose of the machine dipped and the helicopter began to drop sharply and with potentially lethal determination towards the ground.

Sopwith only just managed to halt the plunge. The rotor blades sent a swirl of down-draught over the grass as they levelled out, flying *under* the electricity wires. As they regained height, the pilot raised an admonishing index finger and addressed Carl with trembling solemnity – and commendable restraint: 'Carl, never, never do that again.'

These risks and thrills are now the stuff of memory. Wandering among the outhouses at Hillbrow Farm these days, peering through the panes of glass or cracks in the wood, you can catch glimpses of Carl's Bentley Mulsanne, dusty and long unused; or you might see his Jaguar XJ 120, which he raced at Silverstone, its tyres now flat and its bodywork showing the odd blister of rust; there too are his Range Rover and Land Rover, the first models ever sold. These were adult toys of the most spectacular kind, but Carl may never play with them again. 'I don't like to think of them too much,' he says.

Giles on the Move

2: The Family at Large

When Carl and Joan moved into Hillbrow Farm just after the war they acquired more than a house. There was the land, of course, populated by pigs and chickens; and there were the outbuildings, including Carl's extraordinary workshop, from which emerged the most remarkable love of his long and varied travelling life – the caravan, that extraordinary, even bizarre vehicle that sped through real and cartoon worlds alike, whisking Joan, Carl, friends and family – and Family – around Britain in a series of glorious and hectic odysseys.

Carl's workshop might in fact more accurately be described as a private factory. Sixty feet long, well lit and professionally equipped to build an ocean-going liner (which he didn't) or a studio/caravan (which he did), it was crammed with every imaginable tool a craftsman-cum-engineer might need. There were lathes of every description, a huge compressor, jigs and frames and sheets of metal and wood, row upon row of hand tools, neatly categorized in racks for each type – and an enormous wall area covered in pigeon-holes of the kind you find in the very best old-fashioned ironmongers, home to nuts and bolts and screws and nails and joints and washers and tappets and gaskets and eyelets and grommets, all in an endless variety of sizes and fittings, all lovingly kept in perfect order. No wonder Carl allowed Father's shed in the Family garden to expand magically when needed to

give him a chance to draw a version of his DIY paradise.

Here, in dirty white overalls, Carl would spend whole days completely absorbed in his constructor's world. Joan would deliver sandwiches and cups of tea and fade away again, unnoticed.

Carl did not go entirely unmolested, however. When children were staying, their mothers would shoo them from Sunday lunch preparations by urging them to 'go and see what Uncle Carl is up to'. The little figures would creep into the fascinating shed, at first hovering at a respectful distance to watch the engrossed figure bending over the workbench. Gradually, as they became less intimidated, inch by inch, as if in an impromptu game of Grandmother's Footsteps, the kids would draw closer. Carl would remain unaware of their presence until, all of a sudden, little pink fingers would appear under his nose, picking up and dropping nuts and bolts and other interesting and arcane items.

Carl claims he became impatient with this intrusion and that he successfully employed a simple deterrent. When he was welding, which was often, he would wear the sinister steel face-protector, in whose window was reflected the eerie blue flickering of intensely hot fire, and would from time to time simply run his oxyacetylene torch along the row of bolts and rivets which awaited his attention. They apparently glowed with what Carl called 'black heat'. When the little fingers

"You've bought Grandma a WHAT for Christmas?"

Sunday Express, Dec. 21st, 1980

"Christmas comes but once a year—another fort for me and another doll's cradle for you."

Sunday Express, Dec. 8th, 1985

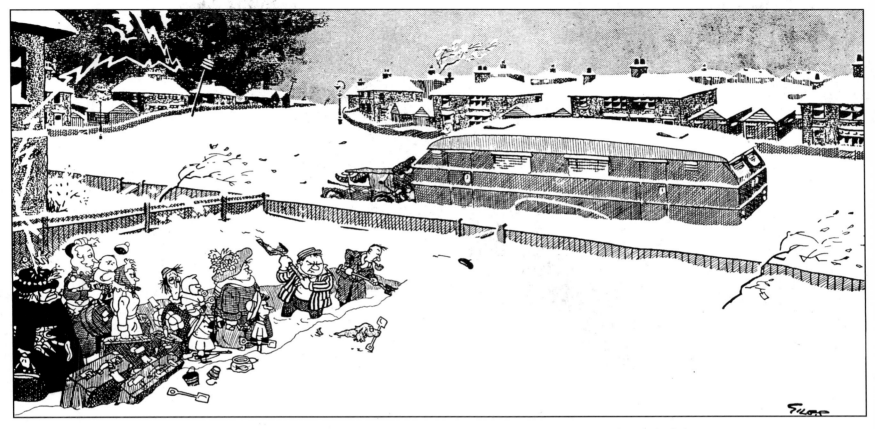

The Giles family left this morning (weather permitting or not) by caravan for its holiday.

Daily Express, Aug. 14th, 1951

Giles had built himself a caravan, an extraordinary vehicle which was both luxury home and travelling studio. His employers in London had viewed the project from afar as simply one of those eccentricities which they had come to expect of the unpredictable cartoonist. They were not to know then what a role it would play in the years to come.

The original caravan had been constructed amidst the outbuildings of Giles's Suffolk farm. It was to become the travelling home both of the cartoonist and Joan, and – in a surreal sense – of the Family members.

seized these objects, there was a short and pitiful cry followed by the scamper of feet and distant wailing appeal for maternal aid.

As with many of Carl's more alarming stories – one is reminded of the ducks – it is impossible to know how much is true and how much is mischievous fantasy.

Regardless of interruptions and the exigencies of newspaper schedules, over a period of a year the gloriously eccentric studio on wheels was completed. Thereafter, year after year through the fifties and into

247

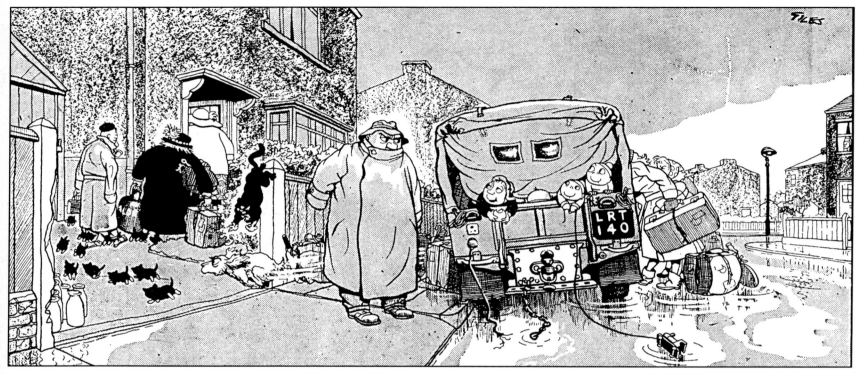

"Caravan? The caravan came off hours ago."

Daily Express, Sept. 11th, 1951

the sixties, it was merrily towed around the British Isles by Giles in his Land Rover, establishing as it went an immediate reputation as a kind of pub on wheels, open all hours, free to all-comers, a kind of never-never land where the fictional cartoon world, especially that of the Family, mingled with the very real existence of Carl Giles the artist, traveller, reveller, craftsman.

The planning and construction of this extraordinary vehicle seemed to owe as much to aircraft design as to conventional caravan manufacture: the wooden ribbing which formed its frame might well have been the basic structure for the fuselage of an early Second World War bomber, and later on a feature was added which looked like an aeroplane fin. This latter was in fact a gravity-feed tank for the caravan's fifty-gallon water supply – built to aerodynamic specifications. From this resource the Gileses – and the Family – washed, showered, rinsed the dishes and filled the kettle.

But the real oddity, and the touch of engineering genius, of this vast travelling home was the studio facility cunningly packed into one end. When required, a section in the side of the vehicle was unlocked and simply rotated outwards and downwards; there emerged a brightly lit area which offered a sloped drawing board, shelves, pigeon-holes and all the other infrastructure a cartoonist required. The studio window even had its own windscreen wiper.

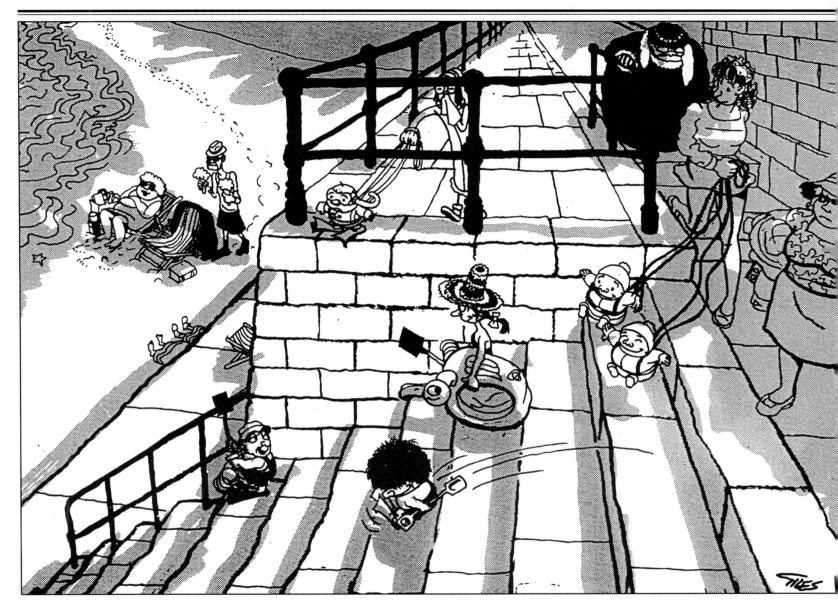

"What an escape from the Gulf crisis—watching Chalkie on holiday!"

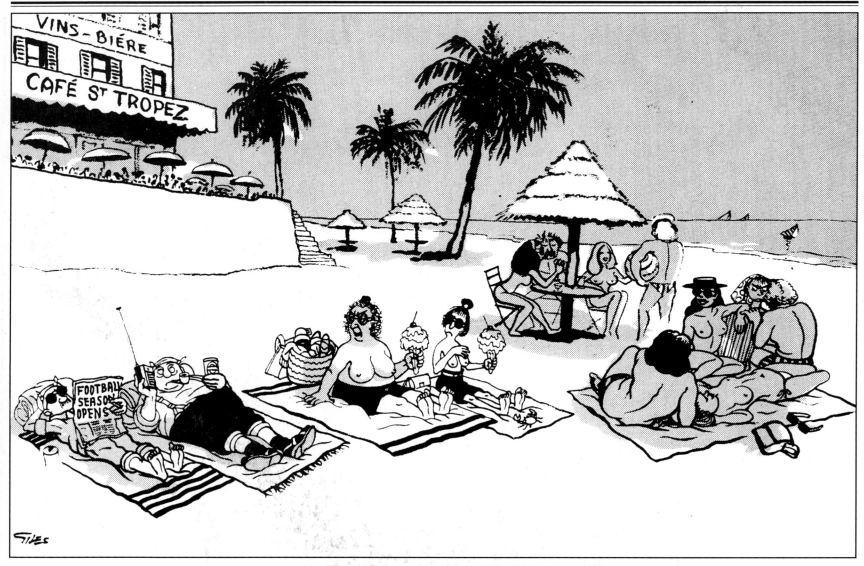

"We'll give them five more minutes to notice us or it will be on cardigans."

Sunday Express, Aug. 21st, 1983

250

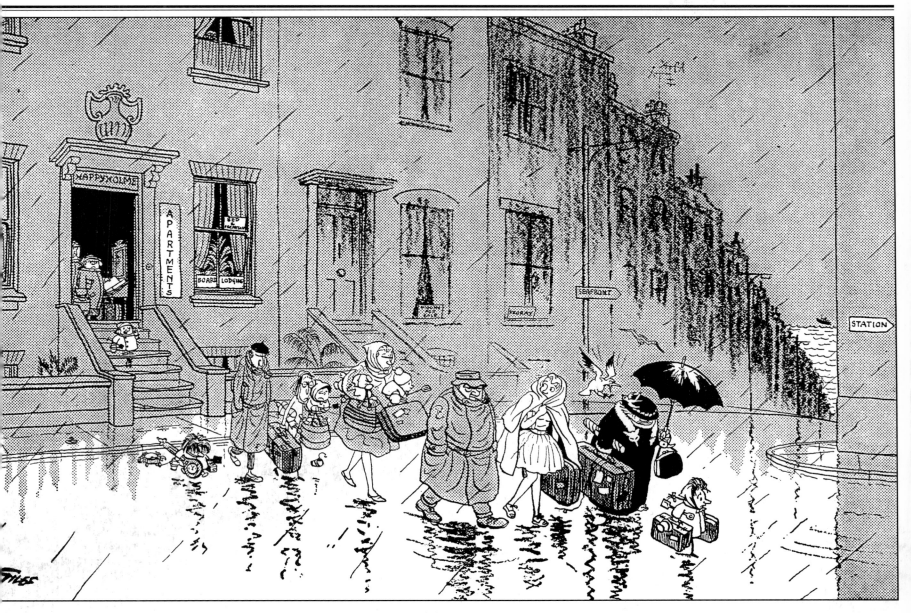

"Dad! Mum says come back and scratch out what you wrote in the Visitors' Book at once."

Sunday Express, Aug. 12th, 1962

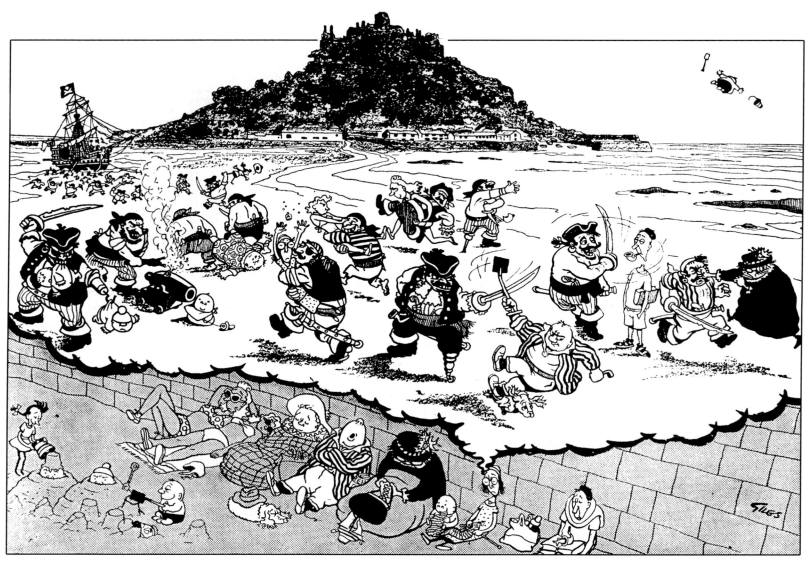

The dream of Vera ... on a Penzance beach

Daily Express, Aug. 28th, 1951

For the benefit of Joan, ever the accomplished hostess, there was a luxuriously equipped galley, glittering and gleaming with convenience devices; the bedroom was fit for a royal princess; and the whole interior was beautifully finished, everything shining and polished. The sophisticated lighting system could produce a bright and garish party atmosphere or a cosy, subtle glow.

The final electrical flourish was an ingenious device on the outside of the caravan, a thoughtful touch bearing witness to the exasperation Giles had himself felt when following inconsiderate caravan drivers in any of his fast cars. These oblivious holidaymakers in their bumbling, swaying vehicles aroused the Toad in Giles as nothing else on the road could (except perhaps a traffic warden): honking his horn with desperation and fury, he would lean out of the car to the right in the permanently frustrated attempt to see if the road ahead was clear to overtake.

Other drivers would not have to suffer thus from the Giles caravan. In addition to its two big indicator arrows, it had a large sign that could be lit up when the road ahead was clear to read: 'Ready to be overtaken'. Motorists, reported Carl, waved appreciatively as they sped past.

Nevertheless, even the best-planned launch is vulnerable to the odd hitch, and the maiden voyage was not entirely trouble-free. It had a splendid send-off: soon after dawn the caravan was hitched on to the Land Rover and, to the pleasure of a small gathering of well-wishers and helpers clustered about the gate above Witnesham, proceeded in dignified fashion out into the lane and on towards adventure.

By Derbyshire – disaster. On a main road in driving rain and a fierce wind, there was a horrible lurch and the Land Rover was yanked to the right. Giles stopped and got out to inspect the damage. It was serious. He had miscalculated the stresses; the right wheel had broken under the huge burden it had to carry.

That night and the next day were taken up with tele-

phone calls and waiting about in constant rain, until Giles – whose influence in the motor trade here stood him in good stead – acquired two lorry wheels of the same size as the originals but also of enormous strength. The caravan never let him down again. At each stop the door flew open, the crates of booze flew open, the studio appeared by means of its magical mechanism and Grandma and her tribe spilled out to mix – on paper, at least – with the locals from Cornwall to the Highlands, from the Channel coast to Blackpool.

Grandma, of course, liked a drink as much as Giles himself, and many cartoons feature her purposeful trot towards the nearest pub sign. It is interesting to note, then, that examination of the Family cartoons reveals it to be seldom that any of them are seen the worse for wear. Grandma in particular, despite her impressive capacity for Guinness, always keeps her wits about her. Once, it is true, in the days before the breathalyser, she was apprehended by the constabulary and required to walk alongside a straight yellow kerbside line without veering off to left or right; she obliged without faltering, no doubt to the disappointment of the police, who would

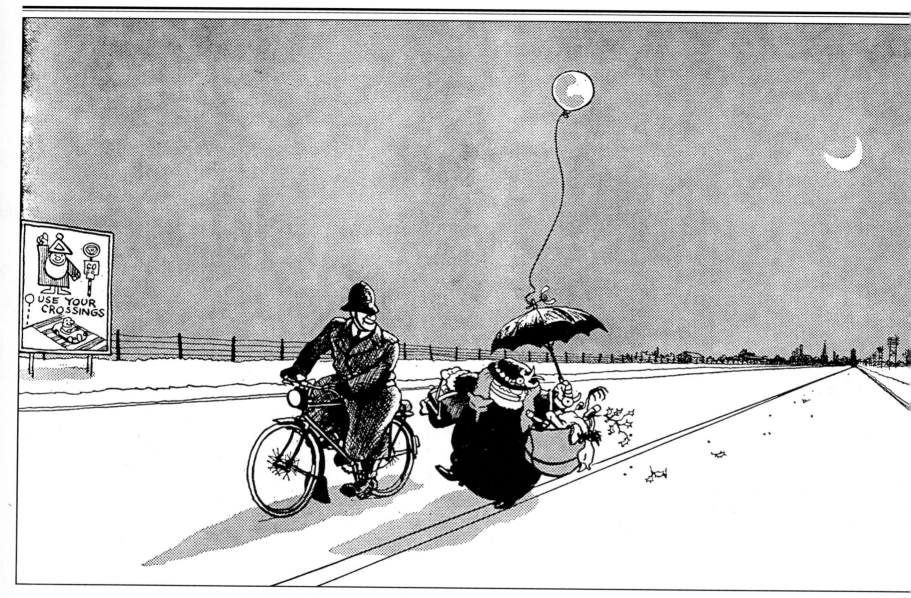

**"Right. You've convinced me you can walk in a straight line for a mile—
now come back to the station while I charge you."**

Daily Express, Dec. 21st, 1962

This was before the breathalyser.

"Sh! Here comes the Dickie Bird."

Daily Express, Sept. 11th, 1954

probably have loved the chance to clap the old menace in irons for a spell. One feels as if certain members of the Family would disapprove strongly were any of them to become overly attached to the bottle. There is little evi-

dence of an overdeveloped sense of propriety in the household – they seem to take Grandma's criminal tendencies and the psychopathic behaviour of the children in their stride, to say nothing of the illegitimate arrival of

"I see you're taking the Loch Ness Monster back with you."

Daily Express, Sept. 18th, 1954

the twins; yet intoxication, it seems, is one weakness beyond the pale. Suburbia has its standards, after all.

Giles particularly enjoyed the forays north of the border, and it was here that cartoon and reality ultimately joined forces, in a Disney-style picture featuring a photo of the caravan surrounded by the sketched figures of the Family – Grandma letting rip on the bagpipes, Father and Mother in tartan and George the bookworm with his pipe still unlit and his nose in the poetry of Robbie Burns.

Such was the abundance of the mutual entertaining

that occurred on High Road and Low Road alike up here that Giles on one occasion volunteered the following disclaimer in the *Daily Express*: 'Should there be any minor discrepancies in tartans, accents or other details which may offend the Highlander, Giles asks that it may be taken into consideration that apart from the 1954 weather and the effort of hauling thirty-six feet of studio up and down mountains he had also to contend with some pretty stiff bouts of Scottish hospitality.'

A particular magnet for Giles – and his Family – in Scotland was the Highland Games at Braemar. The

"If he once mentions Olympic Games or tells us we're all runners in the great race against evil, I'm withdrawing to the Spotted Cow."

Sunday Express, Aug. 5th, 1984

comic possibilities of an event regarded by the American tourist as quaint and by the average Sassenach as not only primitive but barking mad, with the Family spreading their cheerful mayhem about them, were limitless; but it is interesting to note that despite his tacitly acknowledged role as court jester, Giles never featured members of the royal family in his cartoons of the Games, even though various of them were present on one occasion or another. This was a deliberate decision.

There were times when you drew and times when you didn't. If I had included them in those Braemar events it would have been like I was being overfamiliar in a way – like some comedians tend to be. I would have hated for them to think that I was out of line. And it would have been out of line, somehow. The photographers were always poking their lenses at them there. I didn't want to be seen to be doing the same thing with my drawings.

The caravan always aroused huge interest at these events.

People were attracted to it – either because it was so unusual or because they recognized it, I suppose, as the caravan in the cartoons. We would have all kinds of huge Scotsmen in kilts coming in for a drink. They were massive, hairy and muscular figures and their hands were so big that you didn't see the glass they were holding, you just saw them lift what appeared to be their closed fist to their mouth. And – bang – down would go another dram. We had to be pretty well stocked up with whisky. But we were useful for other reasons. Once when the Games were drenched with a downpour the drummers came in with these drumsticks with big woollen balls at the end for Joan to dry out over the stove. You can imagine the sound effect and the horrible splash when hitting a drum

with one of those sodden things. Joan just rotated them over the heat until each of the ends of the sticks went from being a soggy fluffy mess to a dry, firm ball again. You could hear the difference when the band struck up.

It was Scotland, too, that furnished the most striking illustration of the almost magical appeal of Giles's caravan. On one of these tours the artist had gone to visit the *Daily Express* office in Glasgow. This was on the edge of the Gorbals, a notoriously tough part of a notoriously tough city, and Giles had parked the caravan outside the front door.

One by one, out of the side streets, young children approached. They came from all directions and some, it seemed, from quite a way away. There were girls as well as boys, most with dirty faces; one had a tricycle, another a home-made board on wheels, another a catapult. One held up his baby brother up high so he could see, and one had even brought a baby in a pram.

Within a short space of time there were at least fifty of them. They swarmed over the caravan and tugged wonderingly at Giles's expensive suit. For that moment he was their Pied Piper, the merchant of fantasy and fun calling to the young and not so innocent folk who people and enthusiastically terrorize Gilesland.

Gradually the strange caravan became known throughout the land. *Express* readers, in particular, would watch out for it and at each stop the important and the self-important of the locality would assemble to greet it. Company chairmen, Members of Parliament and police inspectors, sports celebrities and vicars, headmasters and scout-masters – all these and more would crowd into the caravan and take advantage of the ever-flowing Giles hospitality.

Just once, however, the anticipated welcome failed to materialize. The tour of autumn 1963 was planned as a really big splash. It was to start in the north of England, and plans had been made and designs drawn up for a massive publicity launch on the front page of

"The Press are not the only ones that get it wrong—that's not Grandma, that's the old harbour buoy on the end of the pier."

Daily Express, Aug. 25th, 1983

the Manchester editions of the *Daily Express*. Following the caravan's arrival, there was to be a big reception party and drinking throughout the evening. There was even a specially commissioned cloth doll of George Junior to add to the publicity.

The sense of keen anticipation had even affected Carl and Joan as they brought the caravan into the Manchester *Express* car park. But where was everybody? Giles parked over in the corner where they would spend the night, so that all the reporters and photographers

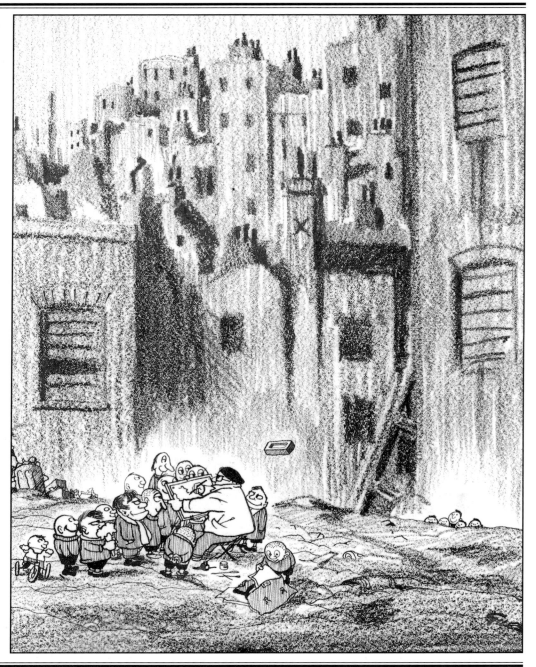

"Dad, you know the Consumers Association said a goose is a better guard dog than a dog?"

Daily Express, Nov. 24th, 1981

could come and go freely – only as yet no one was coming, let alone going. Something was wrong.

Giles checked the time by the ship's clock on the wall of the van. It was 6.10 p.m.. The date was 22 November. He switched on the radio to hear the newscaster intone: 'It has now been confirmed from Dallas,

Texas, that President Kennedy has been shot . . .'

It took Giles less than a second to realize that the odds on his fantasy brood making the front page of anything the next morning had just lengthened rapidly. Here, tragic reality had won the day.

All the same, let world events offer what they would,

"I bet she didn't know her umbrella handle was made of ivory!"

Sunday Express, June 4th, 1989

three times a week, year after year, Grandma and Vera, Mother and Father, George and George Junior, Ernie and twins would spill haphazardly out of the caravan's door and splash their inimitable brand of chaos on the landscape wherever they found themselves.

In the long, dark days of the winter, Giles would generally take them all home. But once, for a change, he stopped off at Ascot for a week, parking the caravan in the huge lot near the racecourse that was the wintering berth and main headquarters of the great Bertram Mills

Circus. The circus people loved Giles – and his creations; after all, the Family was the audience they played to all their lives – and Giles loved the circus people:

They were travelled and they knew about life. They knew ordinary people. They knew the hardships, but they especially understood the humour. We got to know them all. They would come to our caravan, which was in amongst all of their caravans, of course, at any time. Ours especially fascinated them because of the room falling out of the side. Almost every performer must have dropped in to see us at some time or other. Trapeze artists, the two midgets, a girl with marvellous performing poodles, the Bertram brothers themselves – wonderfully funny men – and old Coco the clown. Coco's daughter, Olga, was married to Alex Kerr, the lion trainer. He became an especially good friend for years afterwards, and brought a tiger up to the farm in Suffolk for the day.

And, of course, the comic possiblities of setting the Family down anywhere near the sawdust ring were legion; after all, they were in many ways a circus of their own. They were certainly no strangers to travel, even before the caravan came into existence to provide them with an easy means of getting about; as early as 1948 they had stolen a march on much of suburbia by going to America.

Giles had had one of his summonses to appear before his editor, Arthur Christiansen, in Fleet Street.

'We would like you to go to America,' announced Chris. 'Go wherever you like – coast to coast – have fun – take as long as you like, spend what you like – and take your wife, Joan.

'We would just like a regular report of your travels through cartoons, of course.

'And take the Family.'

To Giles, this was an offer of paradise. In the war he had come to love the Americans and all their works, but America itself had always been a distant, inaccessible place, full of magic and promise but impossibly remote. Not any more.

The voyage out on the *Queen Mary* was luxurious in the extreme: a first-class cabin, invitations to the Captain's table ... but though he could appreciate and enjoy the good life with the best, he hankered after something a bit more down-to-earth – and found it:

'I found out where the stewards used to do all their drinking,' he recalls. 'It was right down in the bowels of the ship, down where the engines sounded like thunder and where it was hot and there was a powerful humming of the electrics. No other passengers went down – this was decidedly below stairs.'

Grandma would certainly have appreciated – and shared – this impulse. Giles might have imagined her reaction to the posh accents and fancy couture of the top table to amuse himself while waiting for the opportunity to escape to more congenial company – for he had brought with him on the voyage, unseen to the other privileged passengers, a motley crew of unaccustomed sailors. Even as the ladies and gentlemen dozed on deck after lunch, a redoubtable figure in black bombazine – no concession to the climate here – goes stumping past, brandishing her parrot-headed umbrella in preparation for confrontation, muttering something about 'seeing the Captain' ...

... Behind her trails a scrawny woman with straight hair and glasses somewhat misted up, her face as green as the sea, clutching a bottle of pills marked SQUELLS – For Seasickness. Do Not Overdose ...

... And propped against a stanchion with his nose in a book by Sartre, so oblivious to the sea that he might as well be propping up a pillar box in Hampstead, is a curious figure with a pipe. He may be about to regret that he hasn't noticed the malevolently grinning small face appearing stealthily from under the tarpaulin covering a lifeboat ...

In due course the Gileses and their Family arrived in New York. All of them were somewhat overawed at first – even Carl, with all his American friends and his

"That's handy . . . you've left the iron on. Vera's glasses gone overboard, and grandma's sulking because they don't sell bulls'-eyes in the Queen Mary."

Daily Express, June 4th, 1948

Giles, with Family, heads for the United States. It was his first trip to that country, even though he had always loved America and admired Americans. He had befriended many of them in East Anglia during the war years, and his famous cartoons of GIs were adored by the American forces.

taste for the flamboyant and extrovert, wasn't quite prepared for the neon dazzle of Times Square; after all, the war was not long over, and England had been smothered by the blackout. But Giles's leisurely two-month tour of America, and the cartoons it generated, gave his readers at home a tremendous boost. In the war he had shown them the brash, cigar-chomping, taxi-hogging GIs and they had been amused and irritated in equal measure; now he was taking ordinary suburban Brits over there and showing them the sights.

The family returned to England today. The U.S.A. has since recovered.

Daily Express, Aug. 5th, 1948

Those two months must have cost Father a fortune. A dozen heads to be accommodated on pillows, a dozen bottoms to be found seats on the Greyhound bus or the train – had the Family won the pools? Father goes off to some sort of job every day, but we never for a moment imagine it as of the kind to fund this sort of spree – he might be a junior manager, perhaps, or boss of a small DIY store; no more. Did Grandma finally pull off her bank robbery, or mastermind a betting coup at Aintree? Where did the money come from?

The question is not a fair one, of course. As Giles says, 'That is something you don't ask. But I suppose the fact is that I was lucky always to have enough money not to worry about it, and so it never occurred to me that the Family should have those kinds of problems either.'

Perhaps it's best to think of them as we do of that other prominent family, the royals. We never see them handling money, after all. It is a commodity which the mighty and the immortal take for granted – and which they never (unless it be Grandma at the races) personally handle.

"I don't think our Captain will doze off—I've just slipped a couple of my Laxitivo Pills in his tea."

Daily Express, Dec. 14th, 1972

"I love the start of the Flat—all of 'em been stuffing themselves for three months in Barbados."

Daily Express, March 25th, 1982

They would have needed even more of the stuff to get to Bermuda, an extremely exclusive and expensive holiday location – but one for which Giles had a taste, and into which the Family therefore gaily breezed, providing some refreshingly earthy ballast in this rarefied millionaire's paradise. In July 1967, Giles recalls, he and Joan arrived on the island in pouring rain. He promptly sent a cartoon home showing Grandma being greeted in a monsoon at Bermuda airport and subsequently, fully clothed and with brolly up for stability, swimming underwater among some disconcerted tropical fish in order to avoid the downpour.

Giles Junior sent a note back to readers in England:

'Dear all, all the family are having a high old time here in Bermooda except mum dad auntie vera and granma. hope its raining your end. Yours truly, giles junior.'

"once more unto the beech dear freinds. . . ."

littel peice of spahgetty

italyan lady saying allo to mr giles

mrs giles saying allo to mr giles

mr rawhide saying O.

dear editor,

Just a few of my lines to let you no that mr giles and the family are still on holdy in itly. the sun has made mr g very red and very ot and he doesnt' like you hitting him with a spade where hes' got burnt and he doesnt' like us calling him rawhide. anutie vera looks like a littel pink lobster and grandma is still her usual shade of putty.

Mr.giles is getting on well with his italian speaking although we still get a big plate of spahgetty every time he orders a pot of tea. the twins have been ever so nice and ill through eating about ~~a hundredwate wate wait it~~ ½ ton of ica creama a peice.

all the italian poeple are very nice and have millions of littel boys and girls all over the place and they call them bambinos. when I mentioned to grandma that the italian grandmas dont wallop their bambinos so often as she wallops us she gave me a thik ear for not minding my own business.

three days ago we left for venice because one of mr giles' friends told him venice was only a few hours away and we're still travelling. providing we dont have to many ica creamas and mr g dont have to many vino biancos we hope to be there next week.

yours truly,
giles junior.

spahgetty

another littel peice of spahgetty

"over my red body"

mr antonio looking at grandma and saying cor struth.

Sunday Express, June 25th, 1961

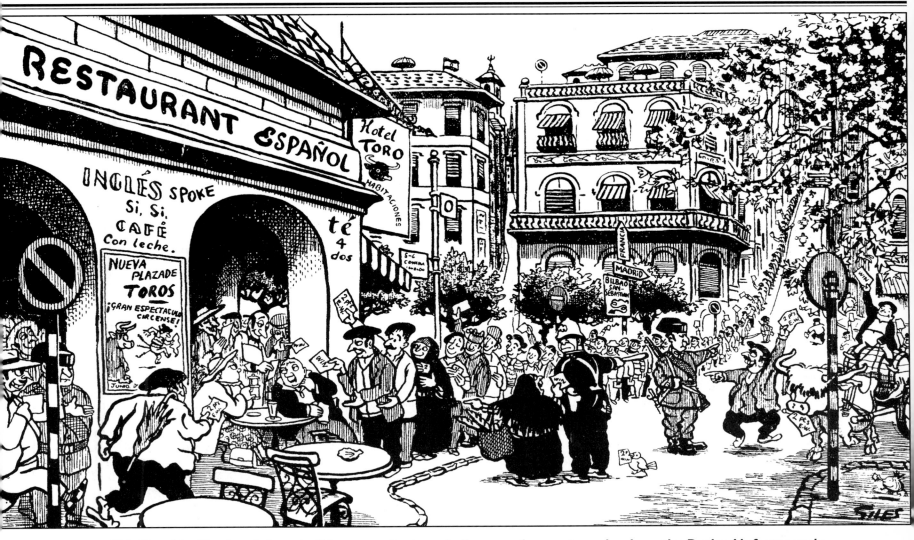

"It's like this, Mother. I thought I'd step up the travel allowance by running a book on the Derby. Unfortunately they all seem to have backed the winner."

Sunday Express, June 7th, 1953

The newly knighted Gordon Richards, riding the 5–1 favourite Pinza, had won his first Derby at the twenty-eighth attempt.

The last word had in fact been spelt JUNOR, with an 'I' inserted as an apparent correction between the last two letters. Carl Giles was a master at the subtle art of flattery by gentle mickey-taking, a practice open only to those whose own positions are virtually impregnable, and this was a gesture in the direction of his editor on the *Sunday Express*, the formidable Scot John Junor, now Sir John and universally known in both fear and affection as 'J.J.'.

Meanwhile Giles himself was practising his well-established technique of non-cooperation and perversity on an unsuspecting Bermudan journalist who was foolish enough to enquire into the artist's private life and the origins of his talent.

Journalist: 'Did you learn to draw at school?'

Giles: 'At my school, in the rural district of King's Cross and Islington, the only art you learned was the art of self defence, and I didn't pick up much of that.'

Journalist: 'Do you not think that you make children look worse than they really are?'

Giles: 'I think I flatter children. They are certainly more anti-social and dangerous than I show them.'

To be fair, Bermuda was the exception as a holiday destination. Most of the Gileses' holidays, and therefore most of the Family's, were taken closer to home, in France, Italy and, particularly, Spain. Spain was the great post-war sunshine destination, and millions of Britons could identify with the Family's exploits there.

While Grandma and her brood committed themselves to sand, sangria and bullfights, their creator did things in his usual style, roaring about the country in his white roadster XJ 120, Joan at his side in dark glasses and sunhat. Considering that in these years the country was still ruled by the Fascist General Franco and that the vast majority of the population were desperately poor, the sight of socialist Giles in his big white car scattering pigs and peasants was not one likely to crystallize as a portrait of the world's downtrodden; but Giles, readily admitting that he could never understand why his left-wing sympathies should doom him to a life of self-deprivation, was never coy about his spectacular style of travel.

One cartoon, indeed, not only flaunted the XJ but once again dizzyingly conflated the artist's actual life and that of his fictional Family. For Giles purists it is an intriguing collector's item.

The cartoon depicts an incident which never actually happened to Giles, though he was always prepared for it. The Jaguar is being stripped by a team of uniformed officials in the customs shed prior to being driven on to the ferry. The owner of the car is quite clearly Father. He is looking crumpled and harassed and is speaking to a lady with a hat-box and small suitcase who is equally clearly Mother.

It is a law of Gilesland that one must be able to jump back and forth between the real and the unreal. It is the same privilege enjoyed by Alice as she steps through the looking-glass and back.

On this side of the looking-glass, Giles and his Jaguar did come to genuine grief while in Spain. Even now he remembers the incident with pain.

'It was somewhere in a small place near Madrid and we had been driving on a very hot bright day. I drove slowly into this town and suddenly came out of the brilliant sun and into dark shadow. I was temporarily blinded and there was a horrible crunch. My heart sank. Even the slightest mark on the car gave me sleepless nights.'

As the locals gathered round, Giles peered wretchedly at the damage. He had hit a lamp-post, crumpling one of those famously streamlined headlamps. He prodded the casualty with his finger, picking little triangles of glass from the rim of the lamp. Among the crowd was a little chap in overalls. He looked at the wounded car and spread his palms as if to say: 'No problem. I will fix it.' Giles simply looked even more miserable. The idea of a village mechanic 'fixing' his beloved XJ120 was a dismal prospect.

He was wrong. The garage man worked for the whole of that weekend, beating out the metal with thousands of tiny taps of the hammer. Meanwhile Giles had called the boss of Jaguar himself, Bill Lyons, and a

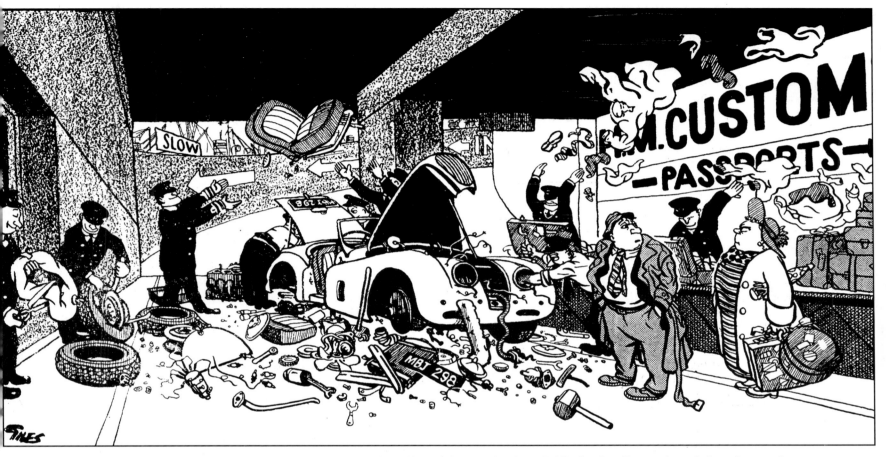

"They said, 'Anything on board there shouldn't be?' and for a joke I said, 'Only the Crown Jewels,' so for a joke they said, 'O.K. there's five minutes before your ship leaves—let's have her down to make sure.'"

Daily Express, May 18th, 1953

new light rim and fittings had been sent on their way. Within two days the resurrection was complete.

'The car was back in showroom condition,' says Giles. 'That little man had been a genius. When I saw the car finished it was the happiest day of my life.'

And so the Gileses rejoined the Spanish highway – Joan and Carl on one side of the looking-glass, Father, Mother and the rest of the mob on the other. Mr and Mrs Carl Giles were, the exuberance of their mode of transport aside, a self-effacing and immaculately behaved pair of tourists; but if the Family settled down for a pavement meal there was inevitably a terrible scene, while their appearance on the beach brought Franco's soldiers to the cliff-tops, fearful of riotous behaviour and alerted by the rumour which had spread along the coast of Grandma's threat to swim in the buff.

271

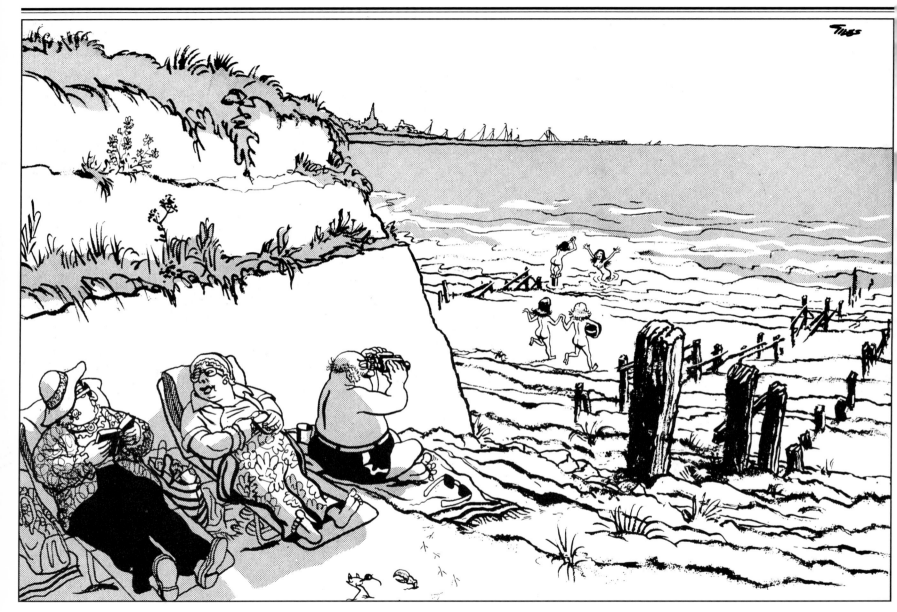

"Harry always takes an hour or so to make absolutely sure they're bathing in the nude before he reports them to the police."

Sunday Express, July 25th, 1971

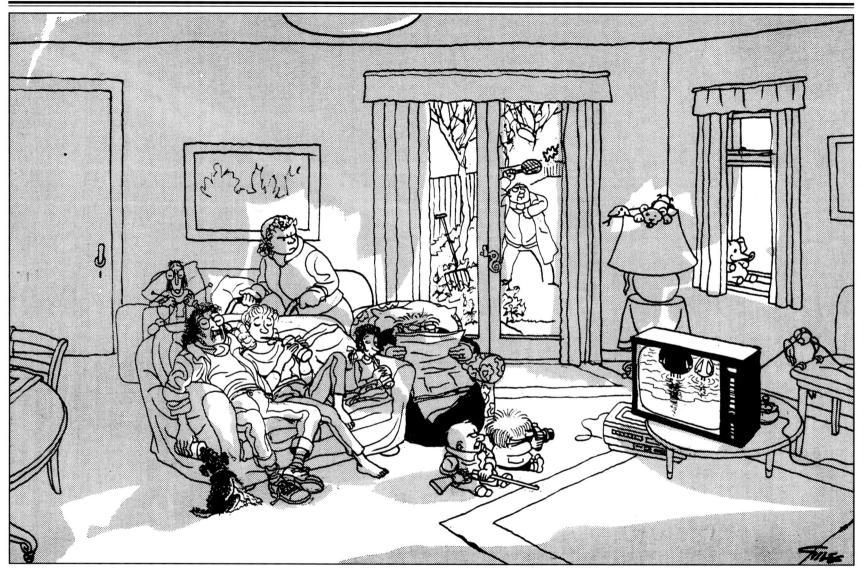

"That's the kind of video nasty I'd ban from the home—two reels of Grandma and Vera paddling in Benidorm."

Sunday Express, Nov. 13th, 1983

"*Far enough, Adonis.*"

Sunday Express, Aug. 12th, 1979

Wherever they went abroad, the Family managed to cause some kind of rumpus. It is the old curse of the British traveller: that woefully misguided assumption that one is at any given moment the centre of affairs, that the town, village or quayside has been awaiting one's arrival, at which everything should stop in its tracks, everything should be made available immediately – and, of course, that everyone should start speaking English.

Giles and Joan, naturally, did not conform to this stereotype. Though neither spoke any French, Spanish or Italian, they never suffered embarrassment, nor wanted for anything. Carl kept a small collection of colouring pencils in his pocket, and whenever he needed something he would simply take out a small pad and draw the object in question – whether it was toothpaste, a three-course meal or an elastic band.

In restaurants the staff gathered round in wonderment. Giles drew bread, brown or white; did a marvellous 'beef' – a bull – and took only a second to represent a fried egg. 'I just did a little circle and put a pale yellow spot in the middle of it.'

Complicated orders could take a little longer. As Giles drew, selecting first one pencil, then another, from his little bunch, the waiters peered over his shoulder in fascination. Escargots, spaghetti; nothing was beyond the cartoonist's skill.

And so, while the master diverted the locals and kept himself fed with his artistry, his famous Family toured the world in his wake, making a spectacle of themselves and, through the pictorial diary of their adventures, providing enormous amusement to everyone back home. 'Thank God we're not like that,' the less perceptive would say.

A Genius for Celebration

Arthur Christiansen, reflecting on the genius of Giles in his autobiography, *Headlines All My Life*, confesses to a certain curiosity about the gifts of this most rewarding and exasperating of employees. 'Carl Giles,' he muses, 'has never had an art lesson in his life.'

The only formal training Carl ever had was in anatomy classes at night school, yet the cartoons which streamed from his pen over the years were as brilliant in their artistic skill as in their perception of the uncertainties of human nature.

Carl was always fascinated by cartoons. As a very small boy he would wait with great excitement every Thursday evening for the arrival of his father with the weekly copy of the *Tatler*, the society magazine which carried the work of Captain Bruce Bairnsfather, a serving army officer who had sent home from France boldly drawn sketches of life in the trenches of the First World War. Sitting beside the coal fire in the cosy Islington sitting room, the young Giles would study with immense concentration every detail of the Captain's cartoons. These sketches, wonderfully funny, portrayed the kind of character that was to become common currency in Giles's own inimitable style in the Second World War: the cheeky Tommy, cocky and good-humoured, able to survive in the most unpromising circumstances by sheer determination and jaunty pluck.

Giles admits to few gods in his own trade, but the *Tatler* did give him one more hero: Pont – the pen name of Graham Laidler – who produced those typical fine-line cartoons of aristocratic and middle-class life for which the magazine was famous at the time when Giles was drawing for *Reynolds News*. Pont's detail, Carl remembers, was exquisite and the backgrounds full of additional humour. When Pont, always a sick man, died in 1940 at the age of only thirty-two, Giles felt, he says, as if he had lost a dear friend.

But of all the influences that were to make their mark on Giles's artistic output, perhaps the most powerful was the period he spent working in film studios. He had left school at fourteen, having had quite enough of the formal education on offer from Chalkie and his successors, and had got a job as an office boy in Wardour Street. Soon, to his delight, he was working as an animator on cartoon films. 'I got ten shillings a week, rising to twelve shillings, but it was wonderful. We worked long, long hours, often up to midnight, but we didn't mind.'

By the time he was eighteen, Carl had moved from Wardour Street to Elstree Studios under the aegis of the renowned film-maker Alexander Korda. As one of a team of animators he worked on a full-length cartoon feature called *The Fox Hunt* which Korda hoped would establish him as a British Disney. But the project was never fully completed, and although the film was screened briefly at the Curzon cinema in London, it was soon forgotten.

Carl moved with the Korda office to Isleworth, then on to another studio in Ipswich. At this point tragedy

"Come on, Sir—
admit you hate
me."
*Daily Express,
April 8th, 1971*

"I'm getting a bit fed up with you climbing up here just to get your picture in the papers."

Sunday Express, Dec. 11th, 1983

Giles suspends the reader twenty feet above the dark mouth of a factory chimney. It is an amazing drawing and should certainly be kept well away from anyone who suffers from even the mildest form of vertigo.

"Mum! that man's thrown all our toffee and oranges out of the window."

Daily Express, July 31st, 1951

struck his family: his brother Bert, ten years older than Carl, died after an injury at work turned gangrenous. Their mother was distraught, and Carl straight away moved back to London to be with her. Almost immediately he was offered a job drawing cartoons for the left-wing Sunday paper *Reynolds News.*

Giles had developed a revolutionary style of drawing, one of almost photographic reality – an apt vehicle for the most startlingly colourful, uncannily true, scalpel-sharp and vibrantly alive cast of characters ever to flow from the tip of a cartoonist's pen. A commentator observed in the late forties:

'The secret of Giles' cartoons lies in his movie training – his training in animation with Korda and people.

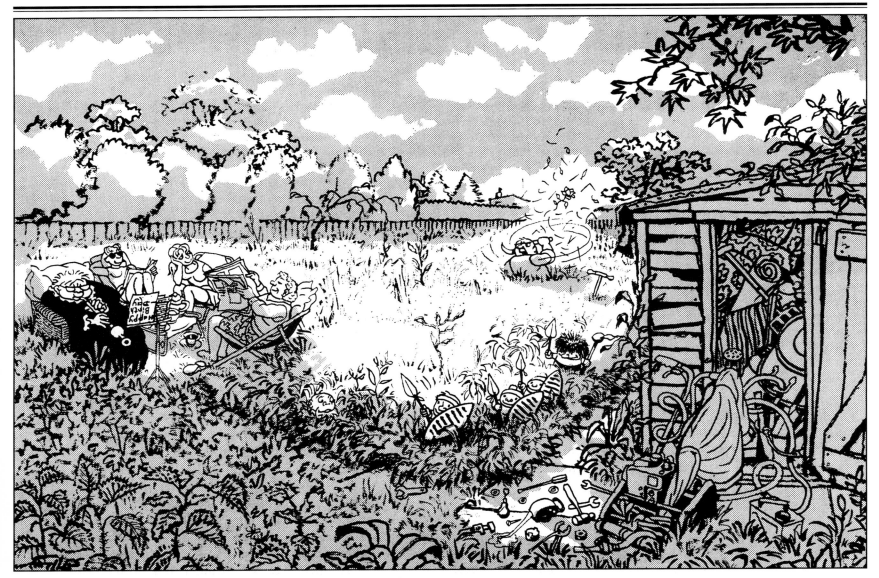

"Stop telling me the Queen Mother is twice my age and does her own garden and you bet it doesn't look a mess like ours."

Sunday Express, Aug. 4th, 1985

'He draws in a panel shaped like a movie screen.

'His carefully built background architecture is as authentic as a naturalistic stage setting. His characters are placed on stage with directorial skill.

'When he shows his drawings to friends he delights in telling them what the characters have been doing up to the moment he has chosen to draw them – and what happens to them afterwards.

'In dreaming up a cartoon situation he imagines a complete dramatic sequence and orders his brainchildren to act it out. When they come to the climactic moment, Giles says mentally "Hold it" and proceeds to draw them.'

The attention to detail that went into these cinematographic representations was always painstaking and came to be a Giles hallmark. Anyone who has ever sailed under canvas will see in a Giles yacht a vessel that could be launched any minute, with every line and halyard, each cleat and stanchion, exactly as it should be – as indeed befits a waterman of note. Every soldier's uniform, British, German or Japanese, is correct in every particular. (It was said in the war that a group of novice soldiers on the Rhine once bagged a Gestapo general after quick reference to a newspaper cutting of a Giles cartoon showing a member of the Geheimstaatspolizei in uniform.) Every nut and bolt, every spare tyre on every jeep, tank and lorry is of the exact type and mark issued by the various stores, from Aldershot to Tokyo.

In this respect, too, Giles's studies began almost as soon as he could walk. He was mesmerized by soldiery, and on Sundays his father would take him down from Islington into London to watch the drilling and parades at Wellington Barracks, next to Buckingham Palace. Here he would watch the rehearsals for the great ceremonial performances such as the Changing of the Guard; transfixed by the spectacle, his insatiable memory would take in not only the minutiae of belts and bearskins but also the famous ramrod spine of the regimental sergeant major, the set of his massive shoulders, the bristling little moustache and the sudden yawning cavern of his mouth as he bellowed, barked or screeched an order to the lines of men spread over five acres around him.

Giles's earliest memory of the emotional power of the military concerned just such a man as this: his own Uncle Arthur, a sergeant major with the Coldstream Guards in the First World War and a figure, his nephew recalls, of ferocious dignity, honour and decency. And discipline:

'I remember I got hold of an air rifle – it could do quite a lot of damage. My uncle confiscated it, took the spring out of it and gave it back to me. I was very angry, but I didn't dare say anything. I was too terrified.'

Uncle Arthur towered physically and morally above the tiny Carl, a hero of god-like proportions.

'I used to spend so much time up in Norwich at my grandmother's house that we went to school up there. After classes I would go and stand with my little friends at the huge gates of Mousehold Heath Barracks, where my uncle was stationed. We usually didn't see him, just a lot of figures marching up and down in the distance. Then one day he appeared. It was the most exciting moment of my childhood.

'There was this frightening clattering noise from inside the barracks, and suddenly these four powerful, shining black horses with great leather harnesses thundered into view, towing a line of gun carriages.

'They broke into a canter as they went through the gate and then out onto the cobblestones. You have never heard such a bloody noise.

'And there, sitting up high beside the chap with the reins, was my uncle. He was straight and proud, with the peak of his cap over his eyes and his arms folded. He didn't glance to the right or to the left – just in front of him. He looked like a soldier should look. It was a fine sight.

'You can imagine the pride you'd feel. I turned to my chums and said: "That's my uncle."'

"Get that nasty thought out of your mind, Wilson."

Daily Express, Aug. 30th, 1945

In Rangoon, Burma, the Japanese forces, still with their teeth to the front, march to sign a formal surrender under the eye of Australian troops. This cartoon is the favourite of Giles's friend, comedian Michael Bentine.

"This is nothing, Tovarishi, you should have seen the one that got away."

Reynolds News, Jan. 25th, 1942

Giles even managed, on at least one occasion, to make the Russians laugh. During the winter battles for Stalingrad, one of his cartoons was reprinted in the Soviet Union as a billboard.

"I suppose we must be thankful, Bertie—Chelsea's manager says football yobs are only one per cent and it's all blown up by a panicked public and Press."

Daily Express, Sept. 6th, 1975

This pride in the upstanding decency of the sergeant major, as well as delight in the devious debunking spirit of the Tommy, shines through all Giles's cartoons of the war years and after. He was neither sentimental nor malicious. There is great warmth in his drawings, even when some of the characters can only be described as monsters. Above all, Giles displayed a touching affection for, and understanding of, his country and his countrymen. His England was – and is – a real land of grocers' shops, bookies and suburban gardens and living rooms; an ordinary, decent, funny England. The pleasure of looking at a Giles cartoon lies in much more than the central joke, or the latest piece of malevolent ingenuity dreamt up by Ernie or Grandma: what we remember so often is the mood and the feeling.

And the weather.

As the writer and art critic William Feaver points out, 'Like the Archers, the Huggetts, the Dixons, the Glums, the Garnetts and the Ogdens – who all owe something to them – the Gileses are not so much your typical English

THE GILES FAMILY TREE

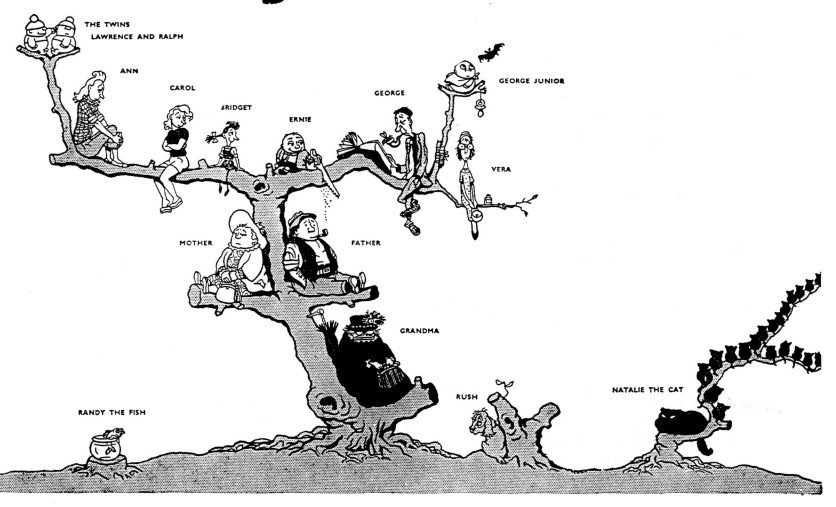

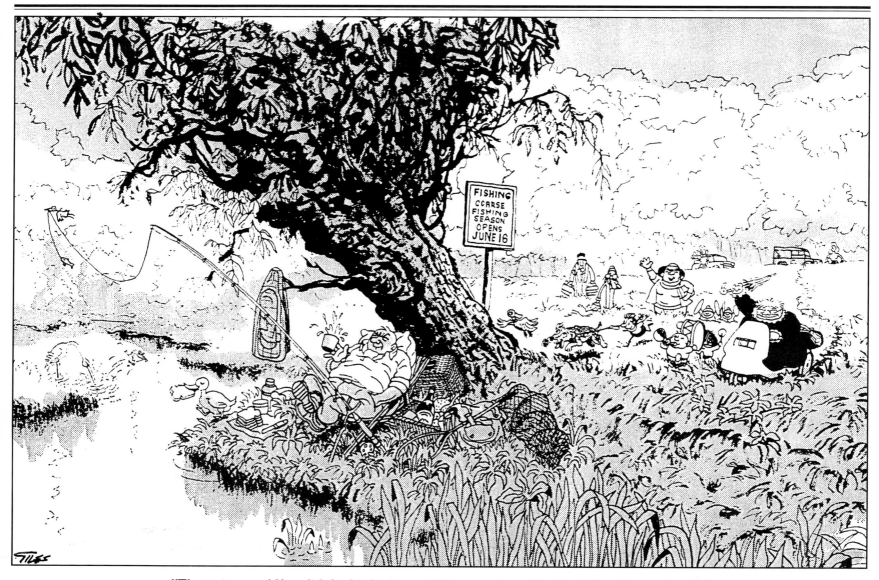

"There you are! You didn't think we would let you spend Father's Day on your own."

Sunday Express, June 16th, 1985

"This is my kind of education—get in late as you like because of fog, sent home early because of fog."

Daily Express, Jan. 23rd, 1964

family as a family around whom everything revolves. They are provincial but come up to town quite a bit – the Boat Show and so on – and travel a good deal. Their credibility depends largely on the accuracy of the settings.'

In the course of a brief review of a year in the life of the Family, Feaver homes in on one event on a sunny day in June which captures splendidly not only the inseparable mixture of domestic affection and horror that clings to the household but also the tangible quality of the circumstances in which it is set.

'Sunday June 16 and Dad slips away on his own for a bit of coarse fishing. Hardly has he settled down with thermos and sandwiches in the shade of a burly Giles willow when across the meadow come Mum and Bridget, Ernie sounding his trumpet, the twins with their cymbals, George with baskets, Vera with her hanky, and Grandma, ahead of the field in her Sinclair C5. He should have known: it's Father's Day.'

"The merry month of Maying ... With a fa, la, la and a fa, la, la ... and in three weeks' time the nights start drawing in."

Daily Express, May 29th, 1962

The power of this cartoon lies only partly in the joke, just as much in the mood and the detail: the grassy river-bank, splashed with sunlight flickering through the willow leaves, the plopping of flies in the water – somehow you know that it is the middle of the afternoon, hot and still; you can hear a dog barking a mile off.

Feaver goes on: 'The excuse for the joke is often less effective than the placing: dour wintry sky over the station approach; mud at low tide; juggernauts churning

the slush; double yellow lines leading from traffic warden to traffic warden. No one is more used to conveying in tone and scribble the precise textures of pebbledash and privet.'

Or rain. Rain on the cricket ground, rain at the races, rain on holiday, rain at the vicar's tea party. Giles loved to subject his Family to the most atrocious weather. Under a banner inscribed on a more favourable day with the words Grand Fete, now

"We've been tobogganing—Dad's in Ward 10 but the sledge is all right."

Sunday Express, Dec. 3rd, 1978

"Right—on the show of hands Sebastian gets a reprieve—one of you go to the shop and get six large tins of corned beef."

Sunday Express, Dec. 17th, 1978

Fatal to give them a name, of course.

sagging horribly, huddles of unhappy people shiver under a tree or crowd into soggy tents, getting grumpier by the minute. The vicar is sodden. George the thinker is emptying water out of his pipe. No one can make a wet English summer afternoon look *quite* so wet as Giles – and with such economy and skill of technique. He leaves the ground undetailed except for those smudgy, watery reflections of the characters. The downpour is conveyed with about a hundred angled dashes of the pen. How simple it looks. It isn't.

And in the winter pictures, what other artist could create so simply and so apparently effortlessly those astonishing snow scenes? It is a late December afternoon and shafts of light stream out of the stained-glass windows of the church. It is grey and gloomy and bitterly, bitterly cold. Sound is swallowed up everywhere by three inches of freshly fallen snow. And behind a gravestone lurk a gang of monstrous choirboys, their pyramid of snowballs amassed in readiness for the arrival of the unsuspecting parson, hurrying towards them from the distance in billowing surplice.

Mike Molloy, himself an artist before rising through the editorial ranks of the Mirror Group, says of Giles:

'He was able to create a snow scene simply by leaving areas and patches of his picture blank on a rough textured board and adding the simplest stroke with a wax pencil.'

Jak, the acclaimed cartoonist of the London *Evening Standard*, makes the same point:

'Carl had this flair for leaving things out. With bricks, for example, he would leave most of them out where I would have put every one of them in. I would draw a Norman arch and he would draw the effect of a Norman arch and his would be better, his would look more effective.'

Jak admits to being a disciple of Giles and a true admirer – but he also wanted his job. From time to time he would say to Jocelyn Stevens, managing director of Beaverbrook Newspapers, the group which owned the *Evening Standard* as well as the *Express*:

'Come on, Jocelyn, when are you going to get rid of Giles and let me take over?'

Stevens was not impressed. 'How would you feel if one day someone were to ease you out?' he retorted.

Jak accepted the admonition. 'He was quite right. Anyway, I never did take over. And I will always have a tremendous admiration for Carl's work, although I felt he coasted a bit in later years.

'He used to treat me with great caution. I once said to him – joking – that whenever I was short of an idea I would get down an old Giles Annual. I learned a few days later that he had complained about me. He had registered a strong objection to me nicking his ideas. He could be very difficult, you know. He was always "resigning".

'Still, he was a bloody genius. I think they should have given him a knighthood. The royal family thought he was marvellous, didn't they? I wonder why he never got one.'

One newspaper knight who would no doubt echo this recommendation is television's most distinguished former newsreader, a former editor of the *Daily Express* and a particular fan of Giles, Sir Alastair Burnet. He reflects on the unique pleasures of Gilesland, 'a country wholly surrounded by choppy seas and duffers in boats. Its pastures are peopled by idle cattle, idle farm hands and even idler earls. No snow falls there that does not end up impacting on the necks of vicars and postmen. No rain falls that does not raise the grass for the lawnmower industry.

'It is not a democracy, but an anarchy, the urban guerrillas led by a gerontic Passionara in black. Its pubs never close, its butlers never falter. Its men are pitiable but persevering, its women patient in their superiority, its children numerous. It is full of mischief. We have to shout on *News at Ten* to make ourselves heard above the Gilesland hubbub.'

'Hubbub' surrounded Giles from the word go. Born next to a pub at the Angel, Islington, the joyous din of carousing and wassail was to accompany him through life from that moment on. From the large, close and

"I'd quit this underpaid job if I wasn't dedicated to scrubbing your sweet little neck every morning."

Daily Express, April 9th, 1987

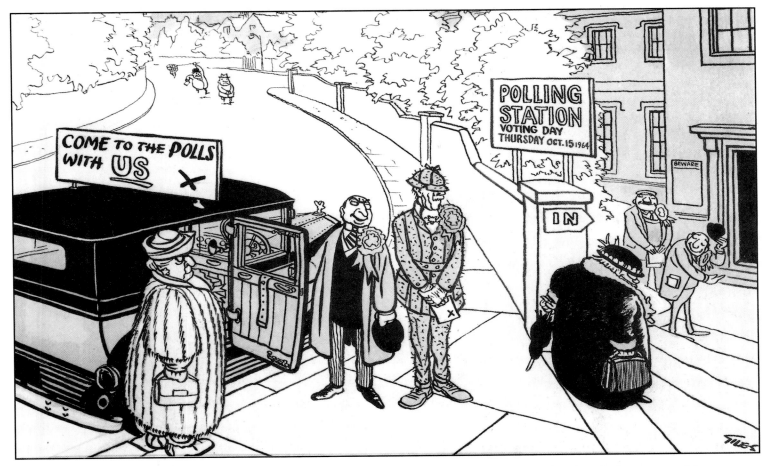

"I've run her round the shops, called on her sister Ivy, dropped her off for an hour's bingo—and I still bet the old faggot votes the other way."

Daily Express, Oct. 15th, 1964

happy family in which he grew up to the drinking dens of Fleet Street and the waterside taverns of Suffolk, from farmhouse to caravan and back again, wherever Giles is, there is something to celebrate. And, to the artist's quiet pleasure, he is now celebrated himself in the inn next door to his birthplace, renamed 'The Giles'. Its sign bears a ferocious picture of Grandma.

Giles has never seen any sense in the ethic of self-denial. A professed left-winger in politics, he has openly lived a life dedicated to fun and the enjoyment of material pleasures, and refuses to acknowledge any contradiction. 'I'm a Bentley-driving socialist,' he says. If you're lucky enough to have the chance, the idea seems to be, then enjoy yourself.

It's an attitude certainly shared by the Family, though Vera seems to have some trouble leaving care behind and George the bookworm would be unlikely to notice whether he was in the middle of a wedding or a funeral. Birthdays, Mother's Day, Father's Day, Derby Day – the Family never lets an occasion for festivity go by without something of an effort, however often mischief and mayhem ensue.

Christmas is in many ways the highlight of the year in Gilesland. Every year Carl drew *Daily Express* Christmas cards for charity: for the Royal National Institute for the Blind, the Royal National Institute for the Deaf, the Game Conservancy Trust – and for his favourite charity, the Royal National Lifeboat Institution. And here it is not just the dazzle of his draughtsmanship and his astonishing ability to convey effects of snow and light that are so impressive; it is also his skill at producing an unmistakably authentic Yuletide atmosphere, combining the magic and excitement with the constant threat of chaos that figure somewhere in nearly everyone's family Christmas.

Father Christmas becomes stuck in the chimney after raiding the brandy, or finishes the night coming off worst in a game of poker with Grandma. Or he gets booked for speeding or for leaving a team of reindeer on a double yellow line. Ernie will flog the mince pies to the Salvation Army at half price and Butch will probably eat the turkey. The kids will have swapped the puny little popping bits in the crackers with serious explosive and Vera is going down with her special Christmas cold, the one, as Giles Junior once remarked, 'which usually lasts till next Christmas'.

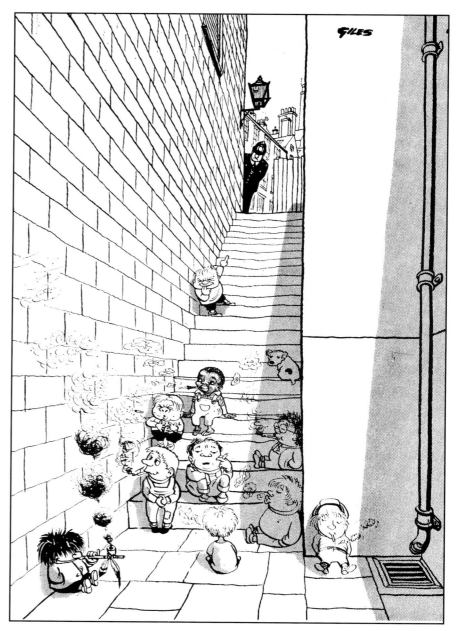

"Legalised Pot! Damn Government takes the pleasure out of everything these days."

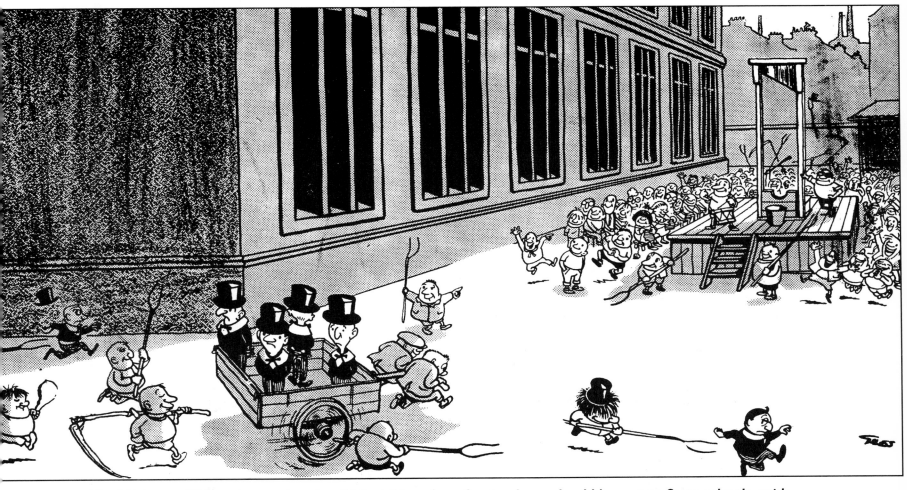

The Minister of Education, urging that ALL children from five to eleven should be sent to State schools, said: "Children of that age learning and playing together are not inhibited by any sense of differences."

Daily Express, Oct. 17th, 1961

Mike Molloy remembers how close to home the Giles Christmas could be:

We lived in a typical lower-middle-class home – a Giles home – and our house at Christmas time smelt of Rupert books and Giles Annuals. You would look at a Giles Christmas cartoon, look at the chaos about you and say: 'How did he get in here? How did he know? So much is going on in a Giles Christmas scene. It was not just full of independent detail, but

everything that was happening was interrelated. It was connected and had a sense of movement. Grandma appears to be dozing by the fire as the kids light the fuse of a firework under her chair. Look again and you can see that Grandma has one eye open and that her hand is just about to reach for the poker. The cat is about to jump up at a decoration and you can see that the chain reaction which will follow will probably bring the whole tree down on Vera, who has her head under a towel inhaling some cold cure out of a steaming bowl.

Here again we see the cartoonist as animator, picking one still out of an imagined sequence.

'Giles works like a camera,' says Molloy. 'But what made his Christmas cartoons so special was that they

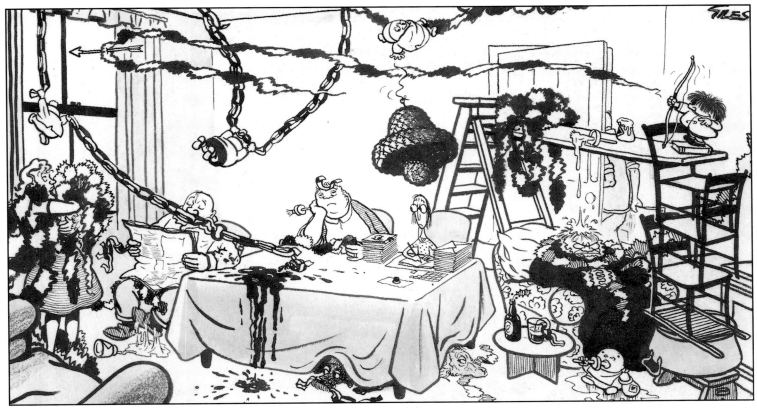

"Decorations are an essential part of the gaiety of Christmas ... the whole family is drawn closer together by the fragile links of a paper chain."

Daily Express, Dec. 13th, 1956

showed the strength of the Family. They depicted the antithesis of loneliness. Despite the chaos and the anarchy there was a wonderful sense of security, of warmth and of belonging. There was snow outside the window, a fire in the hearth and the tree was lit up and festooned with bunting. What more could you want?'

There was also, perhaps, an element of nostalgia in Giles's Christmas art – though, as ever, he is merciless in separating memory from fantasy and any smidgeon of sentimentality.

'Actually, I can only remember it snowing over Christmas on one occasion,' he points out. 'And that was on Christmas evening. White Christmases are a bit of a myth. We all imagine we remember them, but if we think about it, they never really happened.'

But his recollections of the real delights of the Gileses' Christmas are crystal clear.

Although we didn't have white Christmases, they were wonderful, very special times in our home. We had huge numbers of presents, I remember. This was because my father used to bring them all from

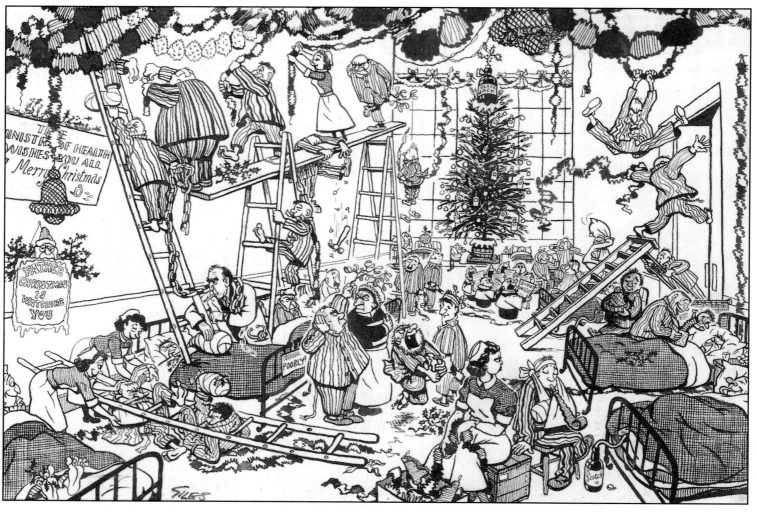

Dedicated to all those compelled to spend Christmas in hospital, where there is little or no escape from giving a hand with the decorations. I know, I've had some.

Daily Express, Dec. 24th, 1954

his shop. Trains, little lorries, all kinds of things. Because he was a tobacconist, he had all these samples which showed the customer what he would be able to swap for a collection of cigarette cards. So many cards would get you a lorry; a large

number of cards would get you something very special. We had stockings and pillow-cases full of gifts.

It was the trains I remember more than anything else. People forget now, but in those days of

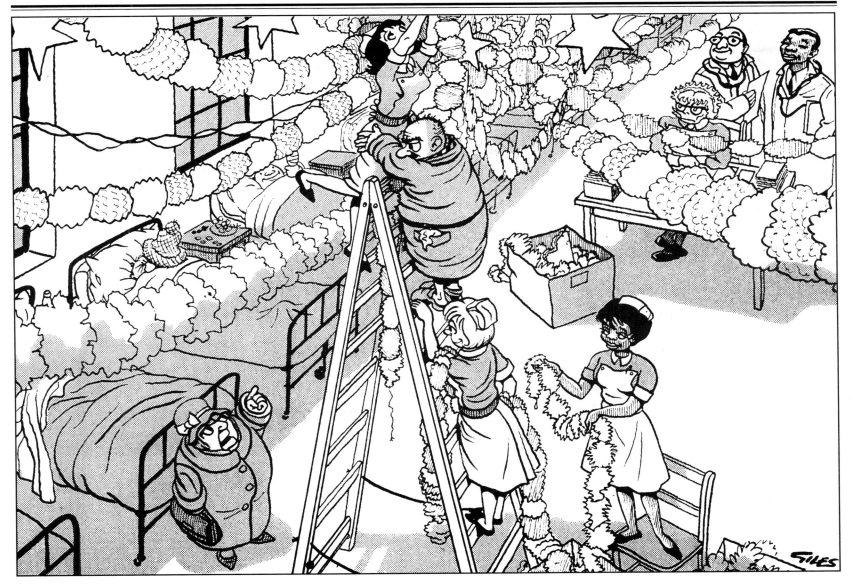

"If you're fit enough to do the decorating around here you're fit enough to come home and do ours."

Daily Express, Dec. 17th, 1963

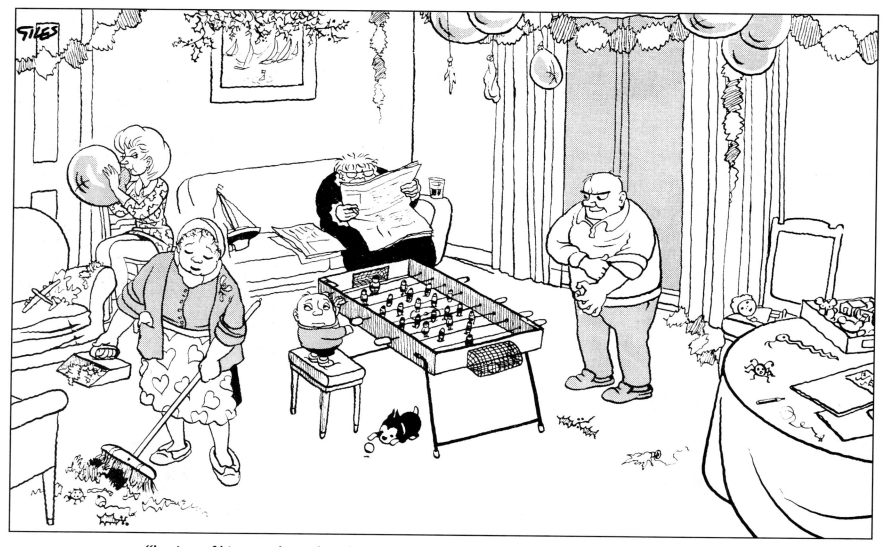

"In view of his team being knocked out of the Cup yesterday, for goodness sake let him win."

Sunday Express, Jan. 3rd, 1971

steam the engines were brightly coloured and shiny. The locomotives on LNER – that was London-North Eastern – were green, with wonderful scarlet wheels. And a red bumper. If you came from my kind of family you would have an LNER train set. If you lived in a rich family your train would probably be GWR – that was the Great Western. Posh people used the Great Western – to

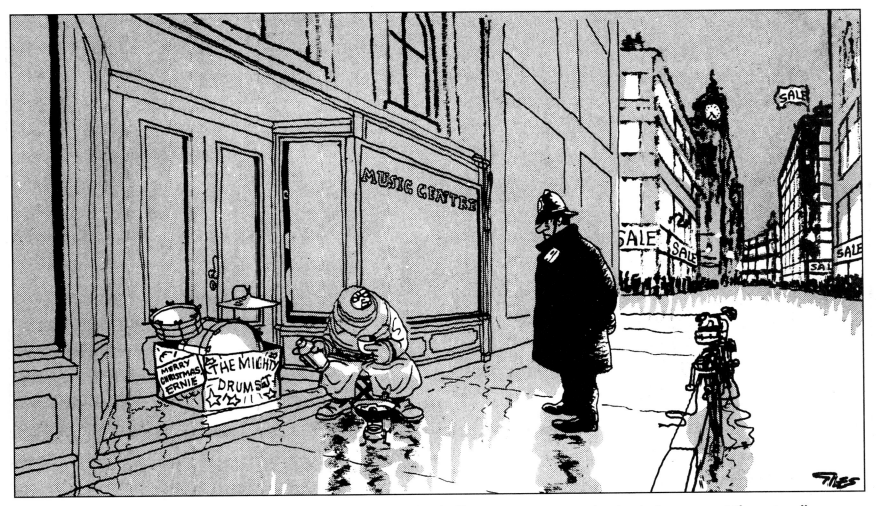

"I know they haven't got a sale on—that's one of my boy's Christmas presents going back the moment they open."
Daily Express, Dec. 27th, 1984

go to places like the races at Cheltenham. GWR livery was brown and yellow. If you look at some of the small stations along the old Great Western routes you can still see the benches, still kept freshly painted in the old colours.

Oh, you all wanted to be engine drivers ...

For Carl, nostalgia has a lot to offer, for on constant reflection he regards the whole of his life as being gloriously happy. He has no complaints, no regrets at all. Of

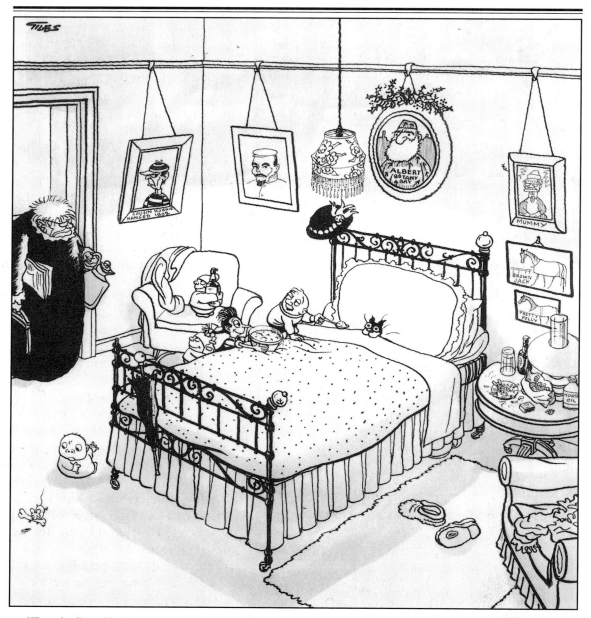

"Don't fly off the handle, Grandma—we're only using your bed while our Christmas present's got flu."

Daily Express, Dec. 30th, 1969

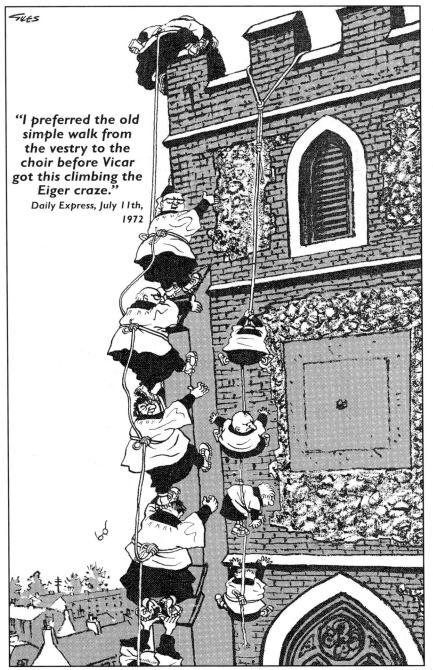

"I preferred the old simple walk from the vestry to the choir before Vicar got this climbing the Eiger craze."

Daily Express, July 11th, 1972

his wartime days in The Fountain with his black GI friends, he says: 'That was such a happy time.' Of his trip to America with Joan after the war, he says: 'What good times they were.' Of his time with Alexander Korda in the studios before the war, he says: 'What an honour it was and what fun we had.' Of the days of *Reynolds News* and the fifty years with the *Express*, he recalls: 'So much laughter.' Of his motoring and yachting and DIYing, of the caravan and the films and the parties and the pubs and the roistering, he declares with inclusive relish: 'Marvellous!'

In the past Joan, pouring tea for them both as they sat beside the French windows in the Suffolk sun, was wont to comment: 'You're always saying that.'

And Carl would reply: 'Well, that's how it was.'

Can this be the same man with a reputation for being awkward, difficult, a torment to editors, reporters and minor officialdom the world over? Michael Bentine, companion of many sailing trips, says:

'I really don't know him all that well. He's an elusive character. Well, of course he's crotchety, all artists are. I think of him as one of the most straightforward, honest, modest men I've ever met. But the most striking thing about him, and the thing I adore him for, is his profound and never-ceasing love of humour and the ridiculous. How could you not feel deeply for a man who sees the whole of our existence, particularly this very peculiar and unique British kind of existence, as something which is endlessly and gloriously funny and absurd?

'Of course he's a ruddy genius. Has any artist ever caught the British so accurately and with such a mixture of mischief, good nature and compassion?'

303

And John Gordon, who, as editor of the *Sunday Express* in the forties, lured Giles over to the Beaverbrook papers, pronounces:

'I think that in his own particular line of cartoon Giles is without an equal in Britain today. Indeed, I know of no better in all of the world.

'He has that greatest of all gifts of genius, the common touch. He knows the common people, their troubles, their foibles, their joys, their aspirations. He is, in fact, the common man.

'But he is something more than the great cartoonist.

Study his work closely and you will find that he is a great artist as well. His backgrounds are perfect in structure, in detail and in balance.

'And finally, the people in his cartoons, those odd children and those even odder grown-ups. When I looked at them first I laughed at them, but was inclined to say: "They are amusing but they are certainly not people." But I was wrong. I know it now. For whenever I pass along the street I look at the people and say: "After all Giles is right. Every face is a Giles face." Try it for yourself.'